HISTORIC PHOTOS OF
SEATTLE
IN THE 50s, 60s, AND 70s

TEXT AND CAPTIONS BY DAVID WILMA

TURNER
PUBLISHING COMPANY

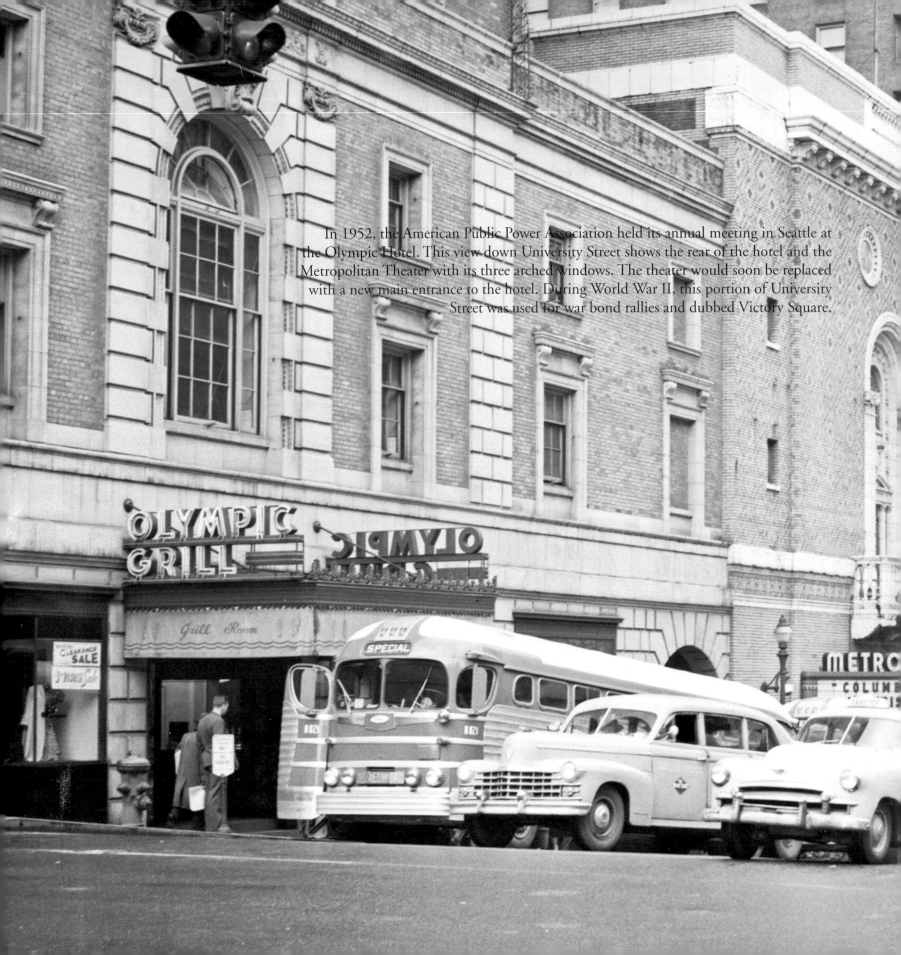

In 1952, the American Public Power Association held its annual meeting in Seattle at the Olympic Hotel. This view down University Street shows the rear of the hotel and the Metropolitan Theater with its three arched windows. The theater would soon be replaced with a new main entrance to the hotel. During World War II, this portion of University Street was used for war bond rallies and dubbed Victory Square.

HISTORIC PHOTOS OF
SEATTLE
IN THE 50s, 60s, AND 70s

Turner Publishing Company
200 4th Avenue North • Suite 950
Nashville, Tennessee 37219
(615) 255-2665

www.turnerpublishing.com

Historic Photos of Seattle in the 50s, 60s, and 70s

Copyright © 2010 Turner Publishing Company

All rights reserved.
This book or any part thereof may not be reproduced or transmitted
in any form or by any means, electronic or mechanical, including
photocopying, recording, or by any information storage and retrieval
system, without permission in writing from the publisher.

Library of Congress Control Number: 2010921719

ISBN: 978-1-59652-596-2

Printed in China

10 11 12 13 14 15 16—0 9 8 7 6 5 4 3 2 1

Contents

Acknowledgments ... VII

Preface ... VIII

The Era of Peace and Prosperity
 (1949–1959) ... 1

Age of the Space Needle
 (1960–1969) ... 69

A Bust and Bouncing Back
 (1970s) ... 165

Notes on the Photographs ... 201

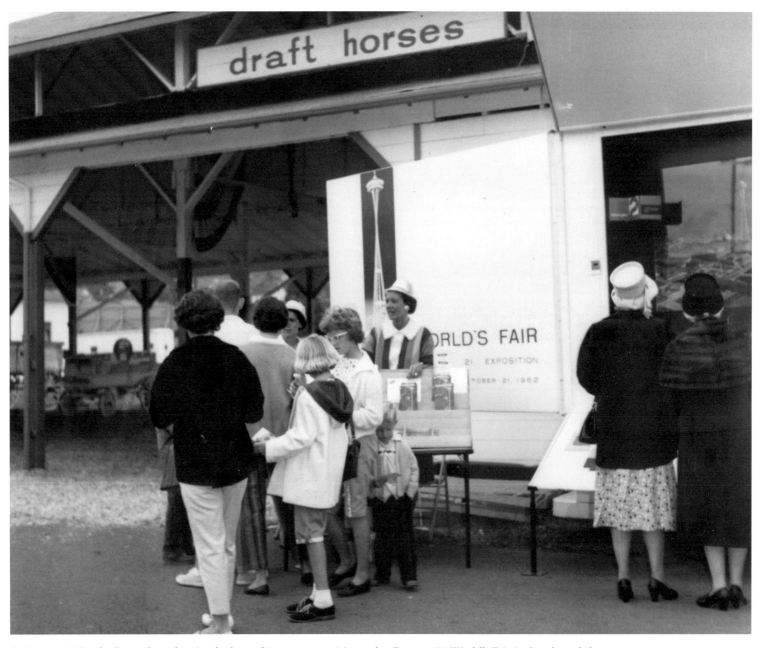

In August 1962, the Puget Sound region had two fairs to attract visitors, the Century 21 World's Fair in Seattle and the more traditional state fair in Puyallup. With some irony, the World's Fair was assigned booth space at the state fair, advertising visions of the future—outside a horse barn.

Acknowledgments

This volume, *Historic Photos of Seattle in the 50s, 60s, and 70s,* is the result of the cooperation and efforts of many individuals and organizations. It is with great thanks that we acknowledge the valuable contribution of the following for their generous support:

www. HistoryLink.org
University of Washington Libraries
The Seattle Public Library
Seattle Municipal Archives
Washington State Archives
Rainier Valley Historical Society
Black Heritage Society
Seattle Parks Department
Seattle Department of Neighborhoods
Seattle City Light
Don Sherwood Parks History Collection
The Thunderboat Museum
University Bookstore
Seattle Folklore Society
The *Seattle Times*
The *Bend Bulletin*
Paul Dorpat
Alan Stein
Andrew K. Dart
Anacortes History Museum
Unico Properties
Columns magazine

PREFACE

At the end of World War II, Seattle found itself larger, busier, and richer by tens of thousands of new residents who had come to train or build ships and planes for the war effort. On one hand, veterans of the war and Seattleites generally just wanted to return to a normal life in a city that still slumbered as a quiet, even provincial, place to live, but on the other hand they pushed ahead to change the face of society, the economy, politics, and the environment. They needed homes to live in and spent money on cars, furniture, television sets, and, of course, children—the postwar baby boom.

Seattle grew in people, territory, and ambition. New cars allowed workers to buy their new homes in distant neighborhoods and suburbs while they worked downtown or out at Boeing. President Eisenhower's Interstate Highway system was intended as a defense measure, but the freeways legislation as spearheaded by Senator Albert Gore, Sr., had consequences almost beyond imagination. Not only did the new, high-speed highways help spur the economy, they changed settlement patterns. Entrepreneurs saw that new shopping centers with acres of free parking were more convenient than downtown and they built Northgate and Bellevue Square. Downtown responded with parking lots and redevelopment plans of its own.

Population grew by almost 25 percent in the 1940s and by another 20 percent in the 1950s, which helped to extend the city limits. After 1960, the number of city residents fell for the next three decades. But if Seattle was smaller demographically after thirty years, it was bigger in every other way. The signature event of this period centered on 184 days in 1962 when the Seattle World's Fair amazed everyone. The iconic Space Needle, the sleek Monorail, and hundreds of exhibits showed ten million visitors the promise of the future from space travel and mass transit to computers and something called miniature micro-mail. Celebrities from Elvis Presley to Prince Philip put in appearances.

When the fair closed, Seattle was left with a remarkable piece of property, the Seattle Center, where families frolicked in the International Fountain and where fans could watch professional sports, opera, theater, and rock-and-roll. The U.S. Science Pavilion became the Pacific Science Center where generations of adults and children learned about the natural world

of Earth and beyond. The Fair unleashed a spirit of progress, some of it already under way. The Boeing Company produced jet airliners that shrank the world. Researchers at the University of Washington Medical School perfected the artificial kidney and the heart defibrillator, creating an industry with a new name: bio-tech. Transoceanic commerce began using containers to facilitate the movement of freight between oceangoing ships and railroads and trucks.

Not all the progress was greeted warmly by citizens. When Seattle experienced the noise and pollution from Interstate 5 and how the city's charming old buildings (albeit sometimes run down and rat infested) gave way to the scientific efficiency of steel and pre-stressed concrete, residents pushed back. Voters pulled Pioneer Square and the Pike Place Market from the brink of oblivion and they saved the Arboretum from on-ramps and asphalt.

The long hair, drugs, and protest of the sixties rattled Seattle's quiet and courteous demeanor. The University District became a magnet for "Fringies," later just called Hippies, and their mind-altering substances, throbbing music, and colorful graphic art. After several summers of love (and a few nights of acrimony), the Hippies dissolved into the popular culture and built upon one idea already fashionable in Seattle: environmentalism. Seattle entered the environmental movement in the 1950s by addressing water pollution and garbage disposal. After Earth Day in 1970, citizens and politicians began to call attention to the idea that the rivers, the air, and the mountains were not just there to be consumed like the coal dug out from under Renton and Issaquah. Afterall, the once-abundant salmon came back in fewer and fewer numbers, and except for a few days of sun when the postcards of Seattle's picturesque northwest vistas are made, a gray-brown industrial haze edged the region like an ugly bathtub ring.

The era's mix of tradition and change is encapsulated in one image from the Pike Place Market from the early 1970s. A vendor offers a potential customer a free sample of his produce, an everyday transaction in place for generations. But in the 1970s he is shown doing so in sideburns and haircut to the collar.

—*David Wilma*

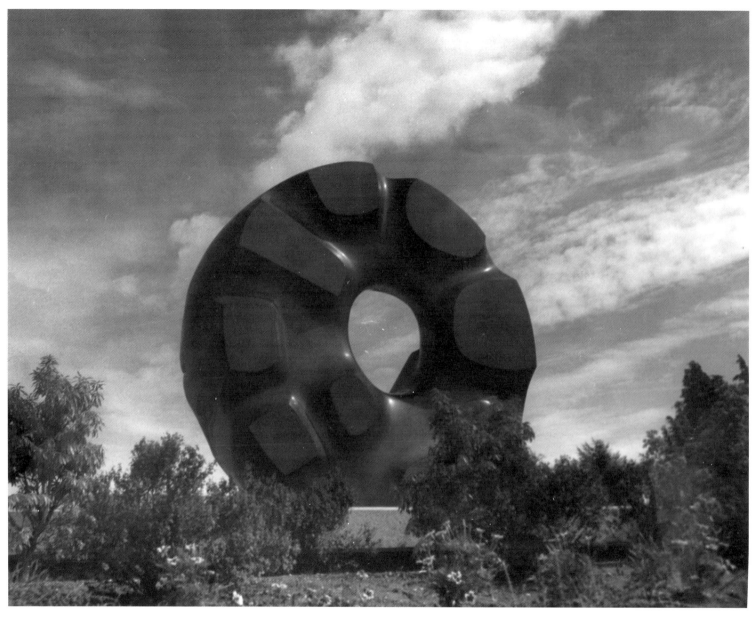

Black Sun, created by sculptor Isamu Noguchi in 1968 from black Brazilian granite, is nine feet in diameter. It was installed in Volunteer Park on Capitol Hill, offering views of the Space Needle, Puget Sound, and the Olympic Mountains to viewers peering through its opening in the middle.

The Era of Peace and Prosperity

(1949–1959)

In 1950, America and the Pacific Northwest prospered amid all the pent-up consumer demand from the war years and relief from the gloom of the Great Depression. Veterans bought new cars and built new homes in Seattle's suburbs. Schools sprang up and expanded to meet the flood of youngsters from the postwar baby boom. This migration spawned shopping centers, which siphoned traffic away from downtown. Downtown merchants responded with parking lots, parking garages, and plans to "redevelop." Automobiles choked streets that had served the motoring public well just ten years before. The first of the limited-access highways—the Alaskan Way Viaduct—sliced around downtown along the waterfront. Seattle gobbled up new territory by annexing neighborhoods from N 85th Street to N 145th Street.

The waters of Puget Sound and forests of Washington still yielded up their bounty and employed thousands. In that decade several movements emerged that would change the city and the region in later decades. Environmental concerns started with garbage disposal and attention to "blight"—unsightly and unsanitary housing and commercial buildings. Chronic pollution of popular bathing beaches spurred visionaries to push for a comprehensive regional solution. Voters approved plans by Metro to build a sophisticated system of sewage treatment. Once the treatment plant was completed, Lake Washington became cleaner and beachgoers returned to the beaches. Other dreamers and activists wanted to improve the look of the city. They formed Allied Arts to advocate for civic improvements, sensible and tasteful urban design, and a vibrant arts community.

Seafair—Seattle's annual water festival—started in 1950 with swim meets, competitions for kids, and parades, a beauty contest, a boat parade, and a traditional clam bake. This grew to include neighborhood celebrations and races on Lake Washington for the newly developed hydroplanes called thunderboats.

Aspects of the international scene darkened corners of the 1950s. The cold war dug in for the next forty years and Seattleites learned to listen for weekly air-raid siren tests and elaborately orchestrated evacuation and shelter drills. Concerns about Soviet threats and communist subversion in general made loyalty oaths for teachers and public employees a requirement. The Boeing Company continued to supply the U.S. Air Force with fast new jet bombers. This technology spawned jetliners that would transform the world economy. But most of Seattle went about life reasonably confident that each year would bring more prosperity and a sense of progress.

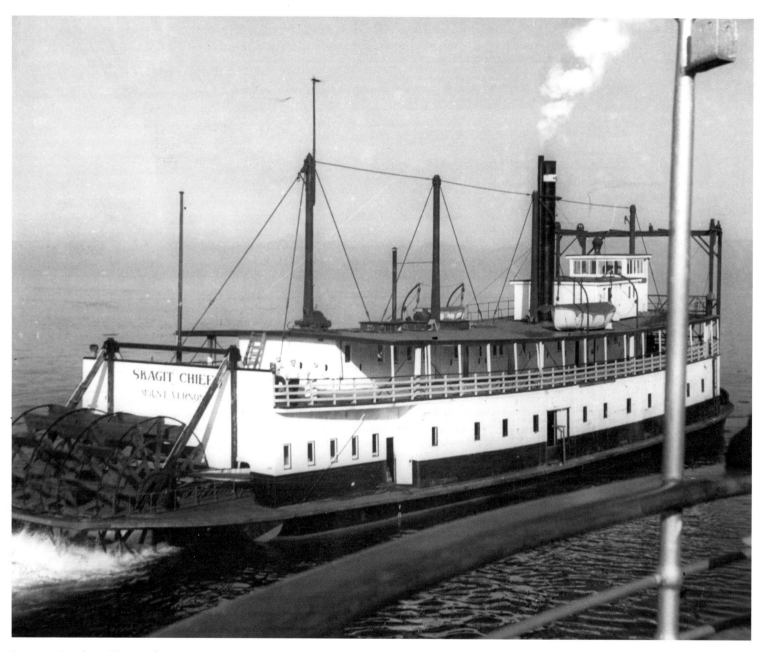

In 1952, Seattle-to-Victoria ferry passengers were treated to a disappearing image on Puget Sound. The *Skagit Chief* was a 1934 stern-wheel steamer that hauled freight to island and peninsula communities, her shallow draft allowing her to visit river landings. New bridges and highways rendered this remnant of the Mosquito Fleet obsolete. The *Skagit Chief* sank while being towed to Oregon for conversion into a restaurant.

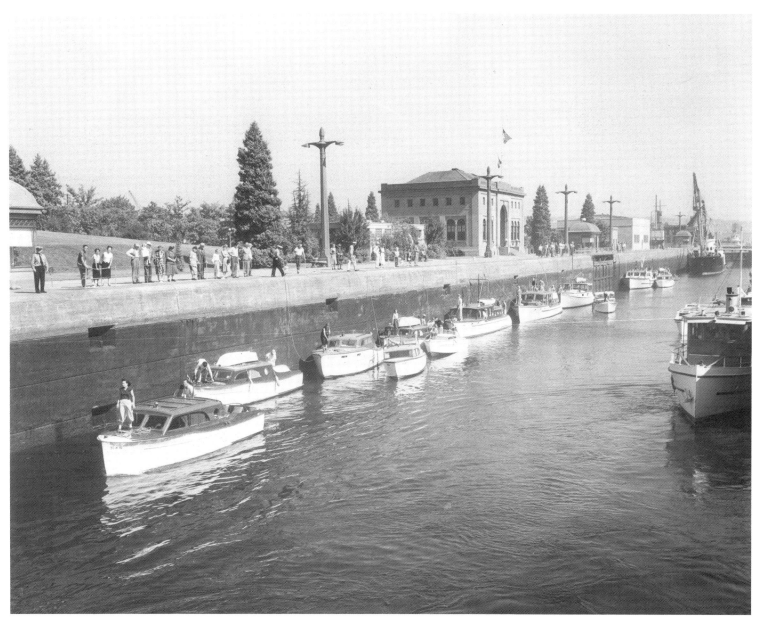

The Hiram M. Chittenden locks were originally built in 1917 to allow oceangoing ships access to Salmon Bay, Union Bay, and Lake Washington. The fresh water killed the organisms that attacked wood-hulled vessels. The main users of the locks became the fishing fleet and the tens of thousands of pleasure boaters who cruised the area. Here boaters tie up along the wall of the large lock just before heading out to Shilshole Bay.

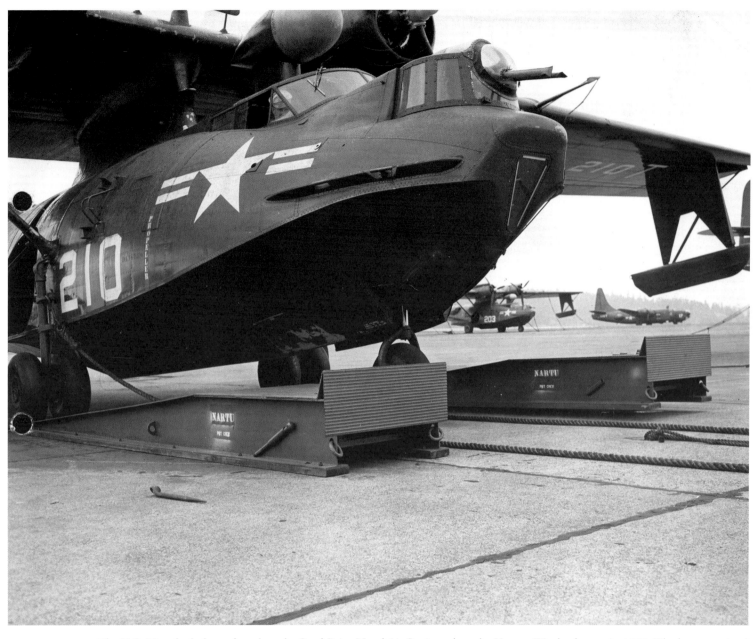

The U.S. Navy had planned to close the Sand Point Naval Air Station when the Korean War broke out in 1950. The base remained active another 20 years before closing and reemerging as Warren G. Magnuson Park. In 1952, the base still served to refurbish aircraft and to provide training for crews. Here a couple of Catalina flying boats and a Privateer patrol bomber await work.

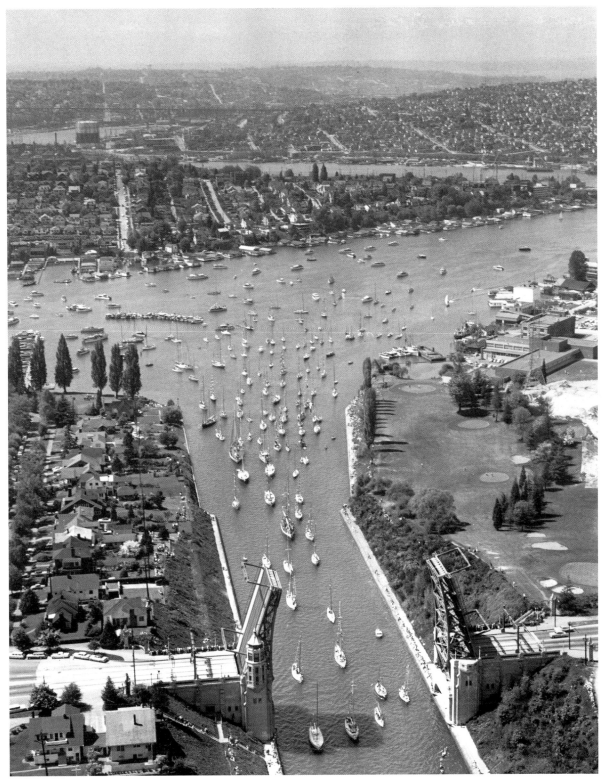

Every spring Seattle boaters parade from Portage Bay through the Montlake Cut into Lake Washington to celebrate the opening day of the boating season. Crowds line the parklike banks of the cut, which was dug in 1917 to connect Lake Washington to Puget Sound by way of the Lake Washington Ship Canal. In this view the University Bridge is open all afternoon to allow sailboats to pass beneath.

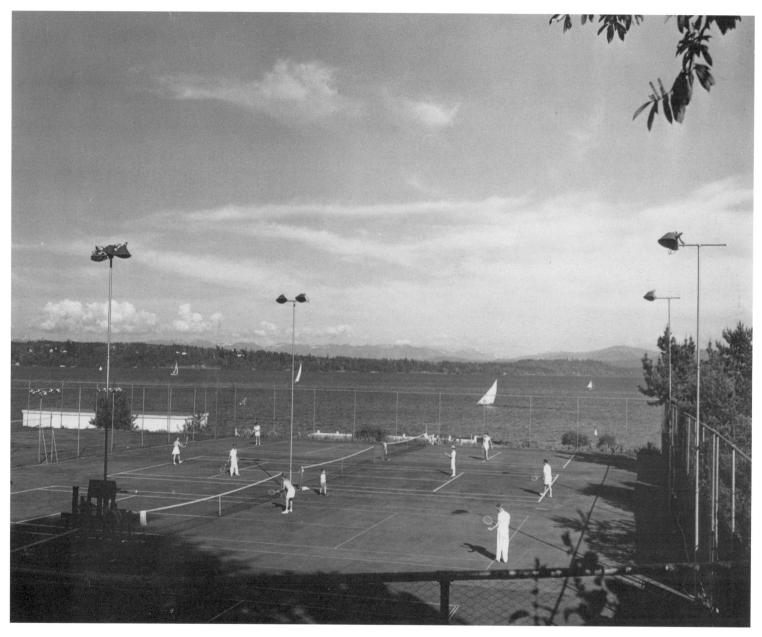

Josef Scaylea worked as a staff photographer for the *Seattle Times* for 35 years recording life in Seattle and in the Pacific Northwest. Here he captures members of the Seattle Tennis Club in Madison Park. In the background on Lake Washington, boaters enjoy a sunny day and some wind.

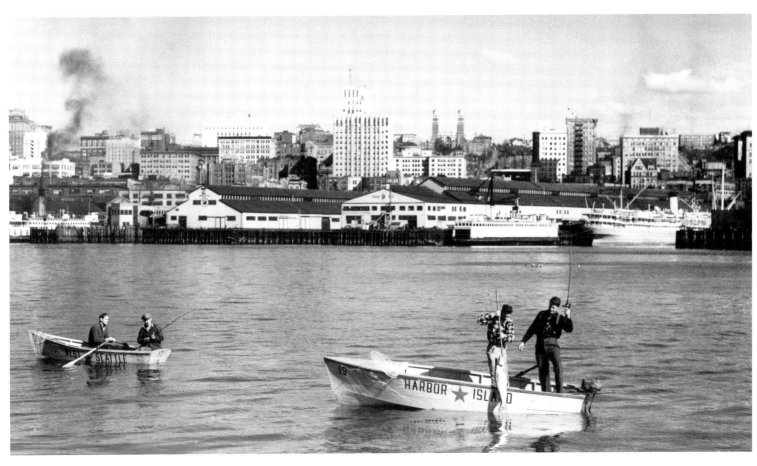

Seattle residents didn't have to own a boat to catch salmon on Elliott Bay. All they needed was the price of a rental from marinas in the area. Anglers had their choice of boats with and without engines. Here a couple of lucky fishing enthusiasts haul in a handsome trophy as two others look on in admiration. In the background the Seattle waterfront hums with activity.

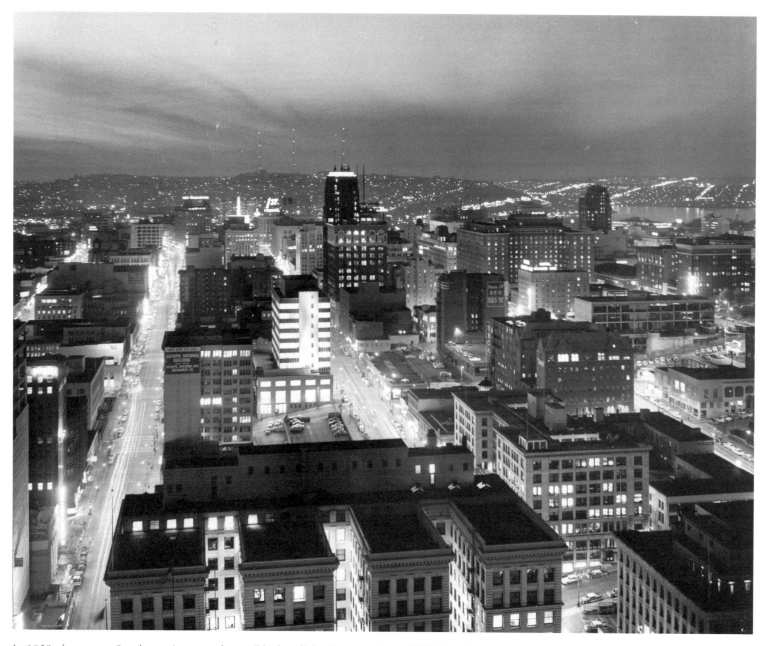

In 1959, downtown Seattle continues to glow as "the best lighted city in the world." That title was granted by a local newspaper 50 years before, when Seattle City Light adopted three-globe and five-globe streetlights instead of the standard one-globe model. Cheap electricity made possible through hydroelectric dams helped build an extensive street-lighting system. This view from the Smith Tower looks up Second Avenue from Cherry Street.

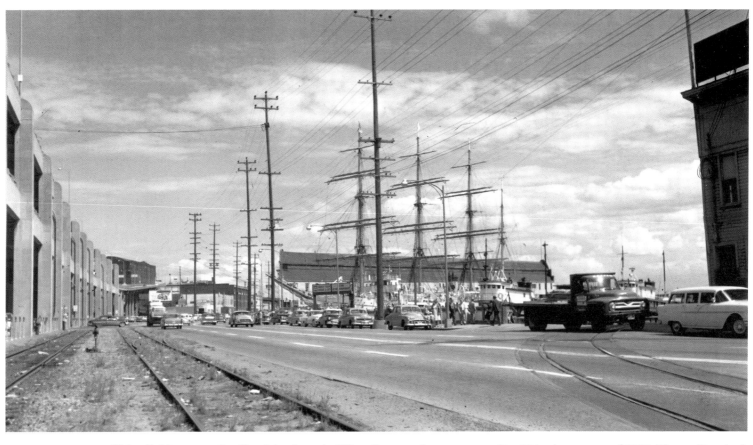
This tall ship, once a familiar sight along the Elliott Bay waterfront, moors at Pier 59 in the summer of 1957. The auxiliary bark *Nippon Maru* is visiting Seattle during Seafair. The railroad tracks along and across Alaskan Way indicate that this is still a working waterfront, before mechanization moved container operations farther south and to Harbor Island.

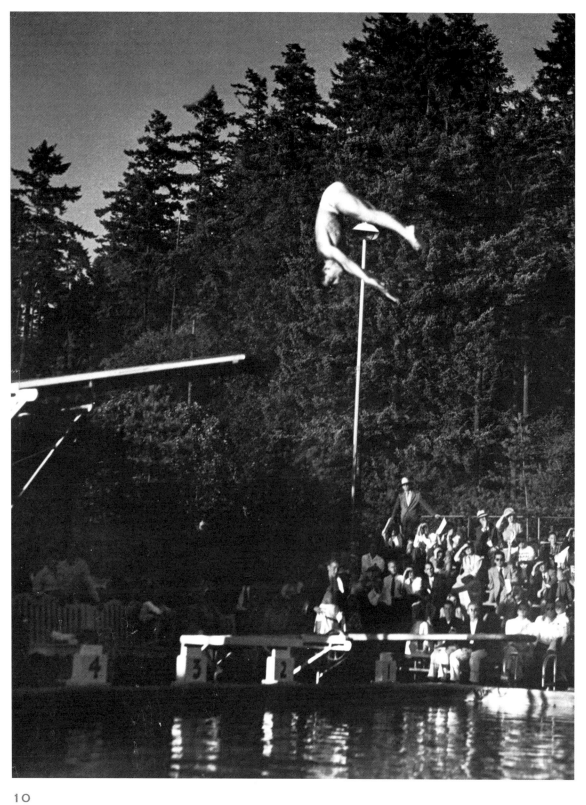

Colman Pool at Lincoln Park in West Seattle was built in 1941 by the family of West Seattle resident L. J. Colman in his memory. The pool replaced a man-made saltwater lagoon dug into the beach. This high diver shows his stuff in 1950.

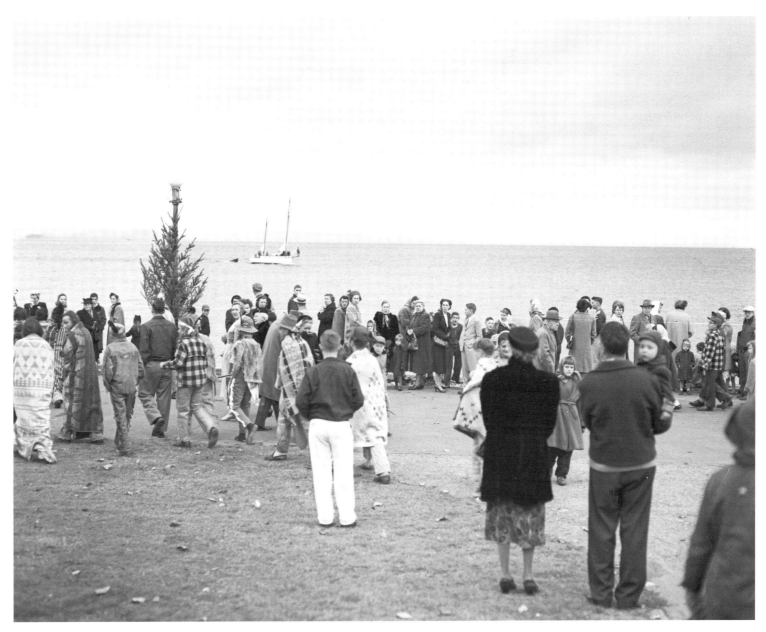

On November 13, 1951, Seattle celebrated the centennial of its founding by reenacting the landing of the Denny Party from the schooner *Exact* at Alki Point. The *Exact* is portrayed by the Sea Scout Ship *Yankee Clipper*. Reenactors in period dress rowed ashore, holding dolls instead of babies. This kicked off a year-long series of events including a new historical museum and the publication of Murray Morgan's *Skid Road*.

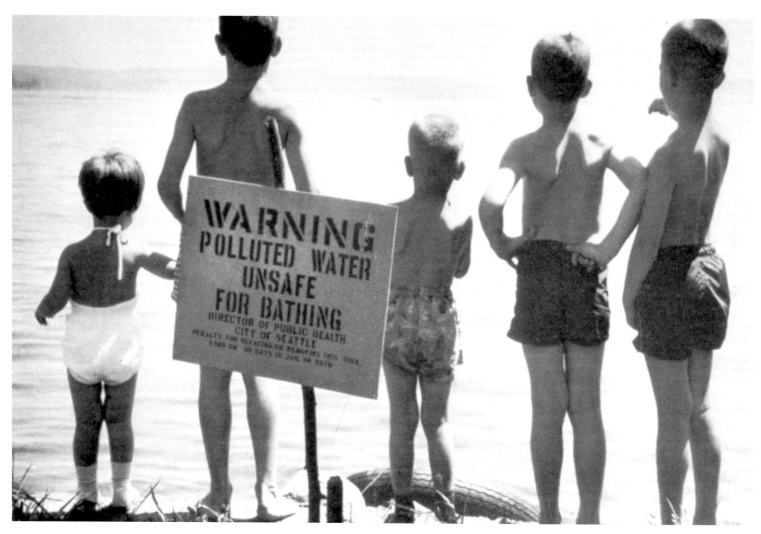

In the 1950s, Seattle and surrounding cities flushed raw sewage directly into Lake Washington and Puget Sound. Public health officials closed bathing beaches because the contaminated water posed a serious threat. In 1957, the children of the Block family pose with a sign banning them from their favorite swimming hole. This photo helped convince voters to establish Seattle Metro, which built sewage treatment plants that significantly cleaned up the area's waters.

In 1909, the Seattle Chamber of Commerce erected a statue at the Alaska-Yukon-Pacific Exposition to remember William H. Seward, the United States secretary of state who negotiated the purchase of Alaska in 1867 from eager-to-sell Russia. The economy of Seattle has been closely linked with Alaska ever since. The statue was moved to Volunteer Park, where it stands near the conservatory in this 1954 view.

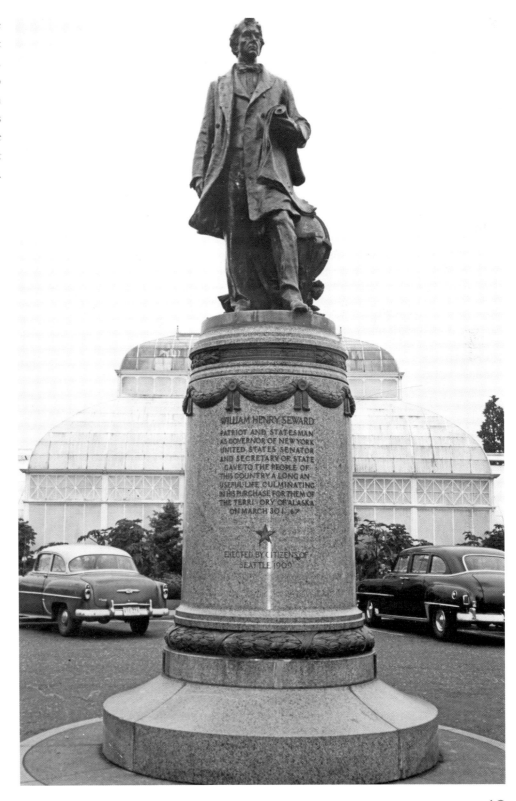

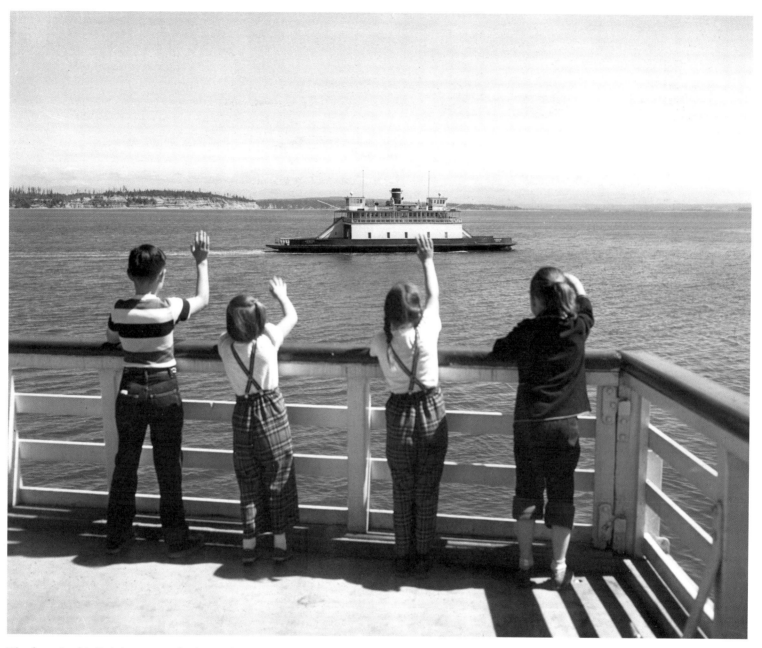

The ferry *Leschi* plied the waters of Lake Washington between Madison Park and the east side beginning in 1920. She was originally built as a side-wheeler and was converted to accommodate automobiles. Her demise came with the completion of the Lake Washington Floating Bridge in 1940. Here in the 1950s, young ferry riders wave to the boat. The *Leschi* worked for the Washington State Ferries on Puget Sound until 1968.

A north wind blows across West Point and the lighthouse there on a clear day in 1959. The snow-capped Olympics rise in the distance. The first navigation light marked the entrance to Elliott Bay and became operational in 1881 with a fourth-order Fresnel lens with 12 separate bull's-eyes. Kerosene powered the light until electricity reached the station in 1926. The station is now on the National Register of Historic Places.

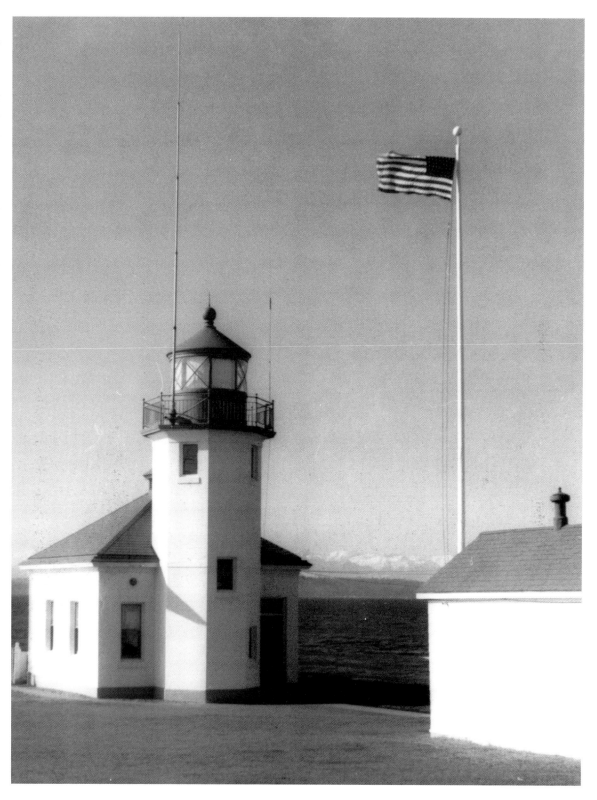

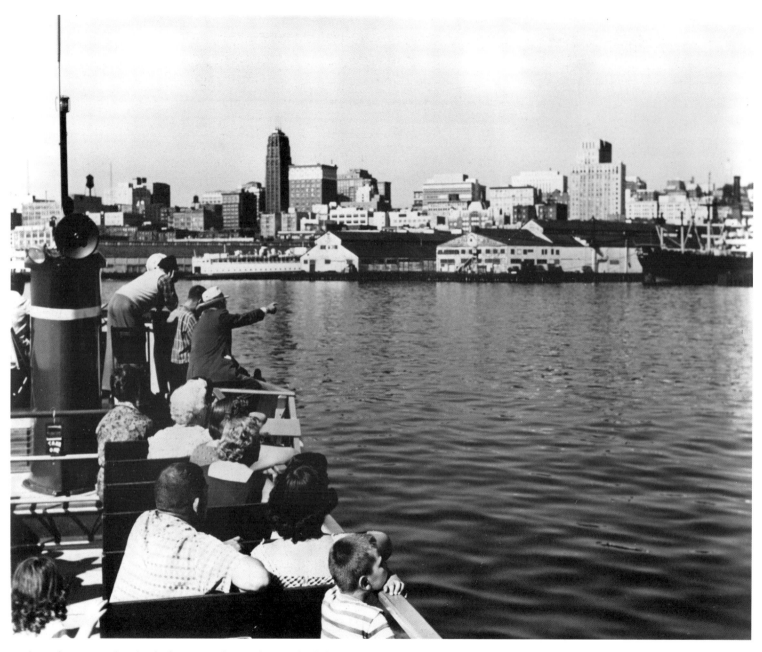

In the early 1950s, a boatload of tourists admires the Seattle skyline on a warm day. By this time the new Alaskan Way Viaduct was cutting along the waterfront. The elevated roadways diverted increasing automobile traffic around downtown and through a tunnel at Battery Street. Sixty years later, the structure is slated to be replaced with a tunnel, which will change the waterfront once again.

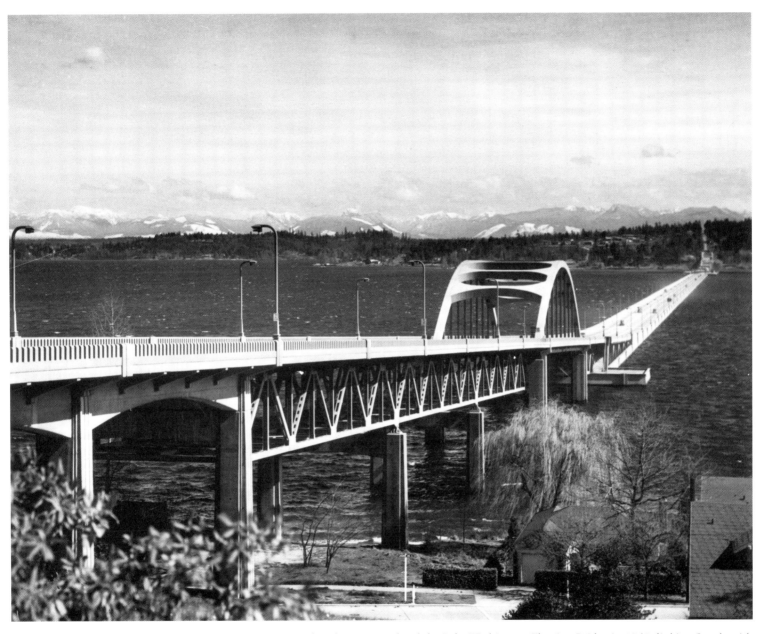

The Washington State Department of Highways completed the Lake Washington Floating Bridge in 1940, linking Seattle with Mercer Island and the growing communities of the east side. The roadway rides on hollow concrete pontoons. The real spur to development eastward was the removal of tolls in 1946. New residents flocked to communities like Bellevue and Medina and by the 1950s a second bridge across the lake was needed.

Fishermen wait for nibbles at the north end of the University of Washington Arboretum in 1959. The pleasant scenery would soon be marred by the construction of freeway ramps serving State Route 520 across the second Lake Washington floating bridge. Plans to build a freeway through the Arboretum in the 1960s would trigger a community-wide reaction, which would put a stop to the project.

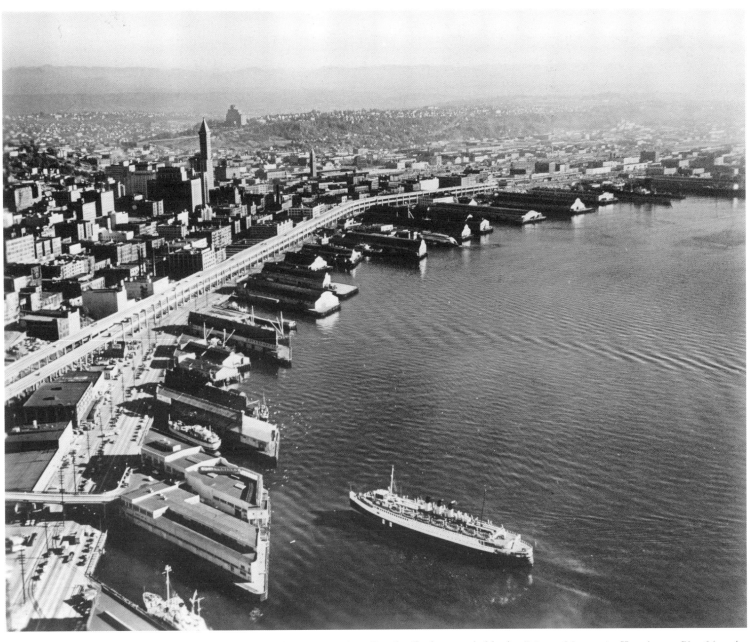

On a summer evening in the 1950s, a Canadian Pacific ferry, probably the *Princess Marguerite II,* arrives at Pier 64 at the foot of Lenora Street. The *Marguerite* made daily runs every summer from Seattle to Victoria providing tourists a leisurely four-hour voyage up to Vancouver Island and return the same day. The *Marguerite* and her sister, the *Princess Patricia,* accommodated 2,000 passengers and 60 vehicles.

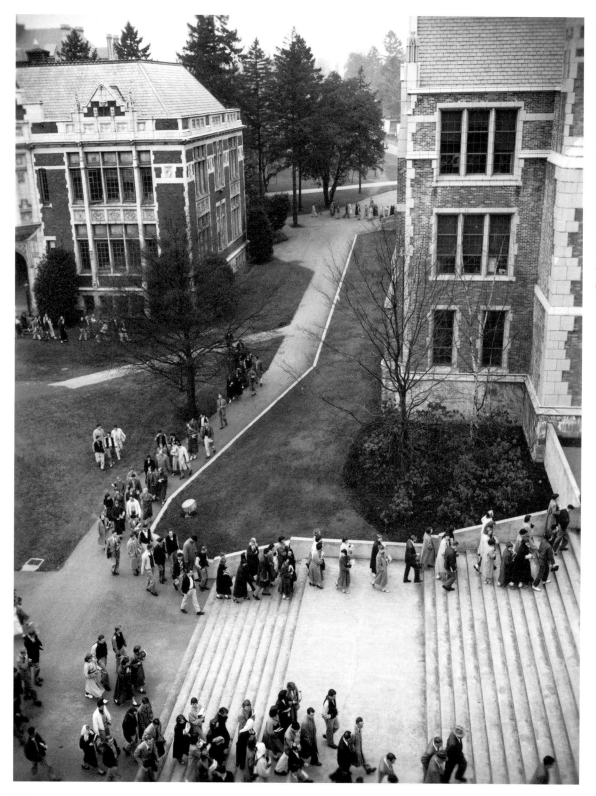

As the cold war with the Soviet Union and its allies took shape, Seattle reactivated World War II Civil Defense organizations. City officials installed a 135-horsepower "super siren" downtown to alert citizens to an impending nuclear attack. Nike missile batteries ringed the city. On January 5, 1954, students at the University of Washington practice filing into sheltered areas in the Liberal Arts Quadrangle as part of an air-raid drill.

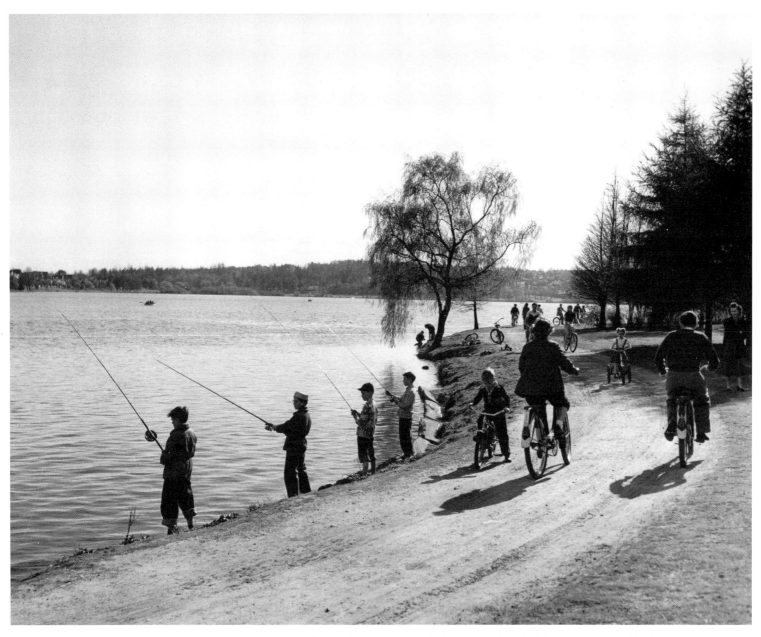

For generations Seattleites have enjoyed relaxing at Green Lake. In the 1950s, enough fish survived in the lake to attract neighborhood fishermen. University of Washington professor Lauren Donaldson hybridized a fish, his "super trout," which he released into the lake much to the delight of the lucky angler who snagged one. In later years the Parks Department had to pave and widen the path to accommodate foot, roller, and cycle traffic.

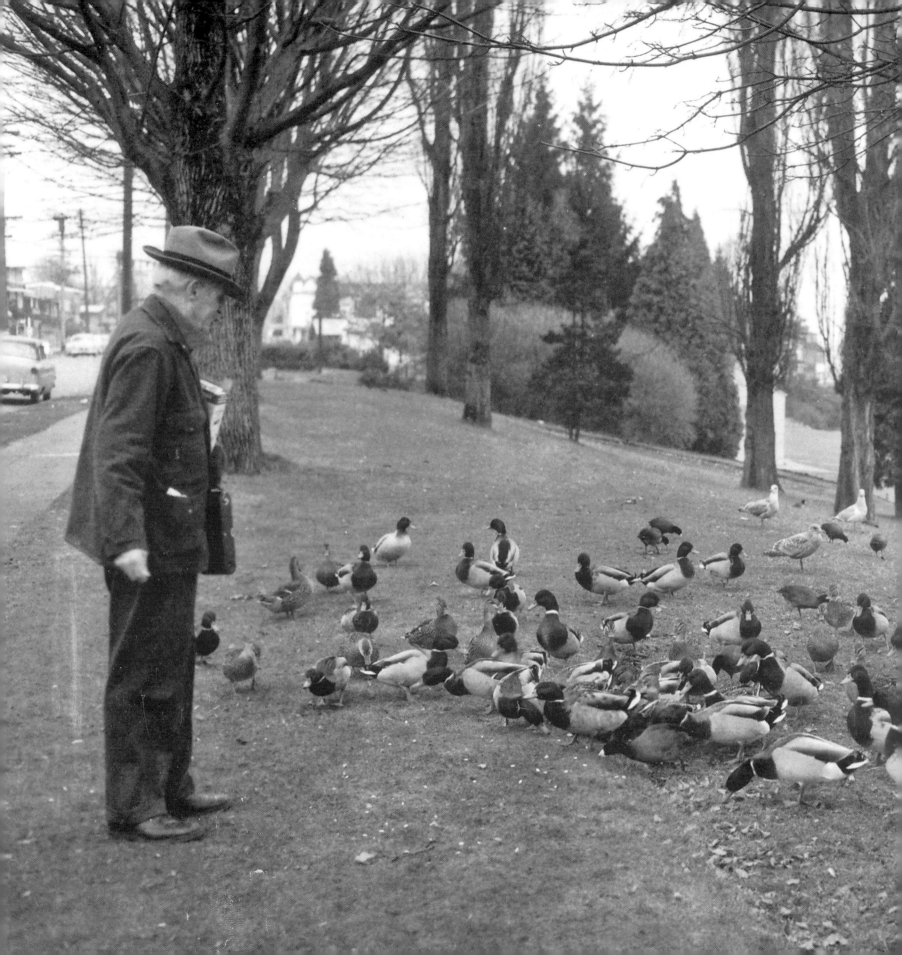

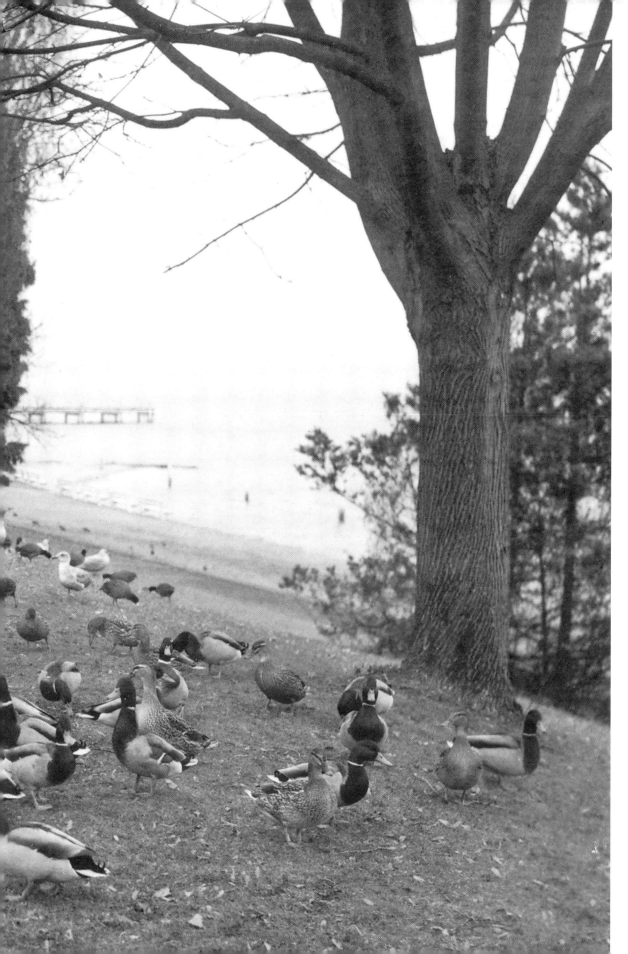

Before floating bridges crossed Lake Washington, Madison Park was the terminus for streetcar lines from downtown. An amusement park and baseball field drew residents on their days off. Travelers and, later, motorists could board ferries for Bothell, Kirkland, and Medina. By the time Frank Atkins was feeding the ducks here in 1952, bridges had put an end to ferry service and streetcars had given way to buses, making the park as quiet as any other in the city.

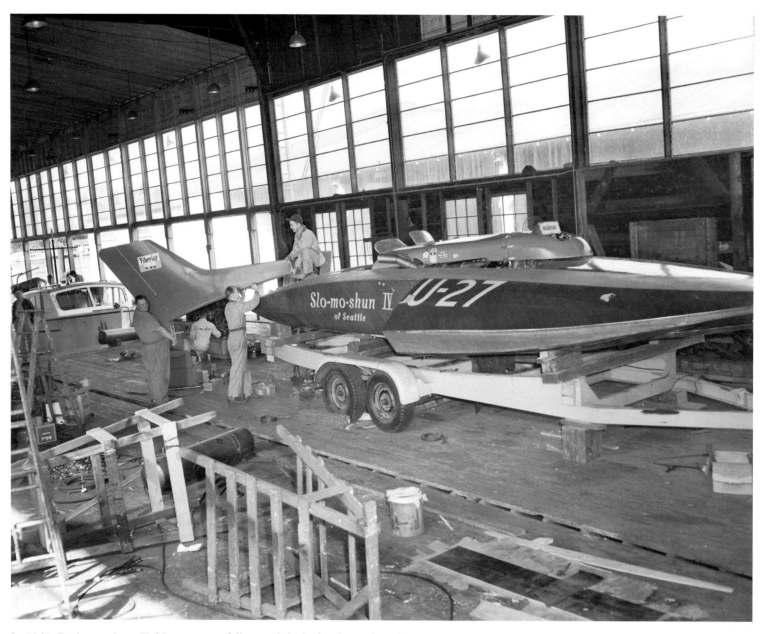

In 1949, Boeing engineer Ted Jones successfully tested the hydroplane, a boat harnessing aerodynamic principles and powered by a war surplus fighter plane engine. Hydroplane racing would become a centerpiece of Seafair, Seattle's annual water festival. Here in 1956, record holder *Slo-mo-shun IV* (nicknamed the Hunts Point Ferry for its repeated crossings of the lake) is being readied for a run with a new vertical stabilizer.

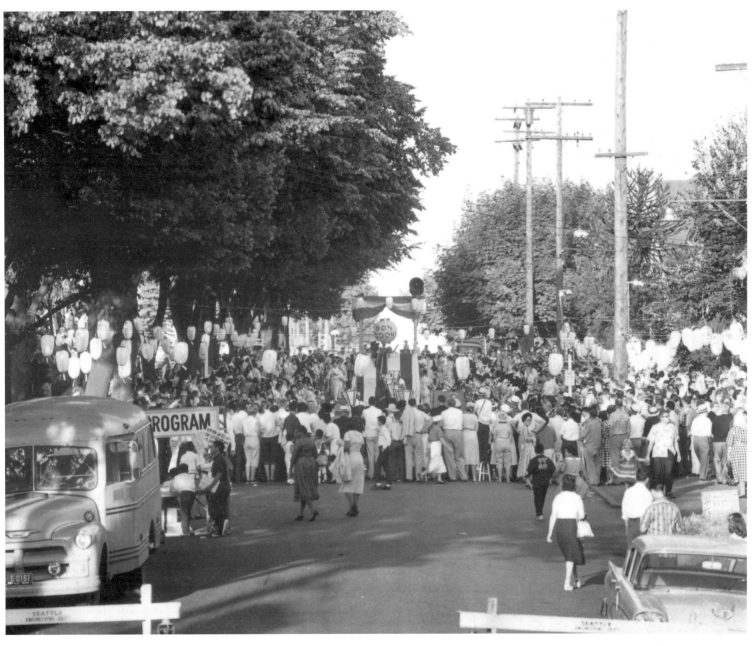

Americans of Japanese descent contribute to Seafair every summer with the Bon Odori Festival. The celebration features traditional dances, clothing, and food. The first Japanese immigrants arrived in Seattle in the late 1890s. The community grew large enough that by the 1920s, the Seattle Public Library featured a collection of Japanese language works at the Yesler Branch, attracting borrowers from as far away as Issaquah.

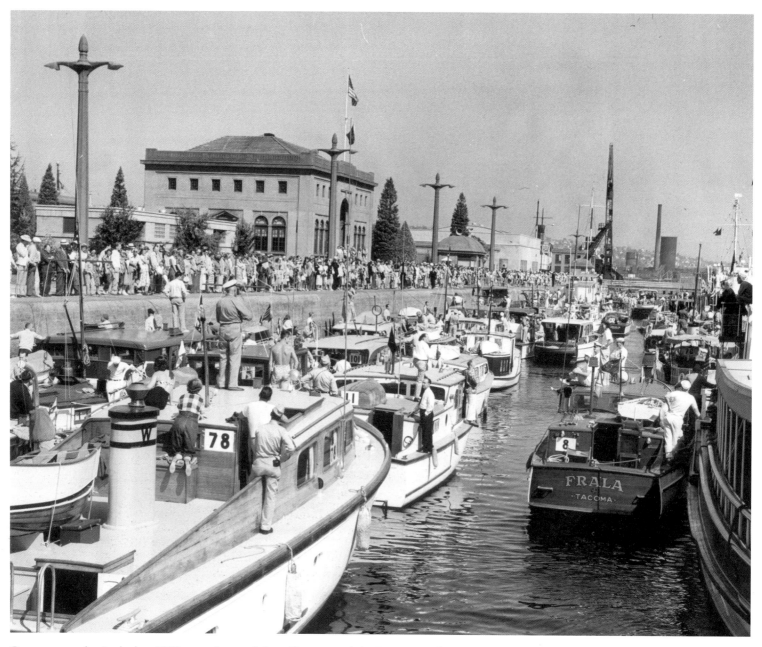

On a summer day in the late 1950s, people crowd the railings around the Hiram M. Chittenden locks. Commonly referred to as the Ballard Locks, the passage between saltwater Puget Sound and freshwater Salmon Bay, Lake Union, and Lake Washington became a leading tourist attraction. Josef Scaylea caught these visitors watching the parade of pleasure boats east-bound, probably on their way to the hydroplane races on Lake Washington.

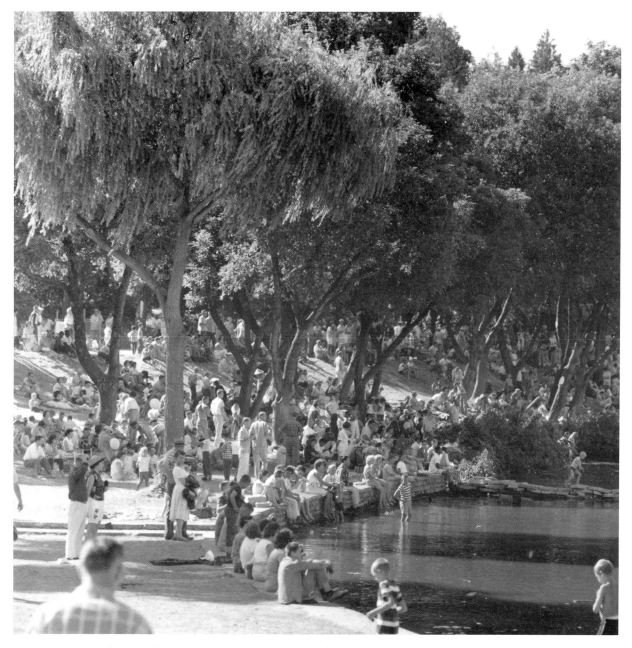

Photographer Art Hupy caught this group of spectators at Stan Sayres Memorial Park during the annual Seafair hydroplane races. The park was named for five-time Gold Cup winner and speed record holder Stanley Sayres, who is credited with bringing hydro racing to Seattle. In later years, the U.S. Navy's flight demonstration team, the Blue Angels, added their performances to the racing pageantry.

John C. Olmsted designed the grounds of the 1909 Alaska-Yukon-Pacific Exposition on the campus of the University of Washington. His plan included Rainier Vista, arranged to offer a view of Mount Rainier (on clear days) down an avenue of classroom buildings and across two water features, the Cascades and the Geyser Basin. After the fair closed, most of the buildings were torn down and replaced with permanent university structures, but the view remains.

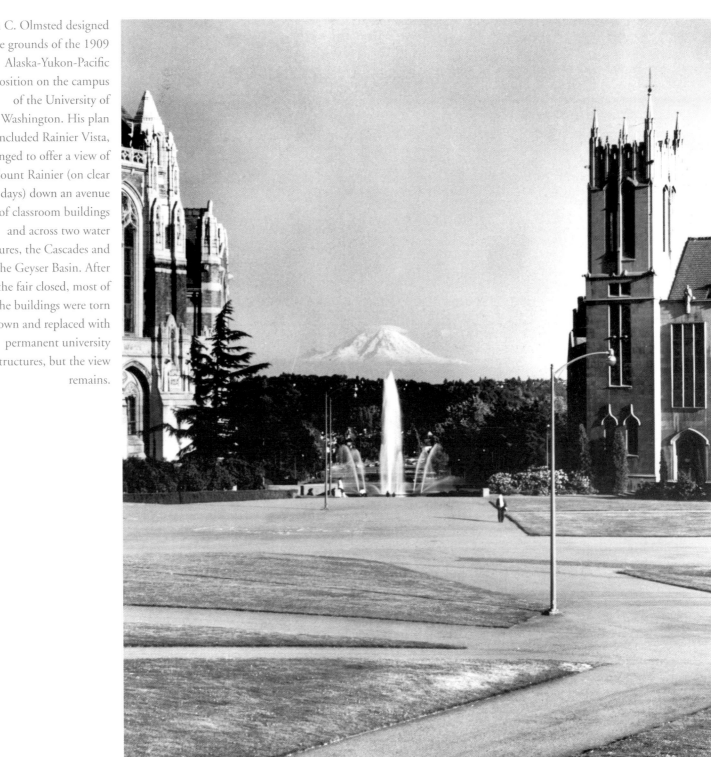

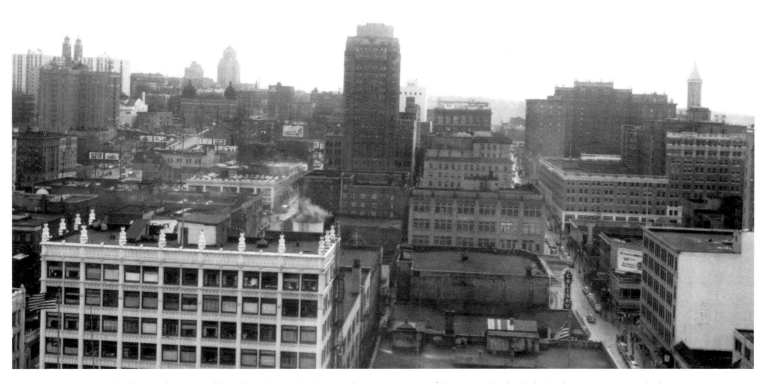

In 1950, the Seattle skyline is dominated here by the Smith Tower, the twin towers of St. James Cathedral, Harborview Hospital, the Washington Athletic Club, the Coliseum Theater, the Olympic Hotel, and the Smith Tower. All but the Smith Tower were erected during a building boom in the 1920s. Building stopped almost entirely with the Great Depression and the city looked much this way for nearly 40 years.

Following Spread: On a summer day in 1957, the *Virginia V,* one of the last of Puget Sound's Mosquito Fleet, heads toward the sound through the Ballard Locks. In the early twentieth century, hundreds of steamers plied the waters between Olympia and Alaska carrying passengers and freight, so many that distant observers compared the sight to mosquitoes on a pond. In 2010, *Virginia V* was to be listed on the National Register of Historic Places as a historic landmark and was still carrying passengers.

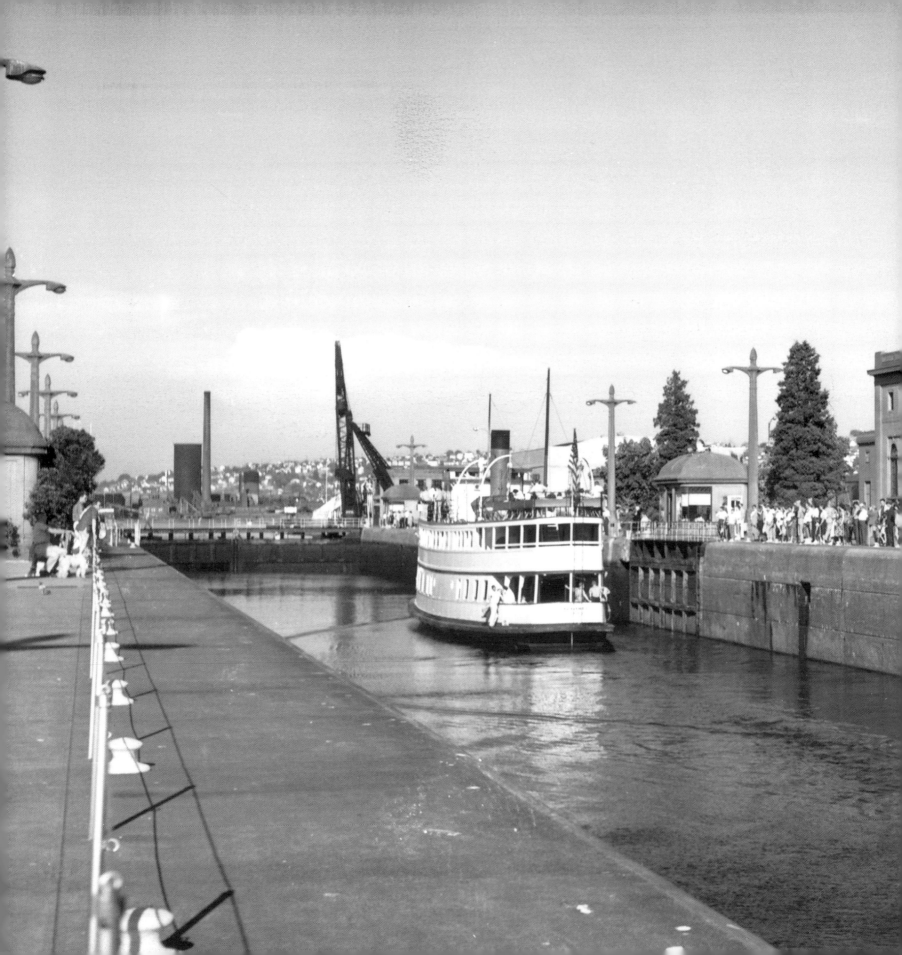

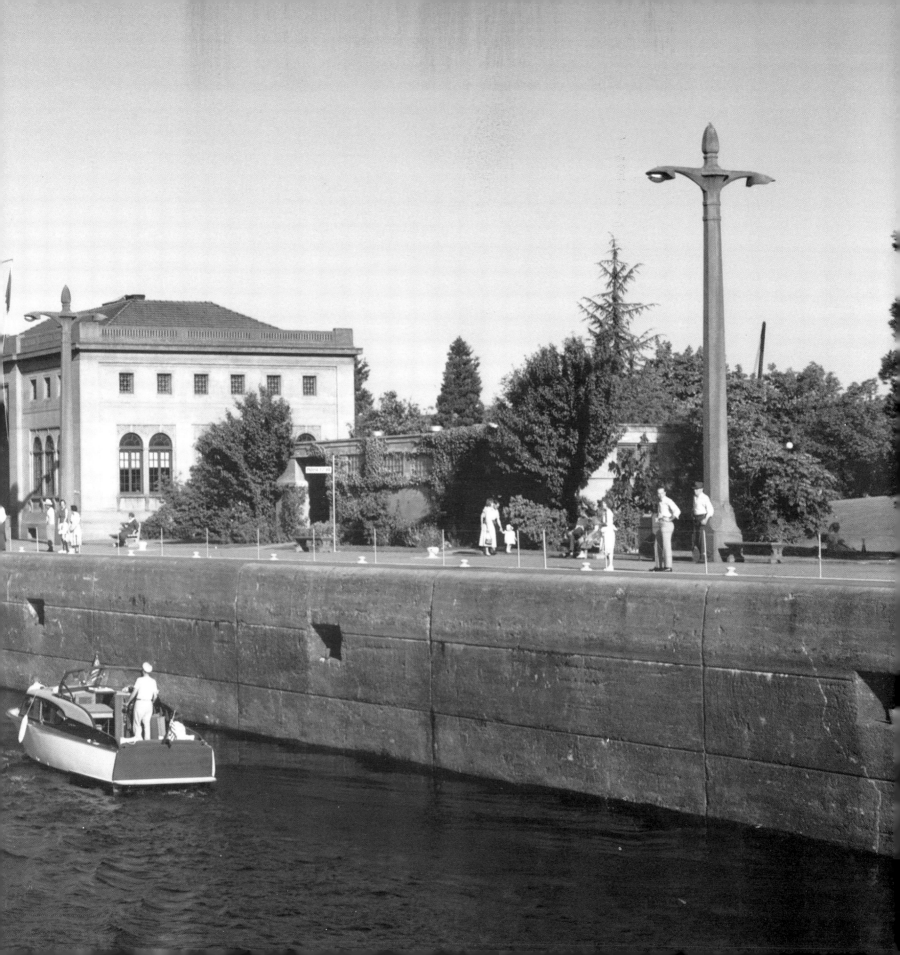

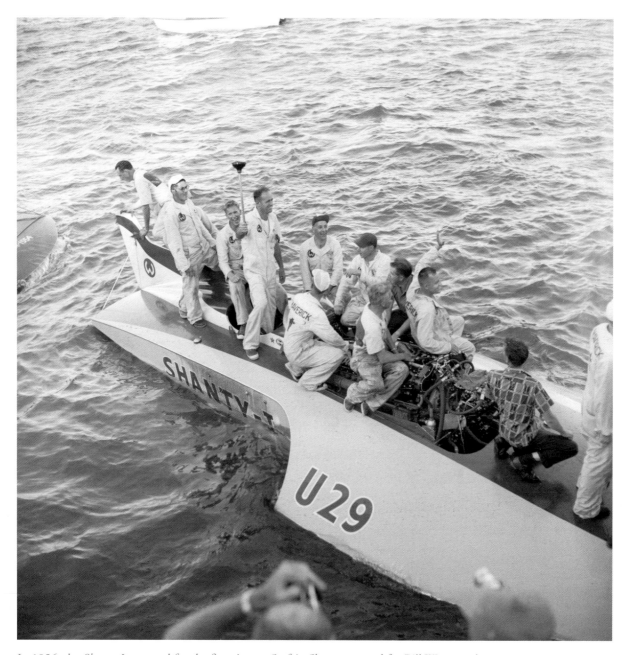

In 1956, the *Shanty-I* appeared for the first time at Seafair. She was named for Bill Waggoner's wife's nickname. *Shanty-I* used an Allison V-12 engine from a World War II fighter plane and set a record of 178.497 M.P.H. over the Lake Washington 3.75-mile race course. The boat was destroyed during a test run the following year. Art Hupy photographed the boat and her pit crew during Seafair, one of whom raises a plunger in jest.

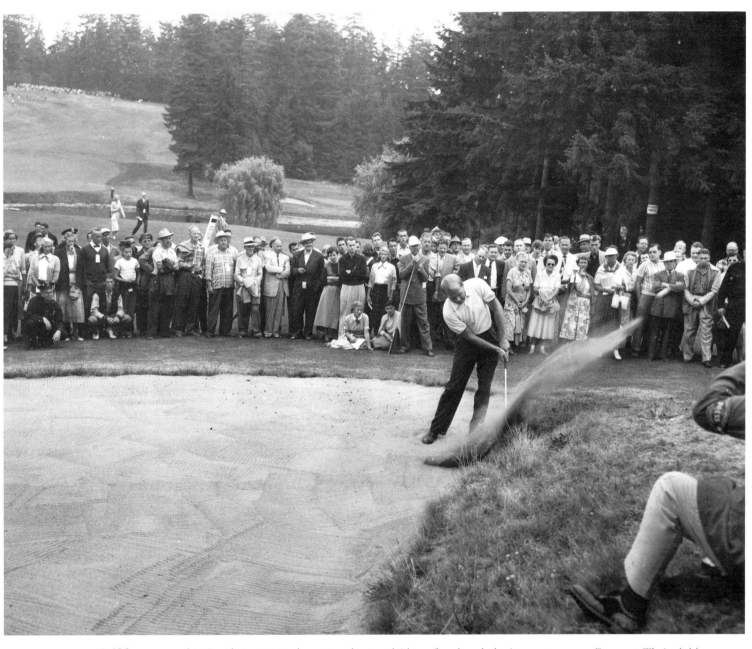

Golf first appeared in Seattle in 1895, when 12 enthusiasts laid out five short holes in a pasture near Fremont. Their clubhouse was a tent. In 1900, Josiah Collins organized the Seattle Golf and Country Club on Ferguson's farm in Laurelhurst. The club moved to the Highlands in 1907. Here around 1955, a competitor blasts his way out of a sand trap.

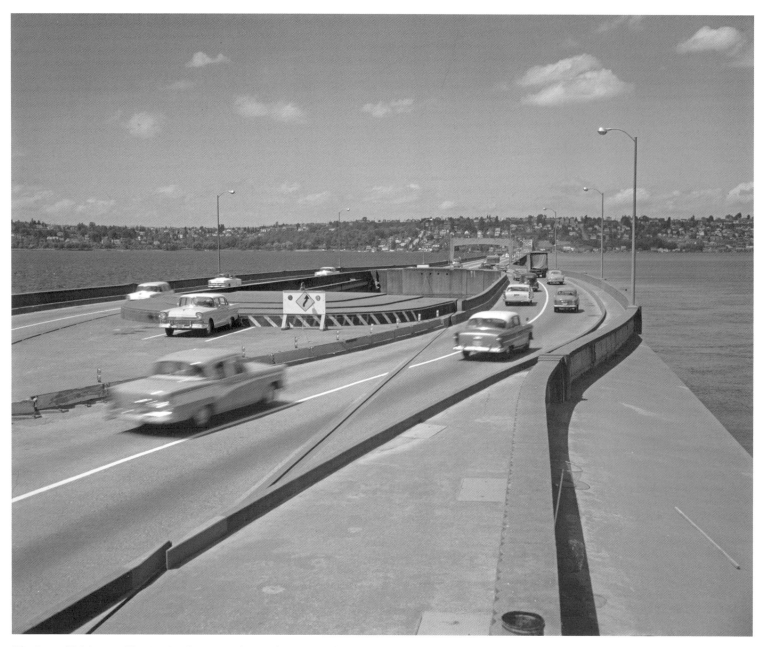

The Lacey V. Murrow Floating Bridge over Lake Washington is almost 20 years old in this view from 1959. Hollow concrete pontoons support two lanes of traffic in each direction. The design proved so successful that two more floating bridges would be built by the Washington Department of Highways, as well as a second set of pontoons and spans alongside this one in the 1990s.

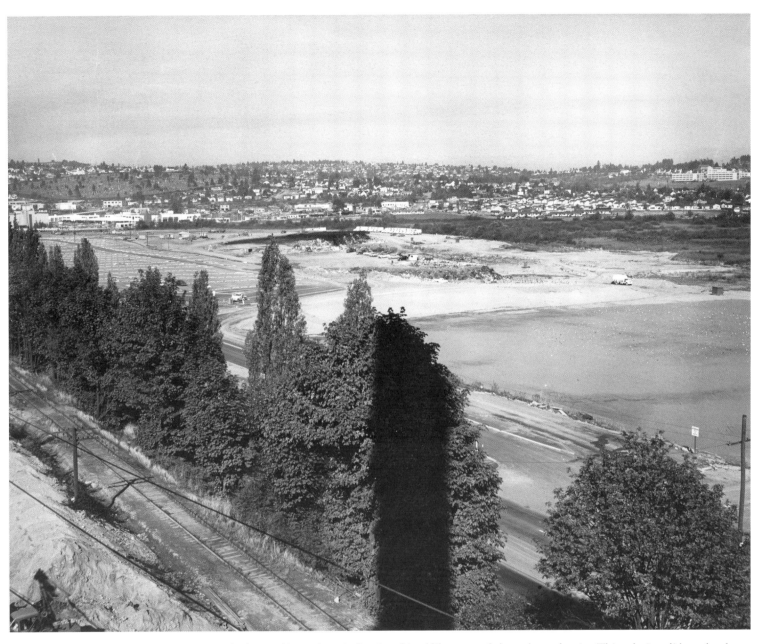

Beginning in 1920, Seattle dumped its garbage in "sanitary" landfills scattered throughout the city. This solution did not last long. By 1958, when this photo was taken, Seattle was experiencing a garbage crisis as the dumps reached capacity. Here the Montlake Dump on Union Bay has another seven years to run before it will close. The Northern Pacific rail line in the foreground would later become the Burke-Gilman Trail for cyclists and pedestrians.

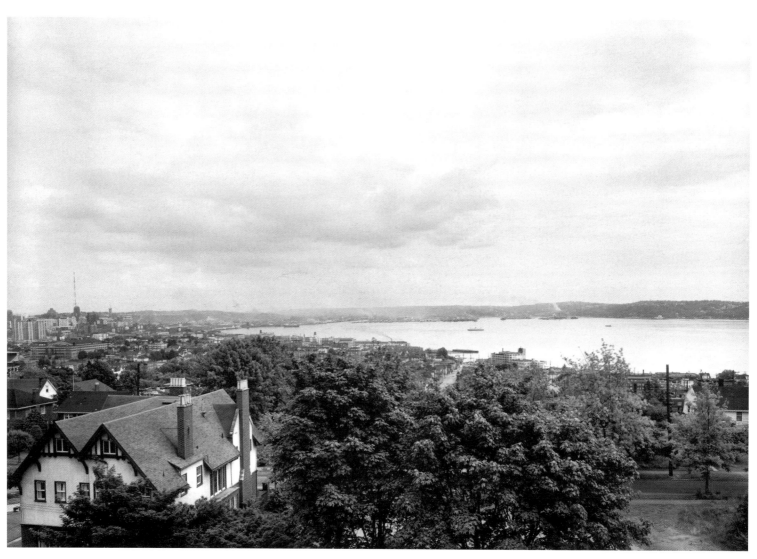

Kerry Park on Queen Anne Hill's Highland Drive is probably Seattle's most-photographed-from viewpoint. Even by the mid-1950s, photographers found the sweeping view of downtown, Elliott Bay, and Harbor Island irresistible. The home at lower left is at 202 West Prospect, originally the Sparger Residence.

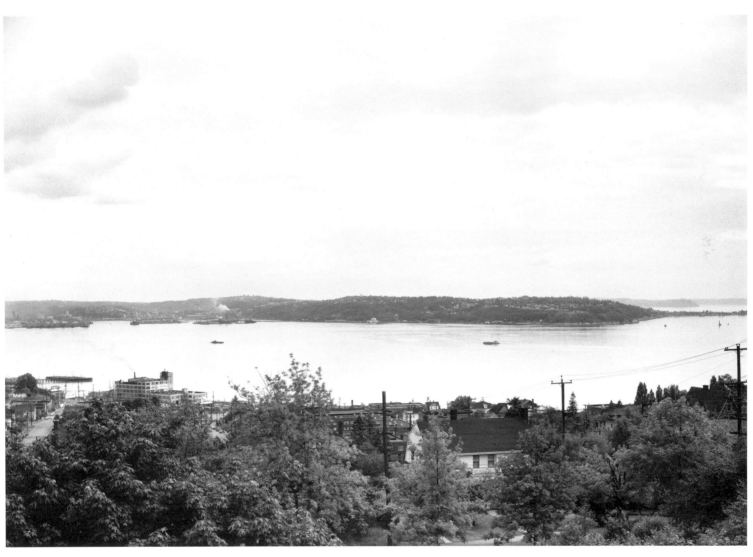

The view from Kerry Park defies even the widest of wide-angle lenses. This panorama shows Alki Point on the far right where the Denny Party landed in 1851. A few months later in 1852, settlers moved their settlement across Elliott Bay to a sheltered anchorage, where downtown would emerge and grow.

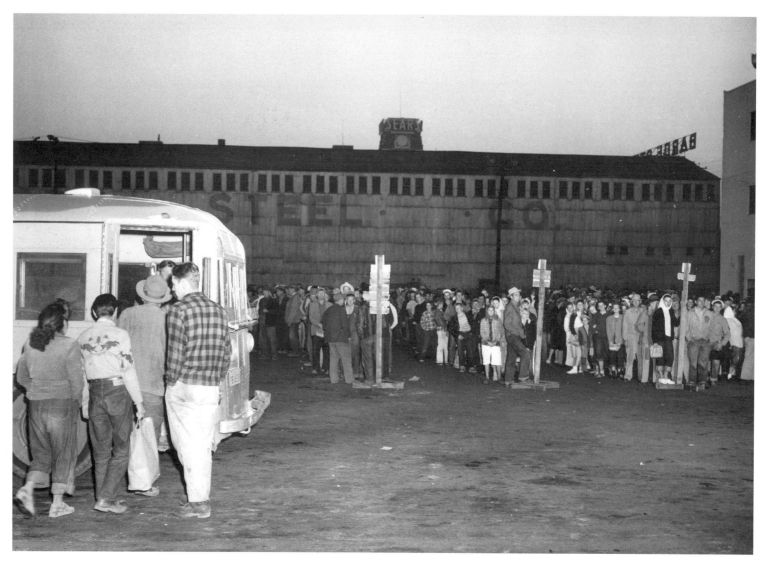

Just before dawn one summer in the 1950s, bean pickers line up for work next to the Barde Steel Company on 1st Avenue S. Farmers and labor contractors erected signs behind which prospective workers queued for bus rides, probably to the Green River Valley. In the far background is the tower of Sears, Roebuck, and Company, later world headquarters for Starbucks Coffee Company.

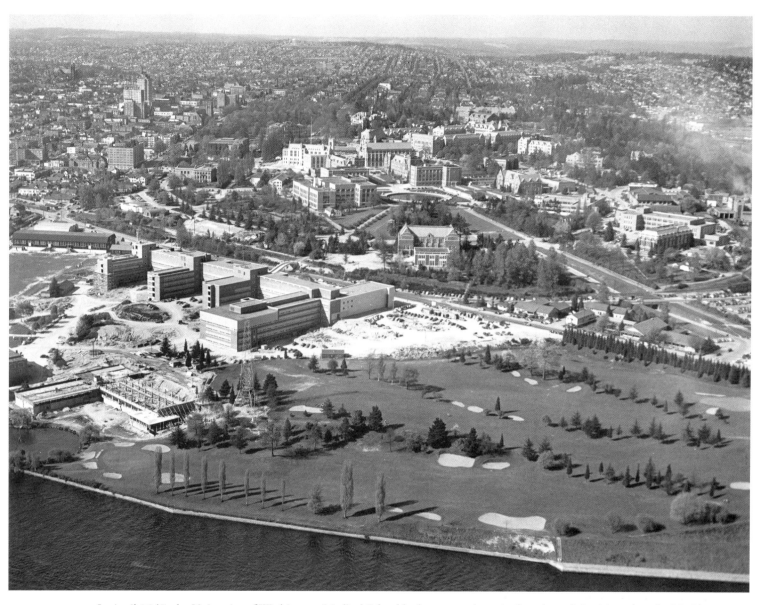

In April 1949, the University of Washington Medical School had yet to graduate its first class of physicians, but the Health Sciences complex is up and running at center-left. More wings for the complex and a hospital are under construction in the disturbed area in the middle. A new Fisheries Building is under construction on the shore of Portage Bay at lower-left.

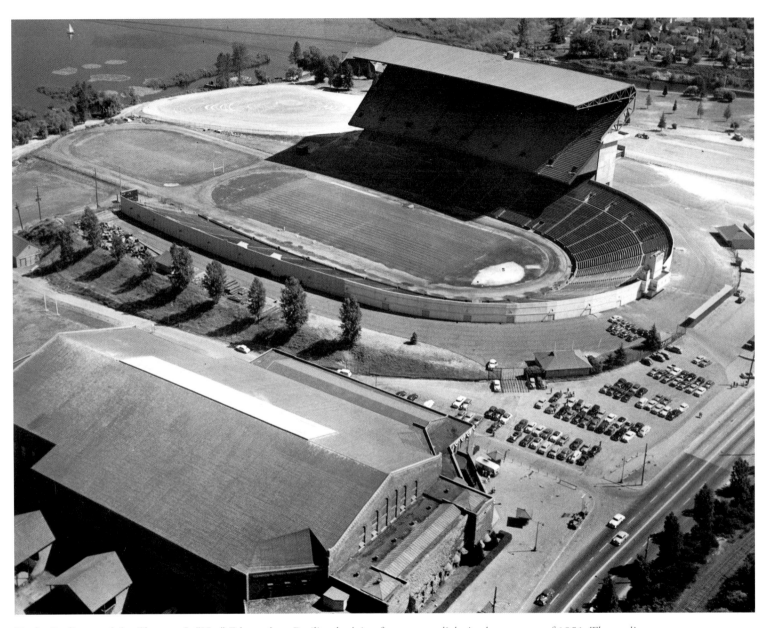

Husky Stadium and the Clarence S. "Hec" Edmundson Pavilion bask in afternoon sunlight in the summer of 1951. The stadium was the home of the football team and scene of track-and-field events. The "Pav" (which had a dirt floor at the time) was used for basketball and graduations. Only a few cars fill the parking lot in this image, but this would change. Enrollment would spike and parking lots would engulf both buildings.

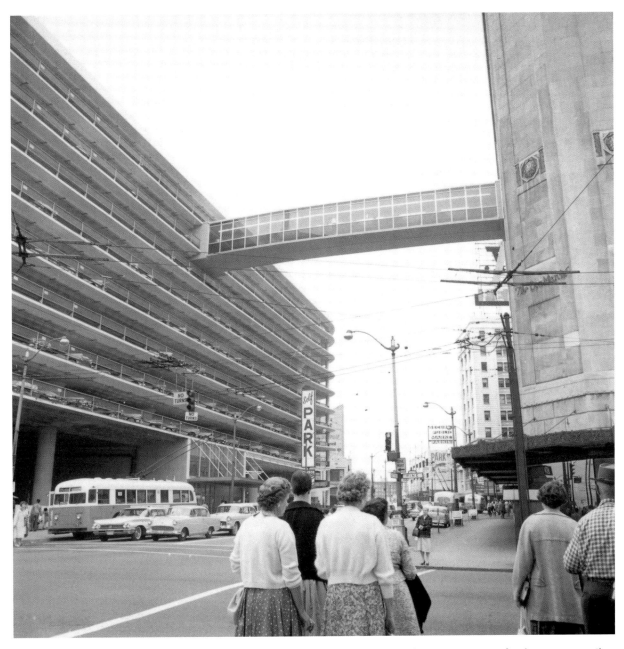

The construction of suburban shopping malls provided fierce competition for downtown retailers like the Bon Marché. "The Bon" built a nine-level parking garage at 3rd Avenue and Pine Street with a connecting "skybridge" for shoppers embracing the automobile. On rainy days shoppers could park their cars, take the elevator to the top floor, cross the skybridge, and shop without needing their umbrellas, a dry convenience the open shopping malls had yet to offer.

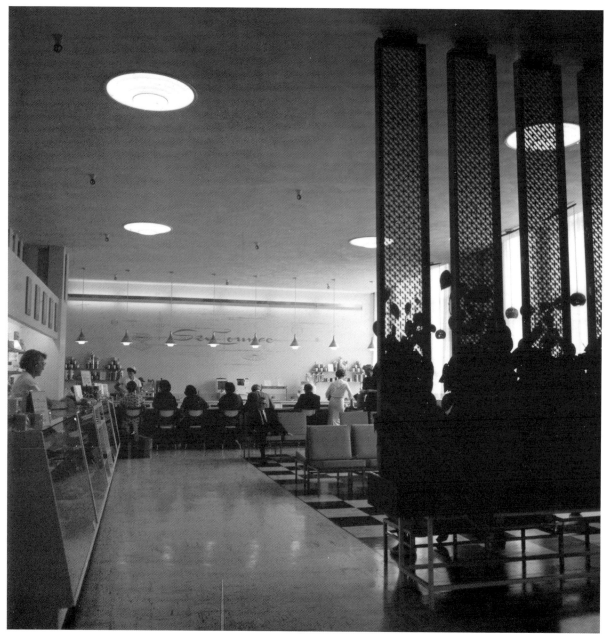

When the Bon Marché built its parking garage and "skybridge" in the 1950s, it had to refit the store with an additional entrance on the sixth floor. The snack bar and bakery moved up to the skybridge level, since that was where most customers were expected. Art Hupy found these patrons enjoying their meals under the distinctive decor of the time.

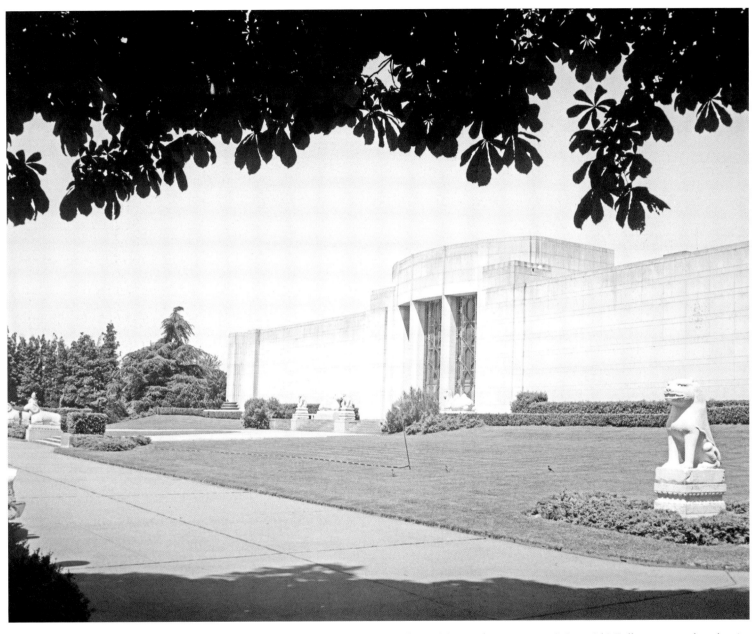

In 1933, Art Institute of Seattle president Richard E. Fuller and his mother, Margaret (Mactavish) Fuller, presented to the city of Seattle a building in Volunteer Park to house the Seattle Art Museum. Carl F. Gould provided the design. In this 1959 view, the main entrance is flanked by Chinese lions collected by Fuller. When the museum moved to downtown Seattle in 1991, this building came to house the Seattle Asian Art Museum.

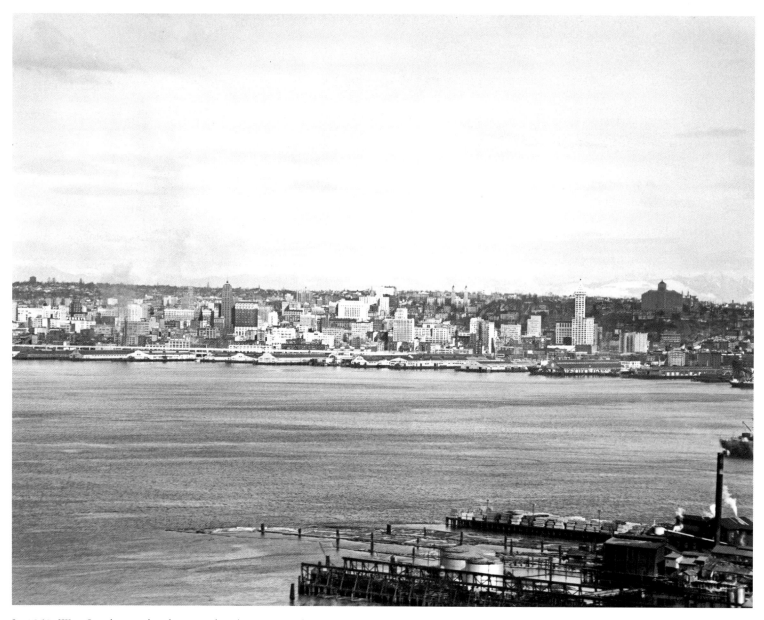

In 1952, West Seattle was already a popular place to view downtown when a Seattle City Light photographer snapped this shot. Until bridges spanned Harbor Island to the right (out of view), commuters used ferries to reach downtown.

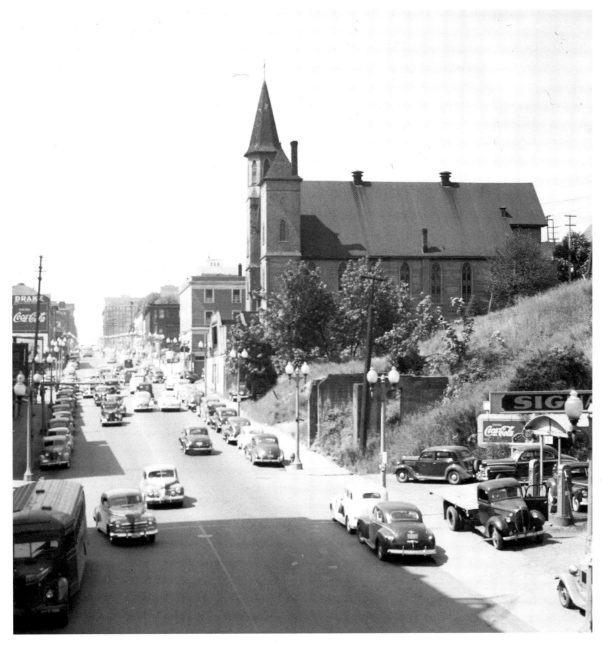

In 1953, Fifth Avenue near where it met Yesler Way still had undeveloped vacant lots. The explosive growth of downtown and the Alaskan Way Viaduct would transform Fifth into a one-way street. Ten years later the construction of Interstate 5 would obliterate the church and the Signal gasoline station on the right.

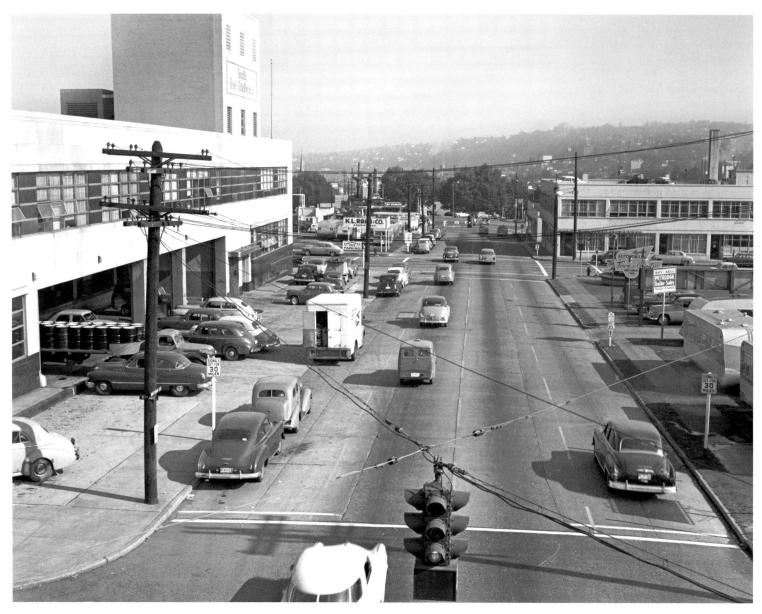
Alaskan Way Viaduct traffic was directed through a tunnel dug under Battery Street in the Denny Hill regrade. A member of the Seattle Engineering Department documented this "before" view of Battery looking north in 1952 with the Seattle Post-Intelligencer building on the left.

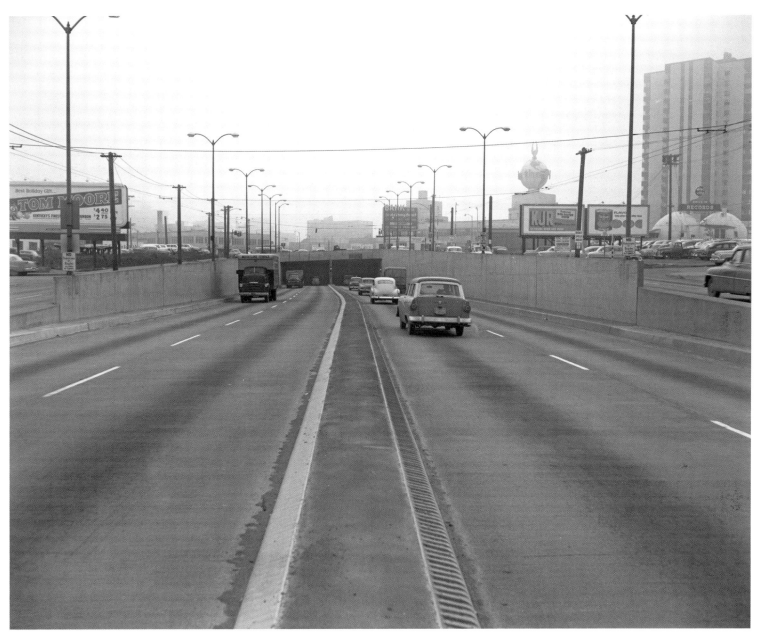

In 1956, a plucky Seattle Engineering Department photographer balanced between lanes of speeding traffic to document this view of the north entrance of the Battery Street Tunnel. The tunnel carried traffic from the Alaskan Way Viaduct to Aurora Avenue N. On the far right is the blue globe of the Seattle Post-Intelligencer building. The year before, main streets downtown were converted to one-way.

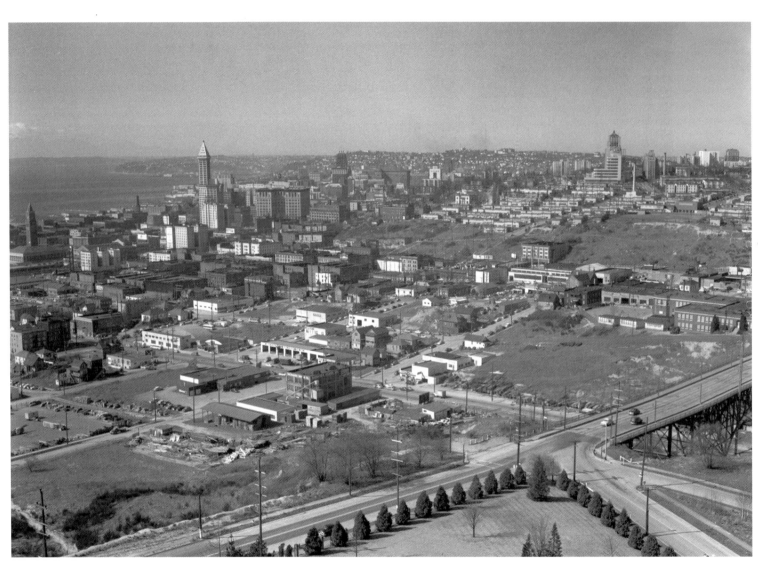

In 1954, a Seattle Engineering Department photographer climbed to the top of the Marine Hospital on Beacon Hill to capture this view of downtown. Interstate 5 would soon carve a swath across the area. The Marine Hospital, also called the U.S. Public Health Service Hospital, would in later decades become headquarters to Amazon.com.

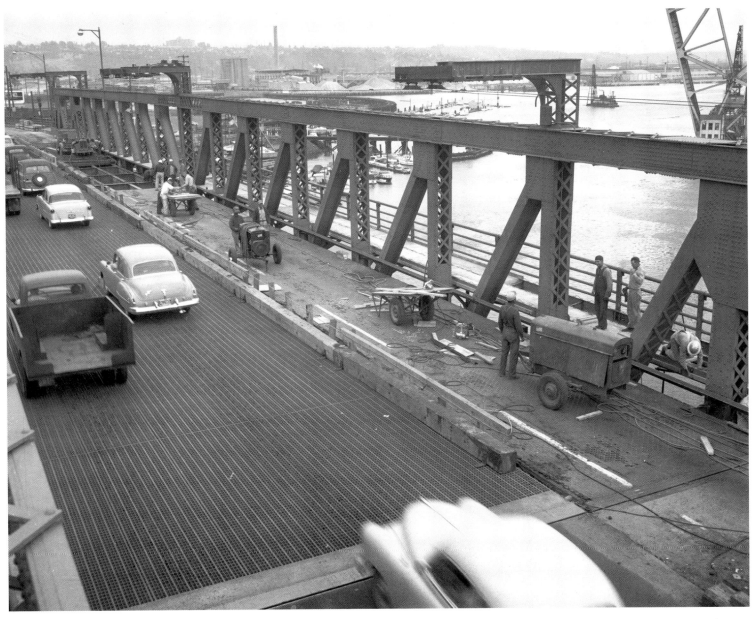

On the gray day of August 28, 1958, crews resurface one span of the Spokane Street Bridge over the Duwamish West Waterway. These bascule spans were the fourth set of bridges to link downtown Seattle and West Seattle. They served until 1978 when the freighter *Chavez* damaged them beyond repair. New spans, high enough to allow passage of ships, would take their place.

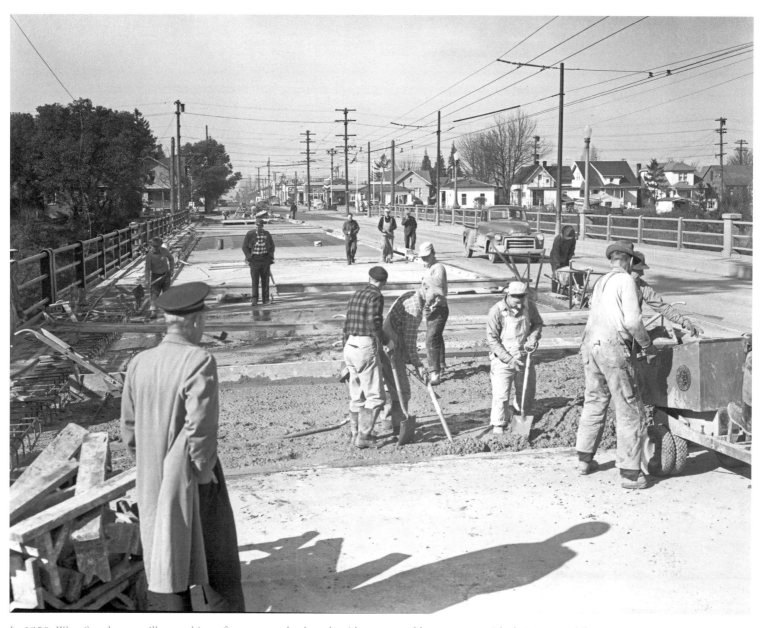

In 1950, West Seattle was still something of a remote suburb and residents wanted better access with their automobiles to downtown. The City built a bridge to carry Admiral Way from the Spokane Street bridges to the top of the hill where Admiral crossed California Avenue SW.

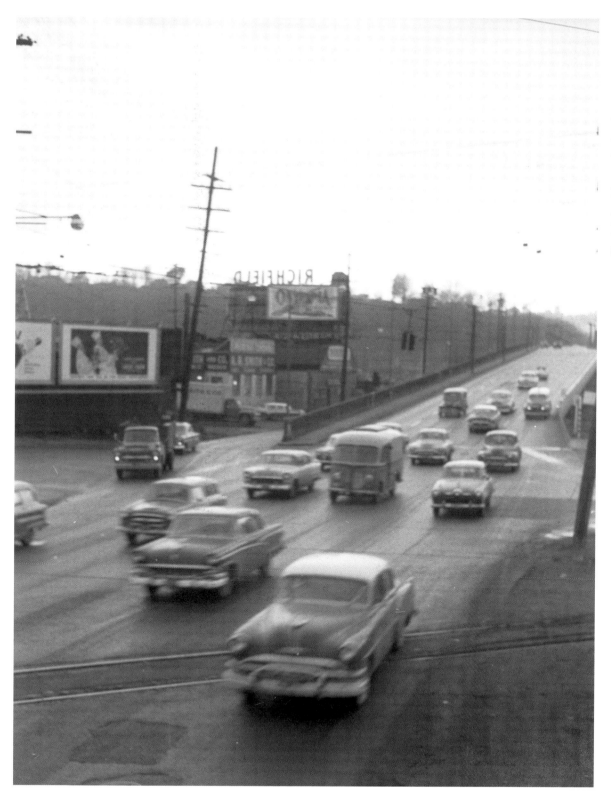

More than 50 years after this 1956 photo was taken looking southwest of SW Spokane Street where it crosses 11th Avenue SW on Harbor Island, a Seattle resident might laugh at its title "traffic congestion." Billboards advertise Olympia Beer ("It's the Water"), Action spark plugs, Lucky Lager beer, and Richfield gasoline.

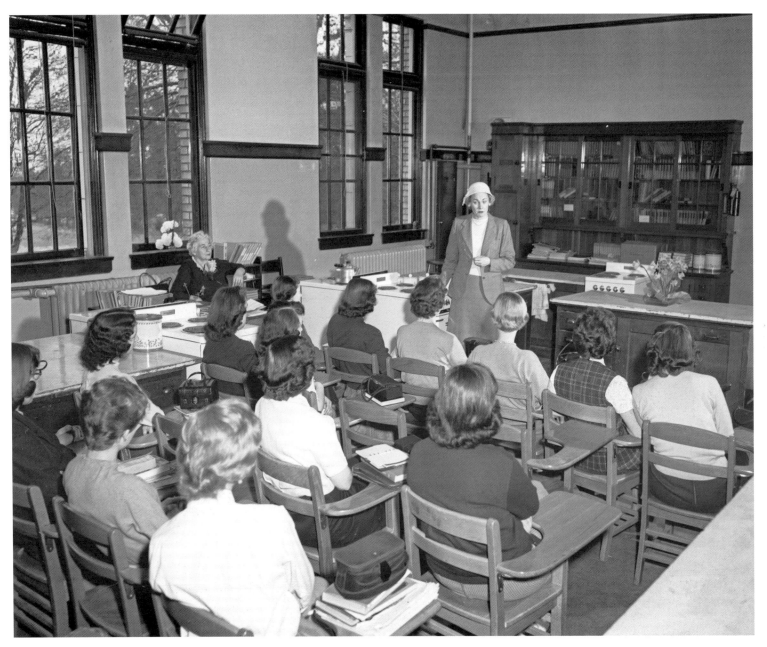

Seattle enjoyed some of the lowest electric rates in the nation thanks to cheap hydroelectric power from its own dams on the Skagit River. The utility promoted the use of electricity to help keep rates down. Part of Seattle City Light's services included home economists who taught customers how to cook with electric ranges and ovens. In February 1954, Mary Norris addresses a West Seattle High School home economics class.

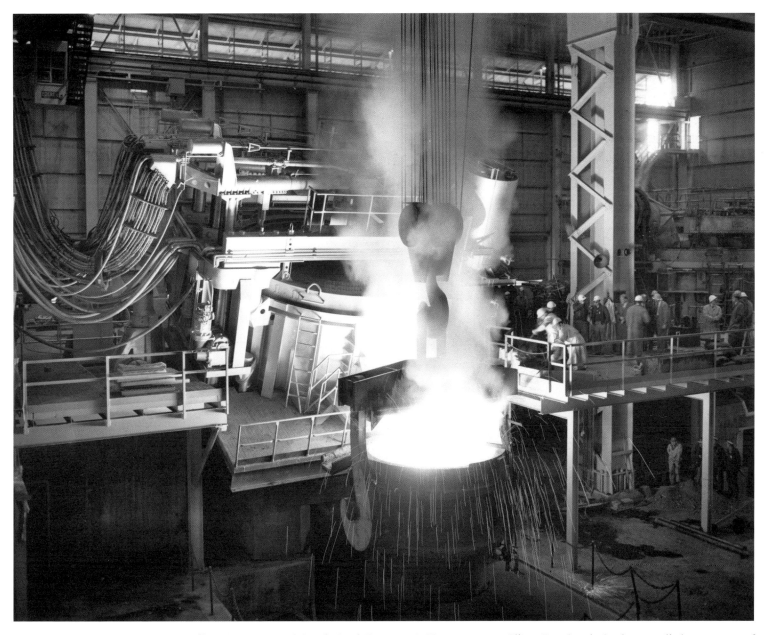

In 1905, William Pigott opened Seattle Steel Company in Youngstown on Elliott Bay. Seattle Steel eventually became part of Bethlehem Steel and Youngstown became part of West Seattle. Here around 1950, Bethlehem workers pour molten steel from an electric ladle.

In 1903, Seattle retained the services of landscape architect John Charles Olmsted, nephew and adopted son of famous landscape architect Frederick Law Olmsted, to design a system of parks. He came up with a plan for 20 miles of scenic boulevards connecting 16 parks to be enjoyed by residents with carriages and automobiles. Madrona Park on Lake Washington was one of his creations. On one sunny day in the 1950s residents enjoy the sun and the water.

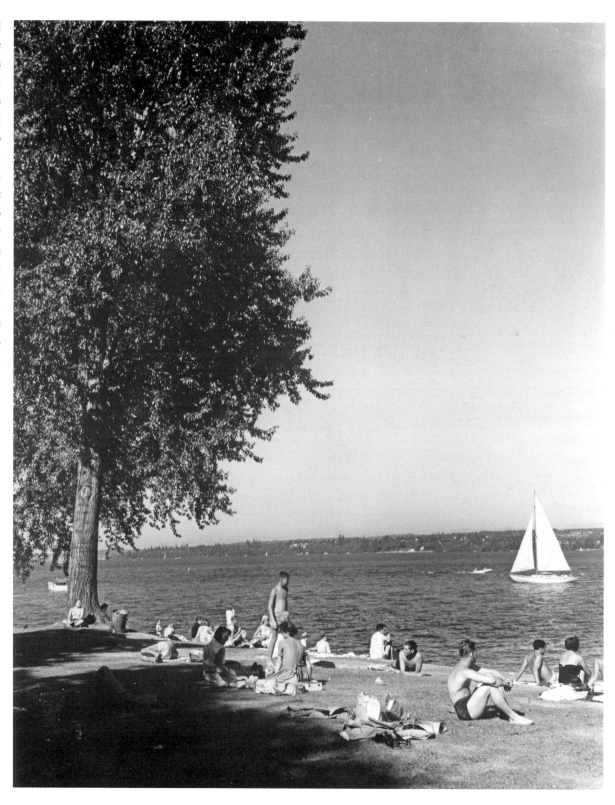

The Boeing Airplane Company of Seattle produced a series of remarkable and innovative military and commercial aircraft over the years. In the 1950s, it rolled out the Boeing 707, the first of many jetliners that would transform aviation and society. Two projects that were not so successful were the B-70 bomber and the Supersonic Transport. To test supersonic wings and other components for the sub-zero temperatures of high-altitude flight, the company constructed three deep-freeze units like this one.

The Smith Tower was built by industrialist Lyman Cornelius Smith and opened in 1914 at 506 Second Avenue. The 36-story steel skyscraper was designed by Edwin H. Gaggin and T. Walker Gaggin of Syracuse, New York. For years it was the tallest building west of Ohio, then west of Chicago, then west of Kansas City, then west of Dallas. It remained the tallest building in Seattle until 1968.

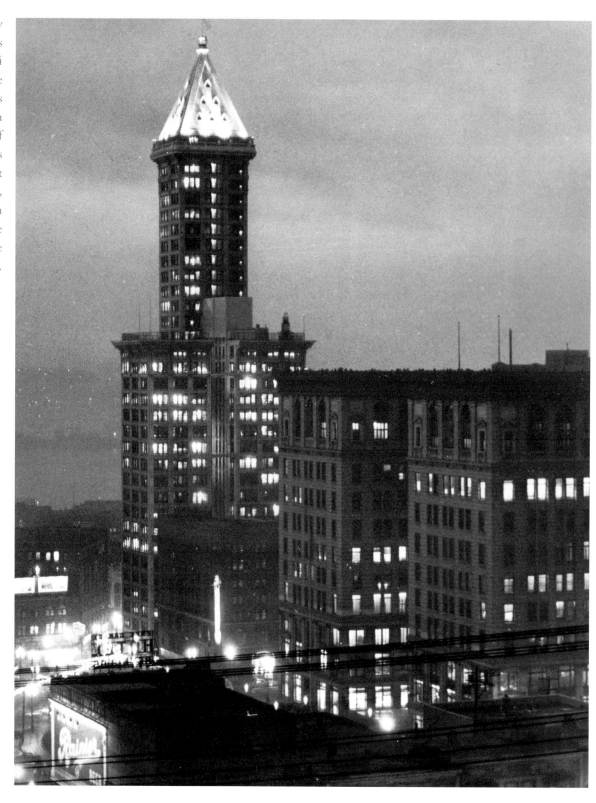

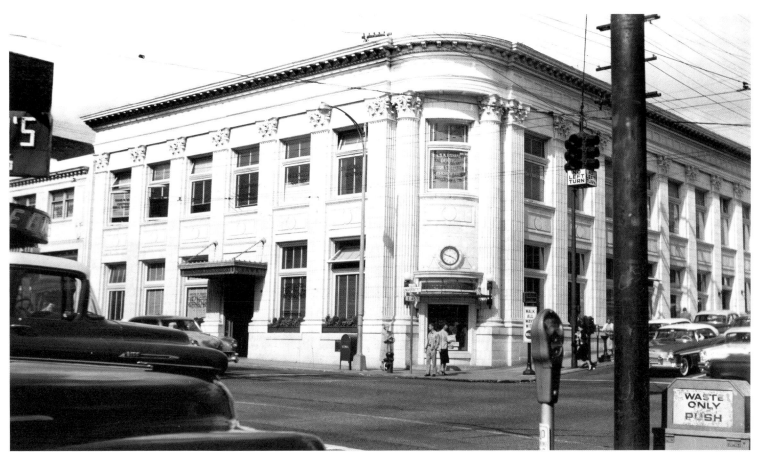

In 1957, the University Branch of Pacific National Bank sat at the corner of University Way NE and NE 45th Street, a block from the University of Washington campus. The building was still there in 2010, but not the bank.

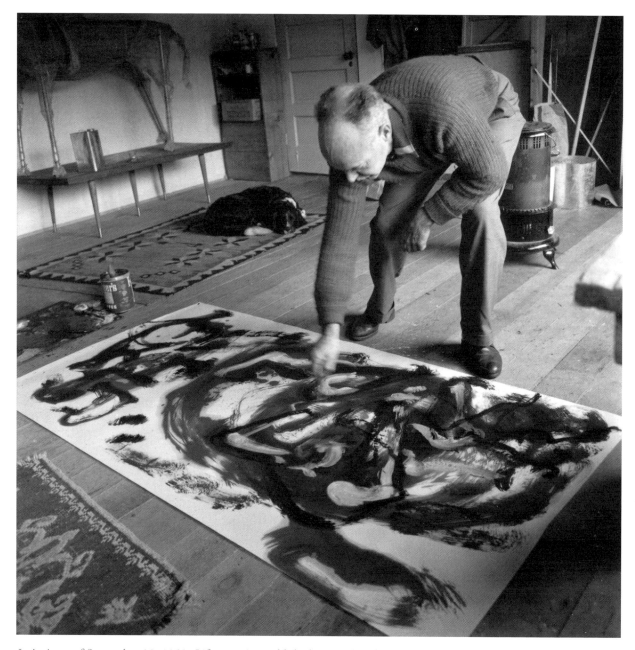

In its issue of September 28, 1953, *Life* magazine published an article titled "Mystic Painters of the Northwest." The piece described a group of artists in and around Seattle which it called the Northwest School. This included Mark Tobey, Guy Anderson, Morris Graves, and Kenneth Callahan. Art Hupy photographed Kenneth Callahan working in his studio.

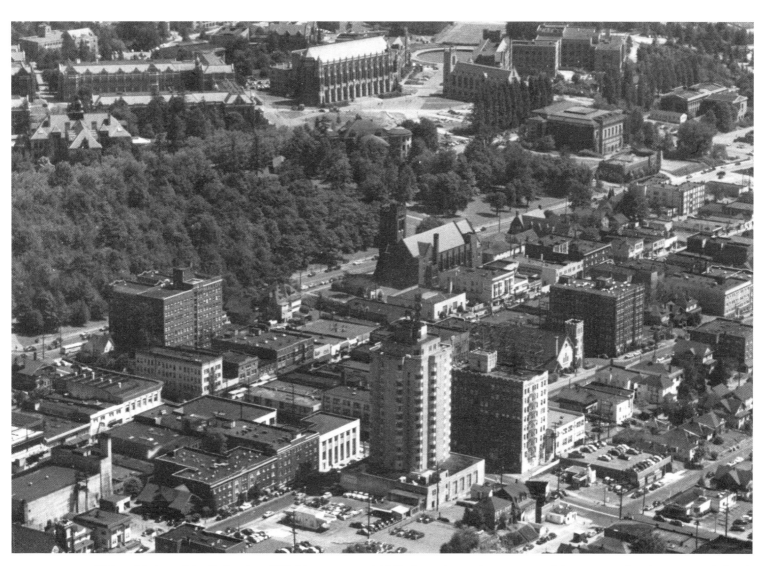

This aerial view of the University of Washington around 1955 shows the northwest corner of the campus when it was a wooded park with walking trails. This area would become a parking lot in the 1960s and the new Law School building in the 1990s. At upper-left is Meany Hall, which would be damaged beyond repair in an earthquake in 1963. The new Meany Hall and its performing arts theater would rise in 1975.

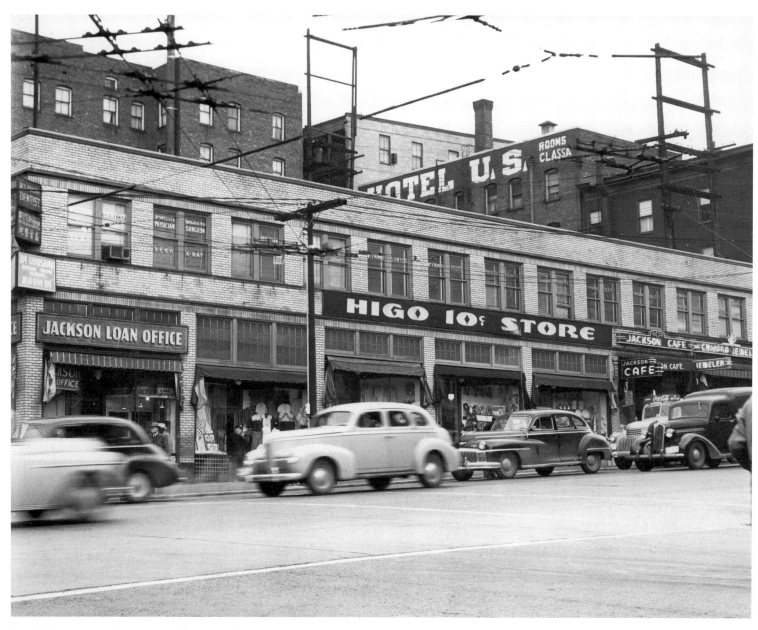

Seattle's International District was home to Chinese, Japanese, and Filipino immigrant communities as evidenced by these businesses in the 600 block of South Jackson Street around 1950. The Hotel U.S. advertises "Class A" rooms for many of the low-income residents of the area. This neighborhood swelled every winter with seasonal workers waiting for warmer weather to return to area fields and forests.

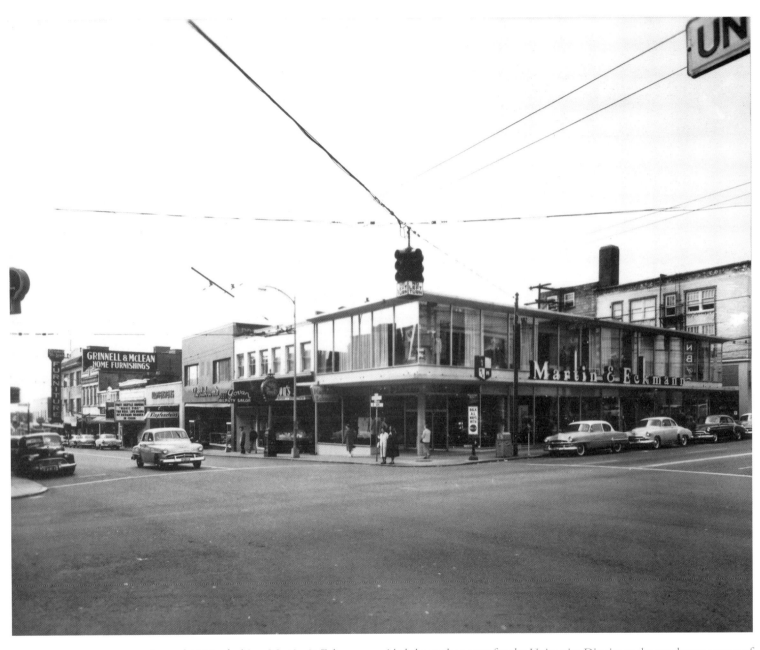

Around 1955, clothiers Martin & Eckman provided the anchor store for the University District at the southwest corner of University Way NE and NE 45th Street. Just blocks from the University of Washington's "Greek Row" of fraternities and sororities, the business outfitted more than one formal affair.

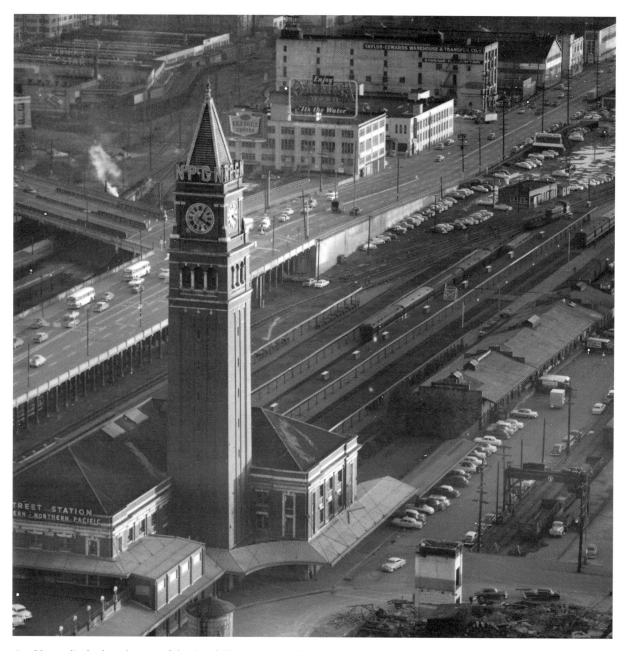

Art Hupy climbed to the top of the Smith Tower to take this photo of the Great Northern Railway's King Street Station sometime in the 1950s. Architects Charles Reed and Allen Stern designed the terminal and its signature clock tower, which were completed in 1906. The tracks disappear at lower-left into a tunnel under Fourth Avenue connecting with the Interbay yards and Stevens Pass across the Cascades.

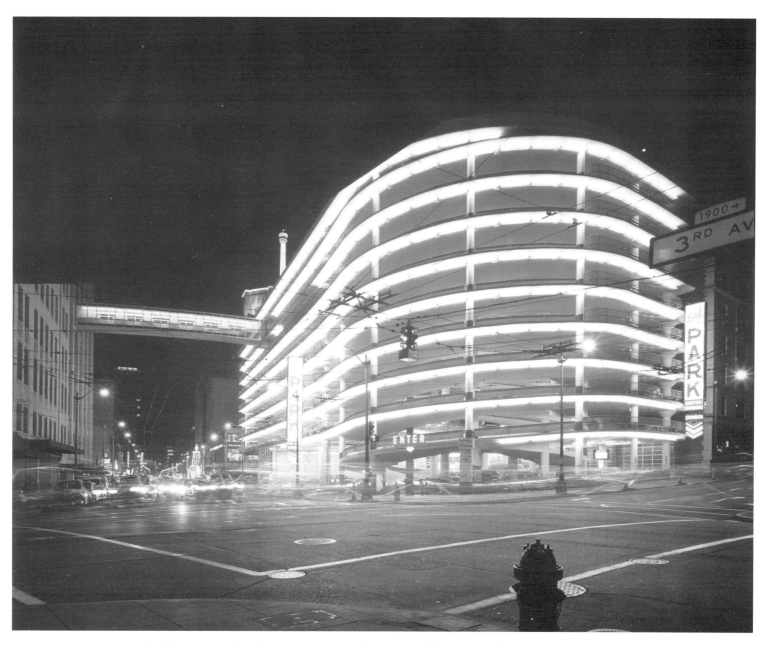

Art Hupy used a timed exposure to capture this image of the Bon Marché's parking garage and "skybridge" from the corner of Third Avenue and Stewart Street. The Bon built the garage to lure shoppers inclined to drive to one of the new suburban shopping malls like Bellevue Square or Northgate instead of visiting the traditional destinations downtown. The garage was also part of an extensive redevelopment effort downtown that destroyed many historic structures.

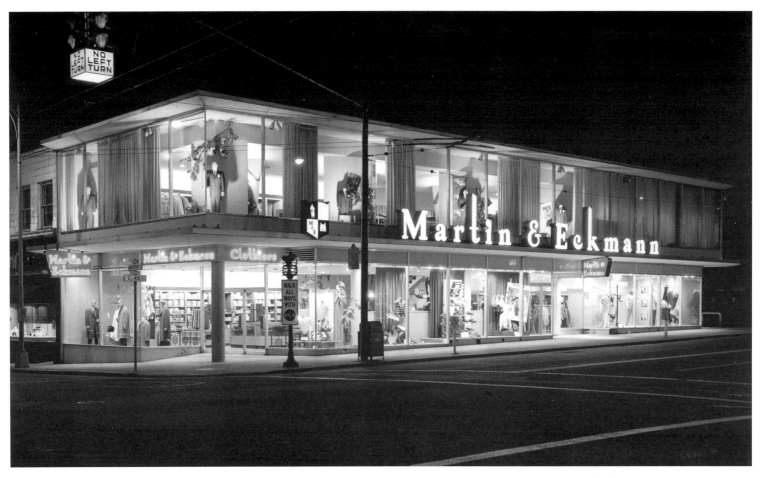

In the 1950s, the cost of electricity in Seattle was so low that retailers like Martin & Eckman at NE 45th Street and University Way NE could splurge with brightly lit displays. Some new buildings in Seattle were built without light switches because running lights all night was cheaper than replacing bulbs and tubes able to be turned on and off.

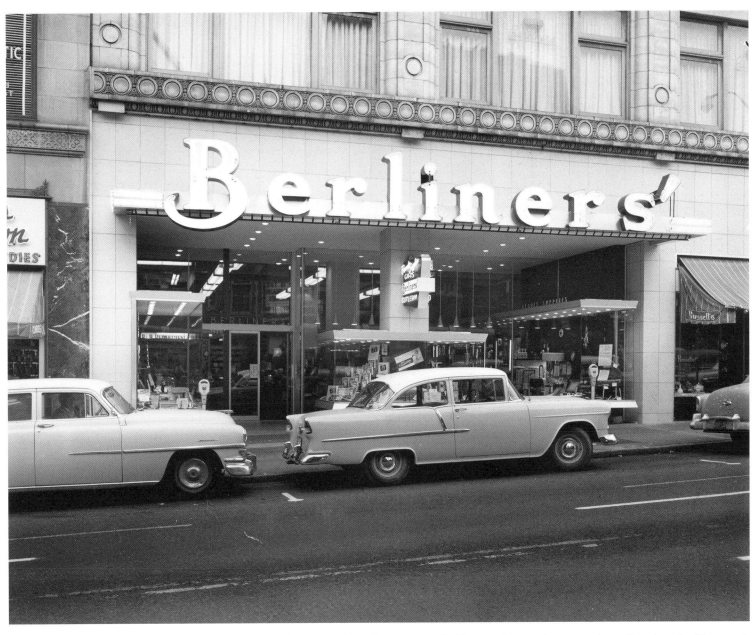

Berliners', at 1422 Fifth Avenue, between Pike and Union, supplied beauty shop equipment and supplies when Art Hupy took this photo in the 1950s.

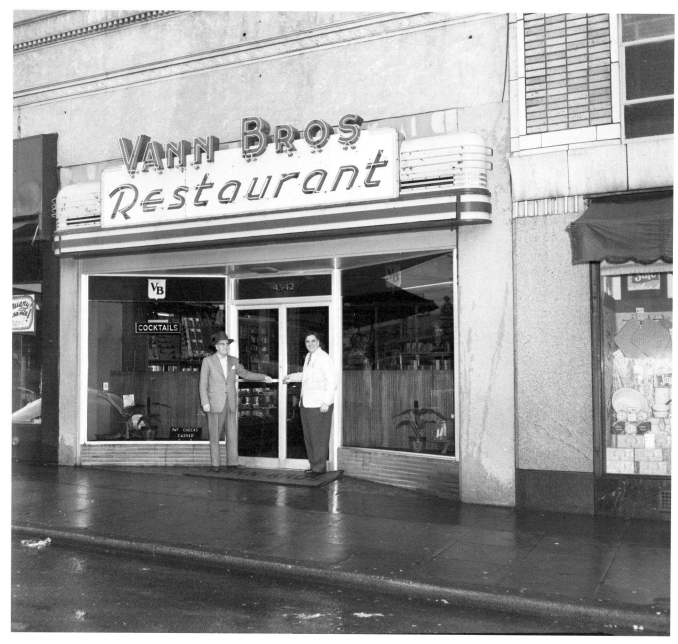

Seattle City Light had this photo taken of Vann Brothers Cafe, at 4542 California Avenue (SW) in West Seattle, to advertise their use of all-electric appliances. The publicly owned utility encouraged the use of electricity to increase revenues, which would lower the cost to individual electric customers. This strategy would continue into the 1970s when dam construction ended and conservation became energy policy.

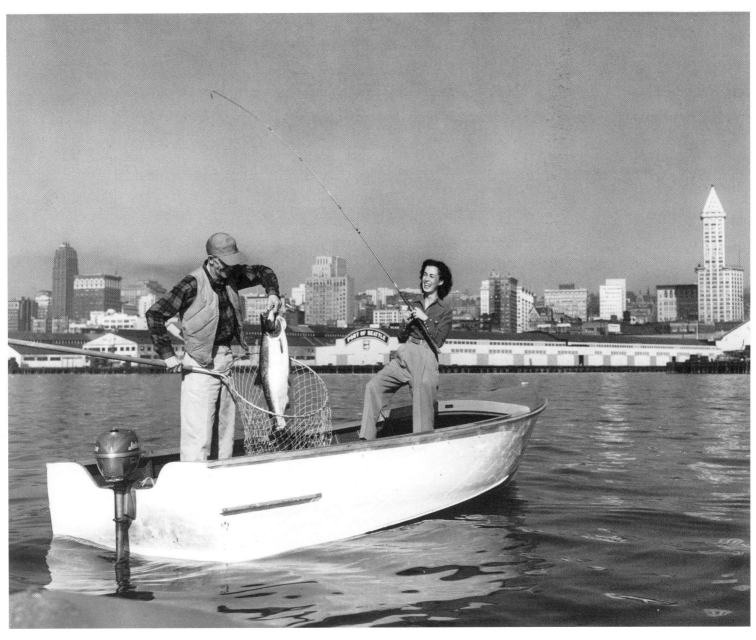

Josef Scaylea caught this couple as they netted a good-sized salmon in Elliott Bay at the mouth of the Duwamish River. Annual salmon runs attracted thousands of anglers with basic gear and in the simplest of boats. Indigenous peoples made their livings from these runs for countless generations. Overfishing and loss of habitat to development would earn the runs a "threatened status" designation in 1999.

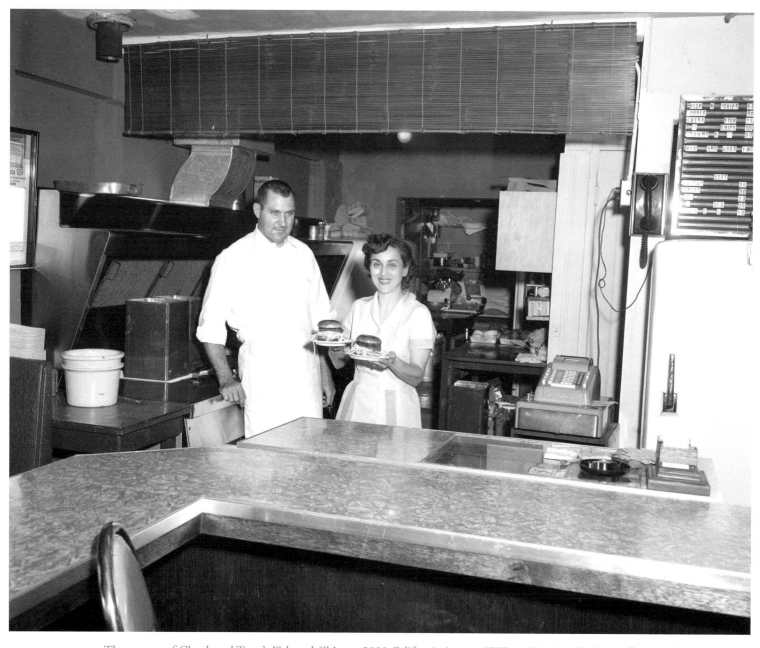

The owners of Chuck and Terry's Fish and Chips at 5923 California Avenue (SW) in West Seattle show off some of their fare. The neighborhood eatery featured an all-electric kitchen and Seattle City Light offered a special rate to all-electric customers. Fish and chips competed with burgers as favorites at Seattle's fast-food diners.

Age of the Space Needle

(1960–1969)

Seattle greeted the 1960s with great anticipation. The Century 21 Exposition—the Seattle World's Fair—was planned not only to put Seattle on the map, but to leave the city with a matchless public venue, the Seattle Center, its enduring icon, the Space Needle, and a model for mass transit, the Monorail. Technology seemed to blossom everywhere. At the University of Washington Medical School, researchers developed a heart defibrillator and an artificial kidney. The Boeing Company took the jetliner business a step further and designed a supersonic airliner and tools to explore space. So many people moved to the area for the jobs in aerospace that they created a housing shortage. The automobile continued its power over the economy and culture as Interstate 5 sliced through Seattle across 4,500 pieces of property, uprooting families and redefining neighborhoods. The highway transformed the city—for good and for ill—as surely as did the arrival of the transcontinental railroads in the 1880s and 1890s.

As in the rest of the country this decade, the Vietnam War, the civil rights movement, and the counter culture had their impacts. Some young men enlisted or were drafted while others resisted and protested or dropped out. Dr. Martin Luther King made one visit to the city in 1961 to find that the white church where he was to speak was unavailable. The University of Washington and other congregations stepped up to give the leader platforms to preach peace and justice. It would take King's murder in 1968 to finally remove the discriminatory housing practices that kept Seattle segregated. Blue laws, which had prohibited the sale of alcohol on Sundays, dropped off the books in 1967 and new leaders wrested control of city politics from old. Citizens pushed back against the government's unrestricted construction of freeways and the destruction of historic districts by government and business.

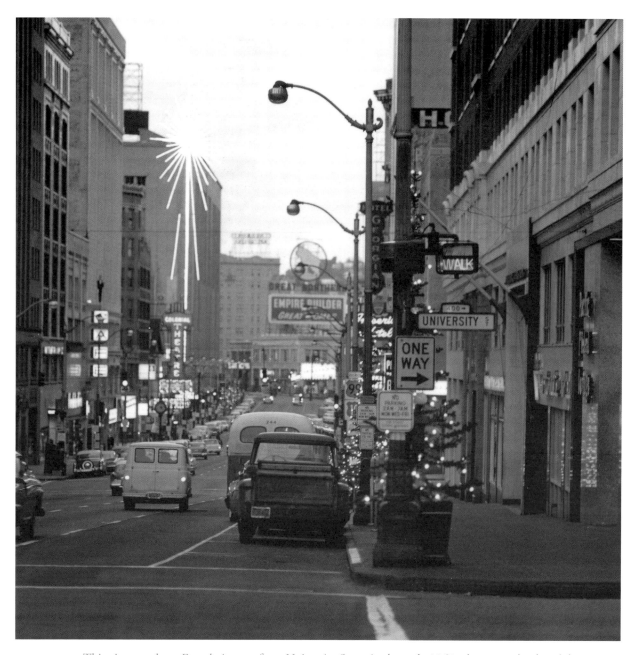

This view north on Fourth Avenue from University Street in the early 1960s shows one landmark long gone: Rocky the Mountain Goat. Rocky was the symbol of the Great Northern Railway and advertised its daily transcontinental train the Empire Builder. By the end of the decade, Rocky and the GN would morph into a new company, the Burlington Northern, and new signs would assume the place of honor on Fourth Avenue. The Christmas star on the Bon Marché would endure.

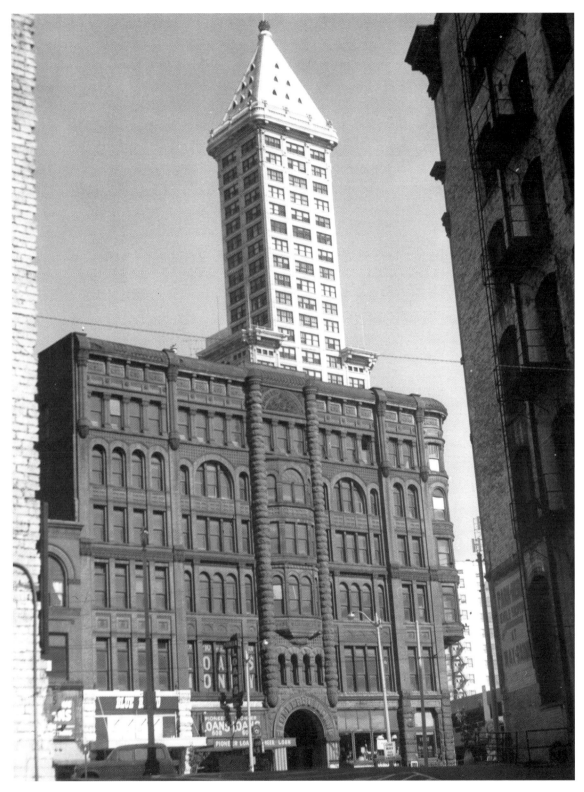

Werner Lenggenhager recorded this look at the Smith Tower and the Pioneer Building from First Avenue and Yesler Way. The Pioneer Building at 600 First Avenue rose on the site of the home of Henry Yesler. This was one of three legacy buildings commissioned by Yesler to honor his fellow pioneers. Excavation of the site began the day in 1889 that a fire devastated Seattle's commercial district.

The Austin A. Bell building at 2326 First Avenue in the Denny Regrade area housed over the years apartments, a Masonic Temple, several taverns, the Washington Paper Company, and finally a Starbucks. The building was designed by Elmer Fisher. The neighborhood would eventually be called Belltown, not after the building, but after Bell Street and Seattle pioneer William N. Bell, who claimed this land in 1852.

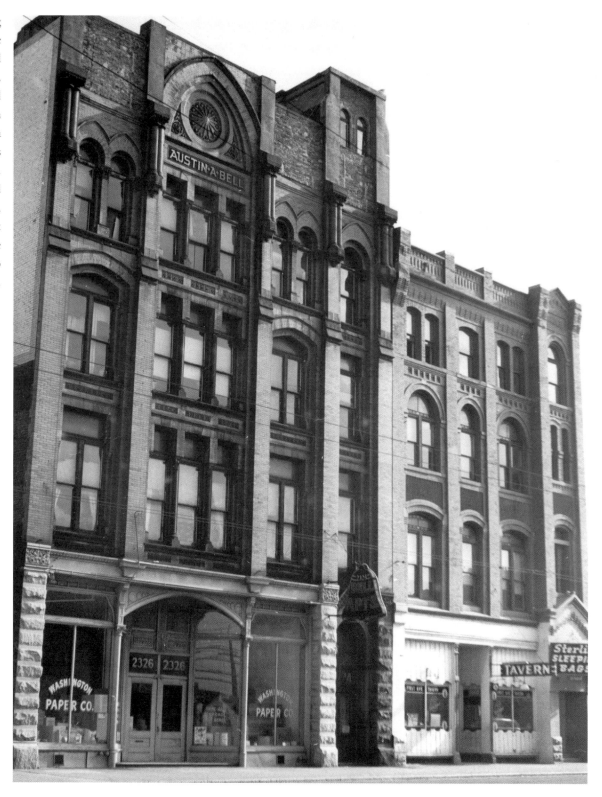

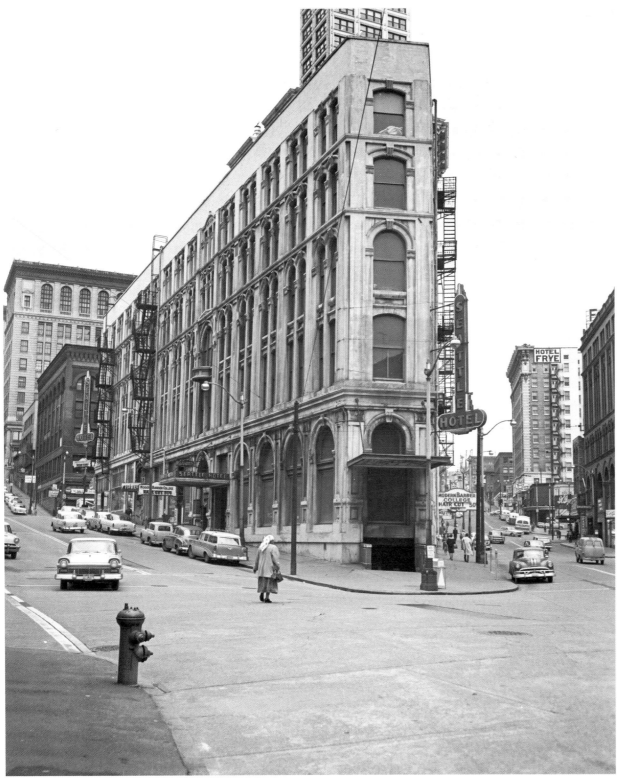

The Seattle Hotel—formerly the Occidental Hotel—sat at the nexus of Seattle growth and King County addresses, at First Avenue and Yesler Way. On April 3, 1961, wrecking balls reduced the building to rubble to be replaced with an ugly parking garage likened to a sinking ship. This act of urban renewal by the government helped spark a citizen movement that preserved Pioneer Square and the Pike Place Market from a similar fate.

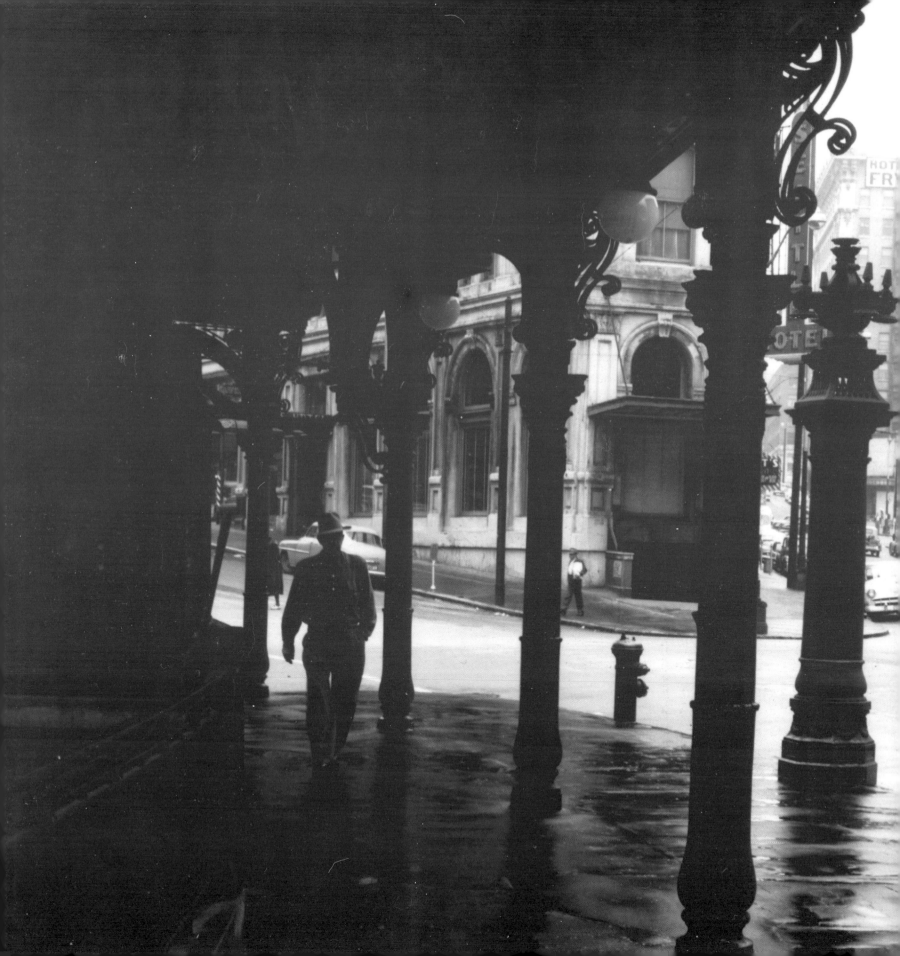

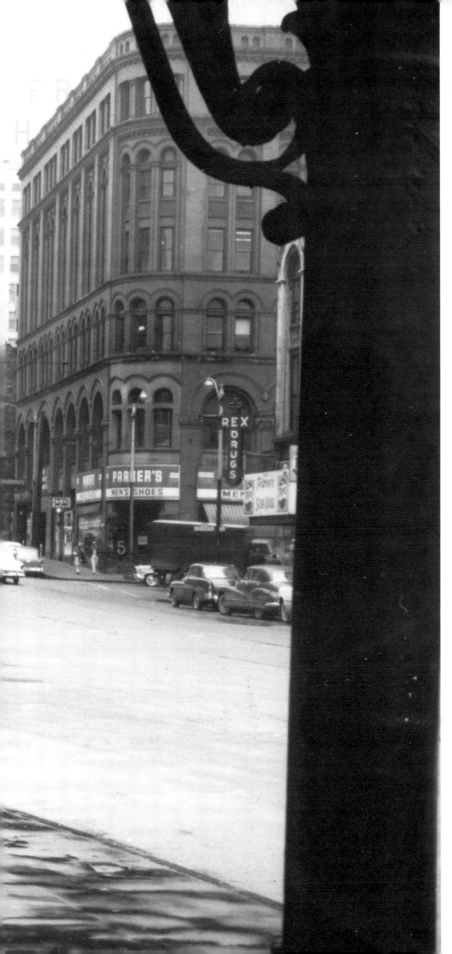

In 1909, the city opened an underground "comfort station" in Pioneer Square at the corner of First Avenue and Yesler Way. The convenience featured marble stalls (both free and for a fee), oak chairs, and terrazzo floors. Up on the street stood a cast-iron pergola with supports concealing ventilators for the odors from below. The restrooms closed in the late 1940s. Straight ahead on the left is the Seattle Hotel and on the right the Frye Hotel.

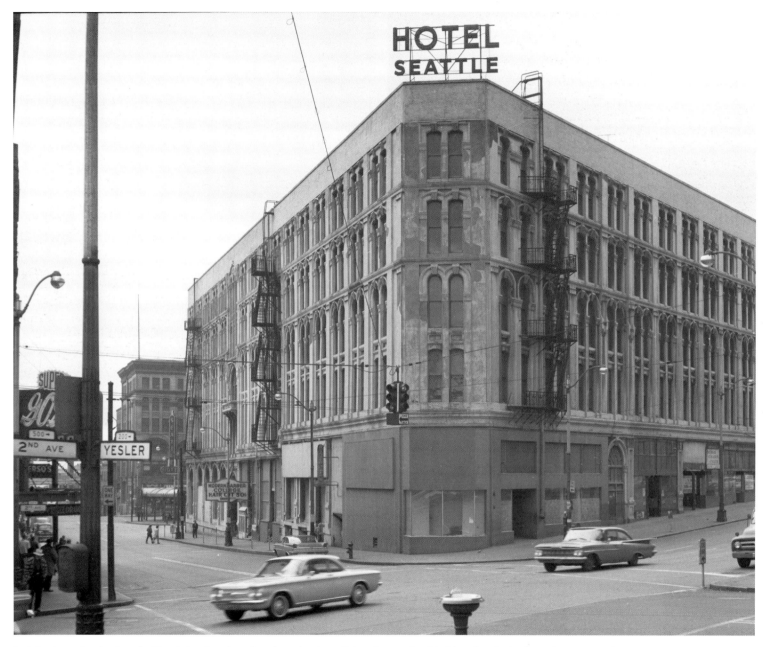

In March 1961, the Seattle Hotel sits abandoned and awaits demolition. It was the third hotel to be built at the corner where James Street, Yesler Way, and First Avenue come together. Urban planners decided that to keep downtown vital, old, inefficient structures like the hotel needed to make way for modern construction. In this case, the city decided that the hotel property would better serve as a parking garage.

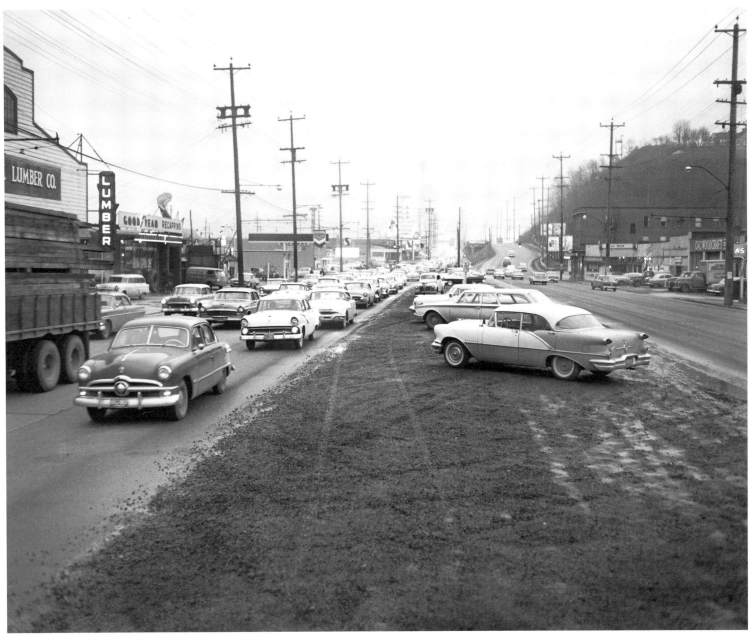

In 1960, traffic congestion began to worry the Seattle Engineering Department. As people moved to West Seattle they used SW Spokane Street and its drawbridges over the Duwamish Waterway to reach downtown. This photo documents traffic volume between 23rd Avenue SW and 26th Avenue SW. The Blackstock Lumber Company is visible at left.

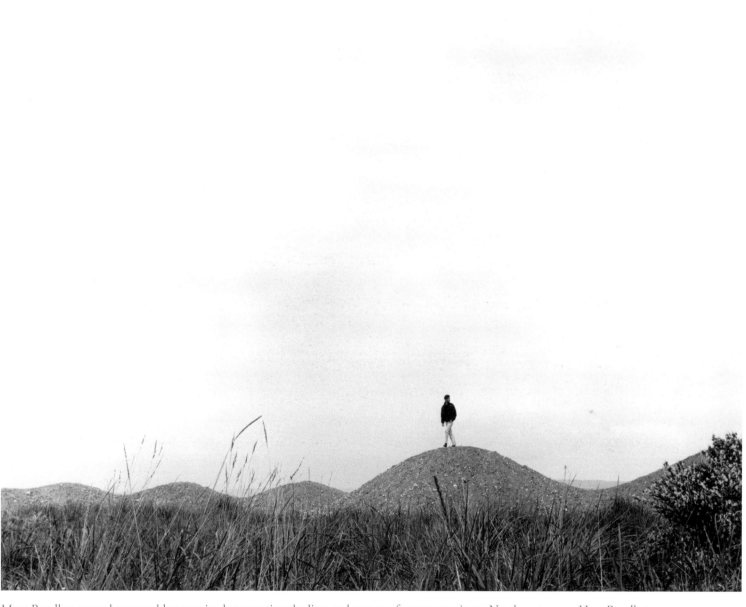

Mary Randlett created memorable portraits documenting the lives and careers of many prominent Northwesterners. Here Randlett captures musician, art historian, paleobotanist, painter, and author Wesley C. Wehr as he strolls across Golden Gardens Park on Shilshole Bay in May 1966. Wehr was a member of the Northwest School of artists.

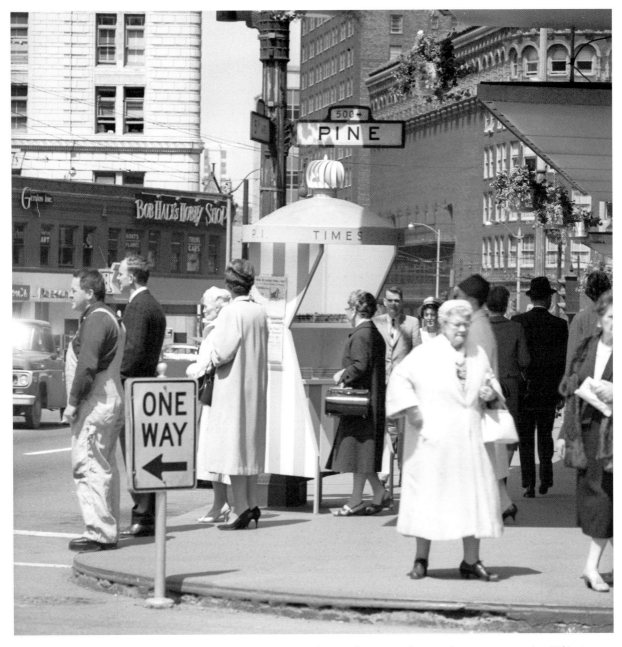

A vendor sells copies of the *Seattle Times* and the *Seattle Post-Intelligencer* from a newsstand at Fifth Avenue and Pine Street in front of the Frederick and Nelson department store. Art Hupy photographed these shoppers around 1965 when Fredericks was Seattle's premier shopping experience. Fredericks would close its doors in 1992, but Nordstrom would take over the building. The *P-I* would cease print publication in 2009.

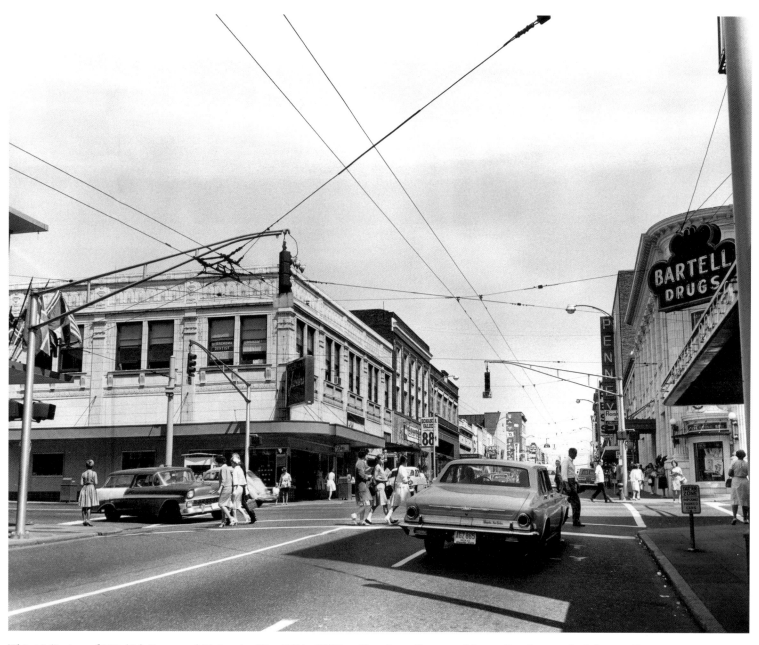

This 1963 view of NE 45th Street and University Way NE by William Eng shows Porter and Jensen Jewelers on the left, Bartell Drugs on the right, Pacific National Bank across the street on the corner, with Penney's and Kress beyond. Until the late 1960s, the U-District drew not only the students from the nearby University of Washington, but also retail shoppers from the entire north end of the city.

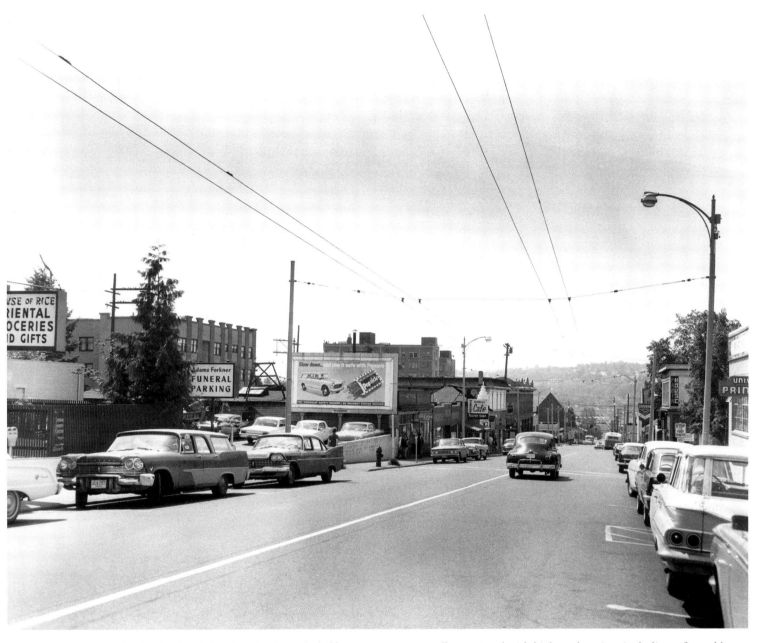

In the 1960s, the University District included businesses not normally associated with higher education, including a funeral home and oriental groceries and gifts. This is the 4200 block of University Way NE. In the distance is Capitol Hill.

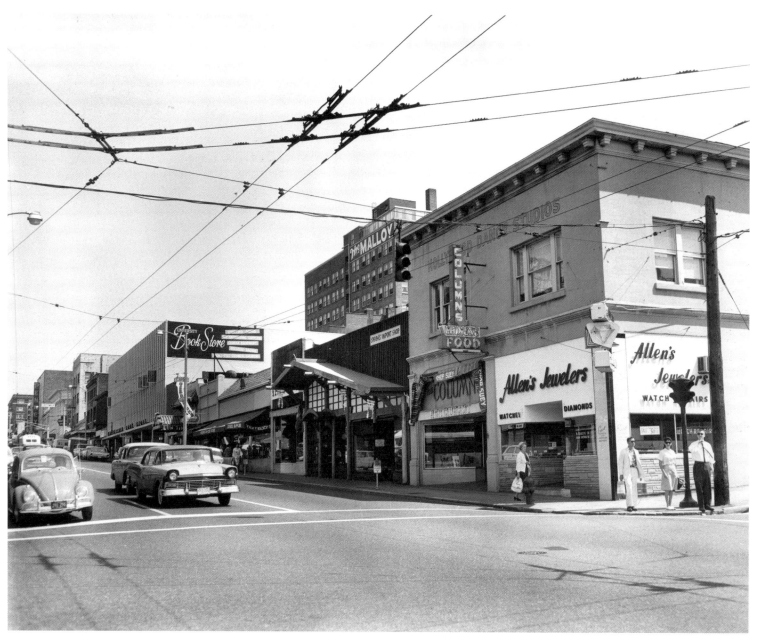

The University Bookstore started in a cloak room in Denny Hall in 1900. In 1924, a fire marshal ordered the bookstore off campus and it moved into a pool hall on University Way. The store then expanded and occupied a new building. This shot of the 4300 block of University Way NE shows the store and some of its neighbors, the Columns Cafe and Allen's Jewelers. The Malloy apartments behind on 15th Avenue NE catered to students.

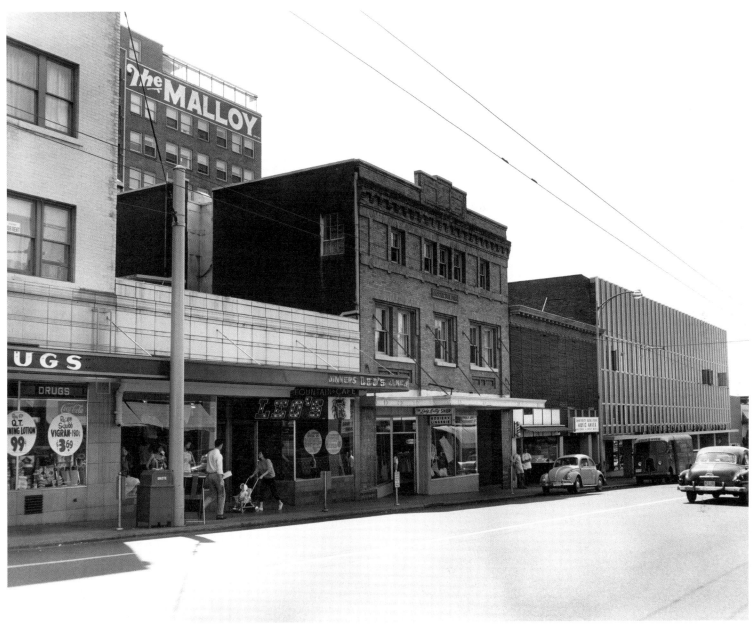

At the north end of the 4300 block of University Way NE, neighbors of the University Bookstore (at right) include the Masonic Building and Bartell's Drugs.

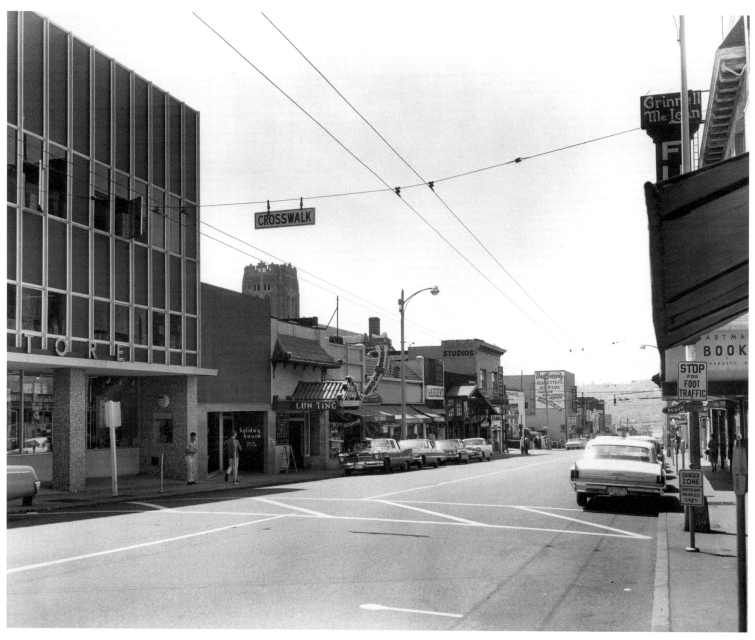

Another view of the 4300 block of University Way NE shows businesses to the south of the University Bookstore. The tower of Eagleston Hall of the University's School of Social Work rises in the distance. One kind of business missing from these views is that which served alcohol. The state legislature banned alcohol sales within one mile of the university, requiring thirsty faculty and students to trek to establishments such as the Blue Moon for libation.

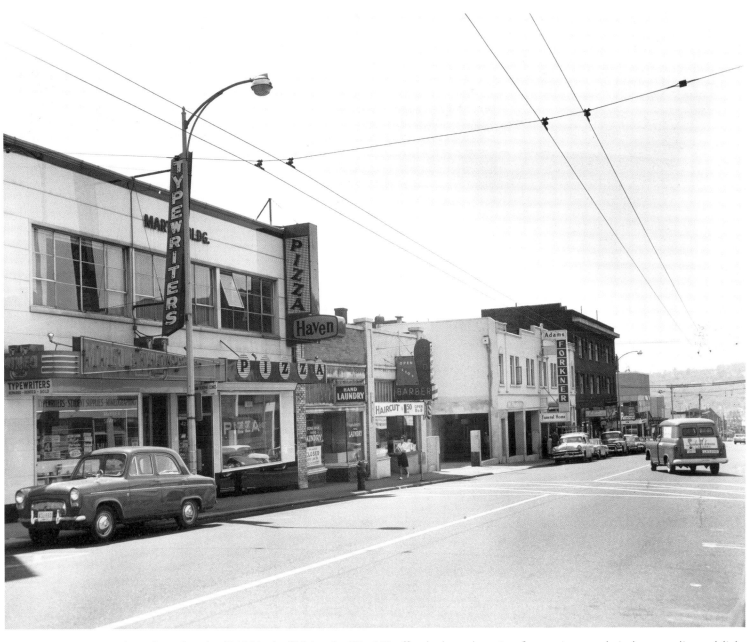

In the early 1960s, the 4200 block of University Way NE offered sales and repairs of typewriters, a relatively new culinary delight called pizza, laundry services, haircuts for $1.50, and funeral services.

Farther down University Way NE at NE 41st Street, Gordon Tracie's Folklore Center offered a venue for folk music, which had gained popularity across the nation. The Seattle Folklore Society evolved from this storefront. In 1963, when William Eng snapped this shot, the University of Washington was poised for explosive growth as the baby boom generation began entering college. Empty parking spaces along "the Ave" would become a memory.

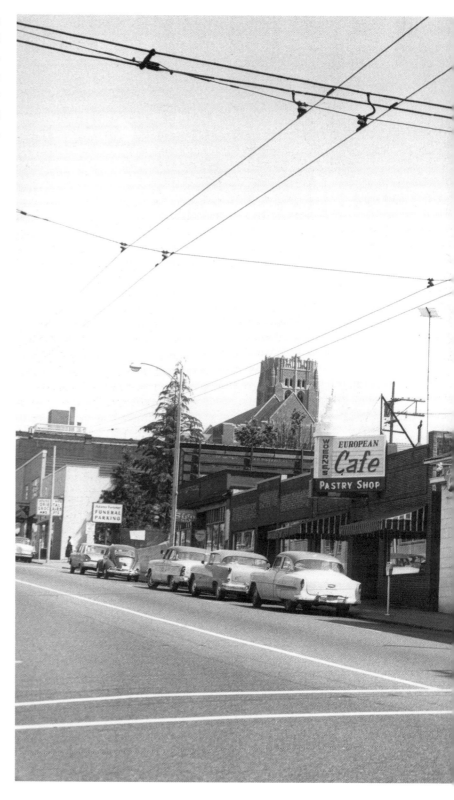

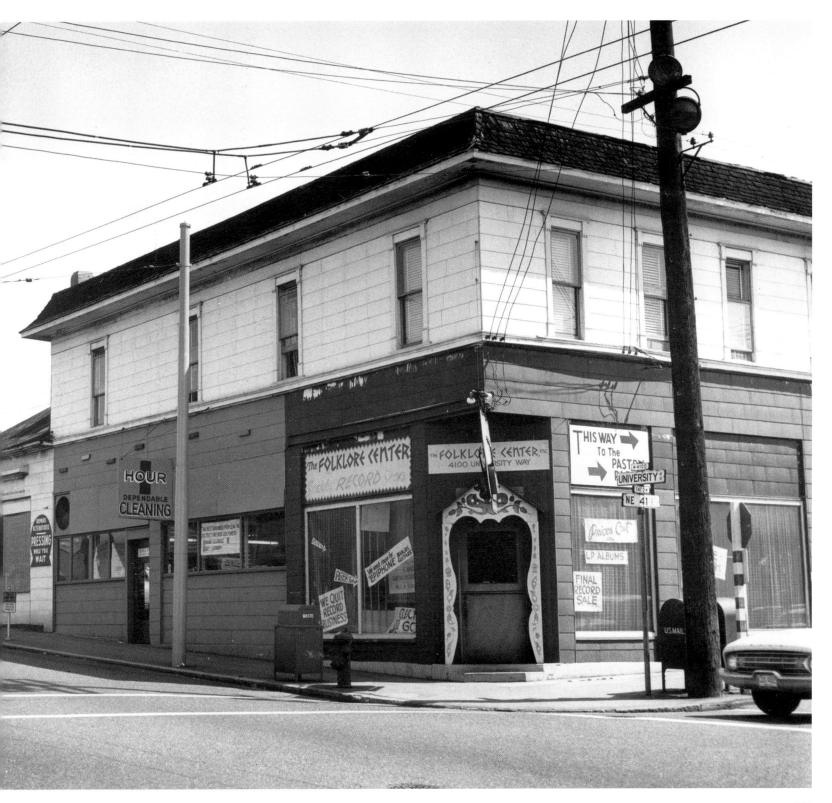

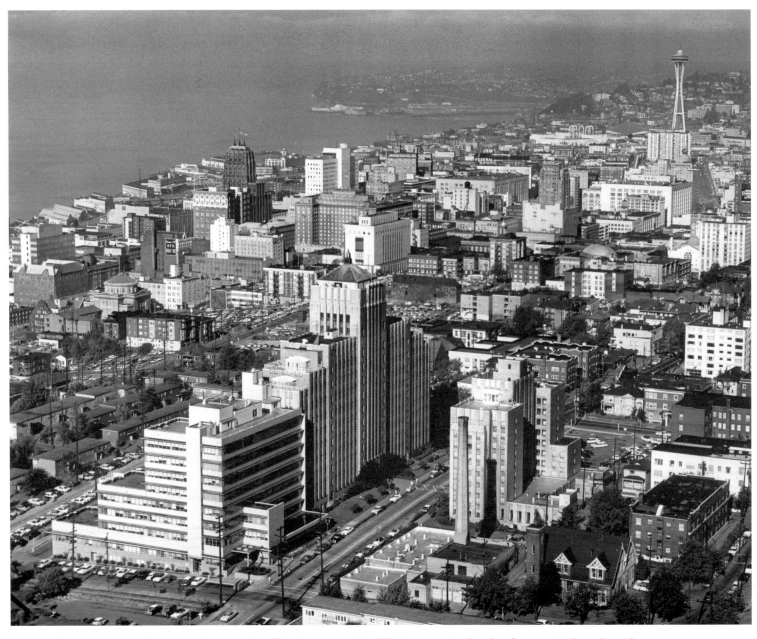

Shortly after the Space Needle rose on the grounds of the Century 21 World's Fair in 1962, this shot from an airplane showed Harborview Hospital at 9th Avenue and Jefferson Street. Interstate 5 had yet to chew its way through downtown. In the distance is Queen Anne Hill, Magnolia Bluff, and Pier 91.

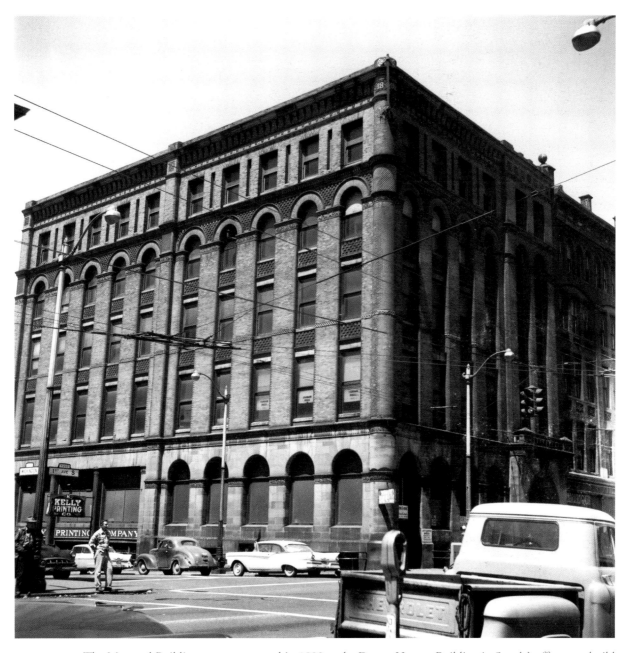

The Maynard Building was constructed in 1892 as the Dexter Horton Building in Seattle's effort to rebuild in brick after the Great Fire of 1889. Albert Wickersham designed the five-story building in a style called Richardsonian Romanesque, inspired by the Chicago School of Architecture. In this view from about 1960, the street-level windows at 119 First Avenue S are boarded over.

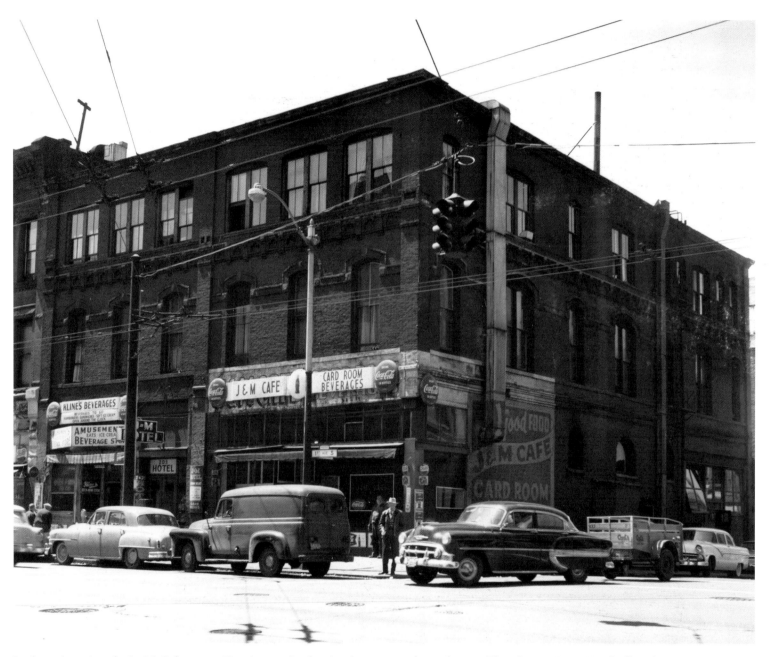

In the early 1960s, the J&M Cafe, at 201 First Avenue S, advertises beverages and a card room. The adjacent J&M Hotel offers cheap rooms. Although state law prohibited gambling, Seattle's tolerance policy allowed games of chance to flourish, particularly in the Pioneer Square area. For generations, the area south of Yesler Way, "below the line," was home to gaming and other vices. The J&M Cafe first opened in 1892 and closed in 2004.

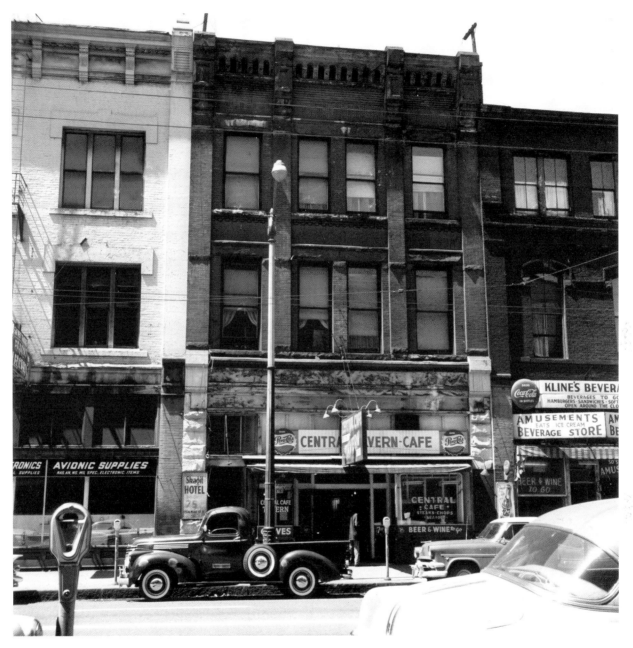

As one of Seattle's oldest businesses, the Central Tavern and Cafe at 207 First Avenue S appealed mostly to local residents in the early 1960s. When Pioneer Square was rescued from bulldozers by designation as a historic district in 1970, former Boeing engineer Bobby Foster bought the joint. He organized Fat Tuesday, Seattle's answer to Mardi Gras and the winter blahs. In the 1980s, the Central would become a stage for the rock scene.

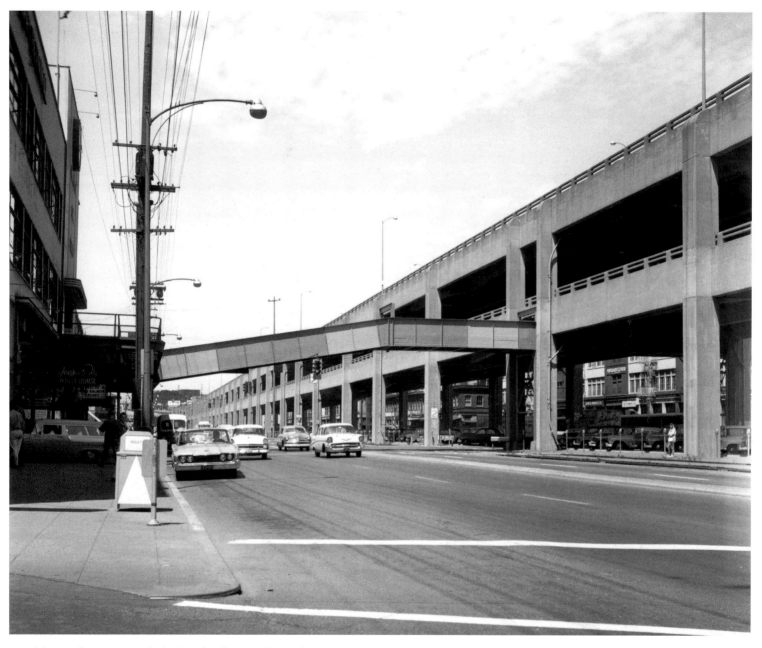

Seattle's waterfront grew with the benefit of a seawall completed in the 1930s to replace piers built out over the original beach. Fill behind the seawall became the foundation for Alaskan Way, allowing trucks to serve the waterfront in addition to rail cars. In the 1950s, the Alaskan Way Viaduct was completed to carry traffic around downtown. An overpass over Alaskan Way once allowed a cannery to move finished product to a warehouse.

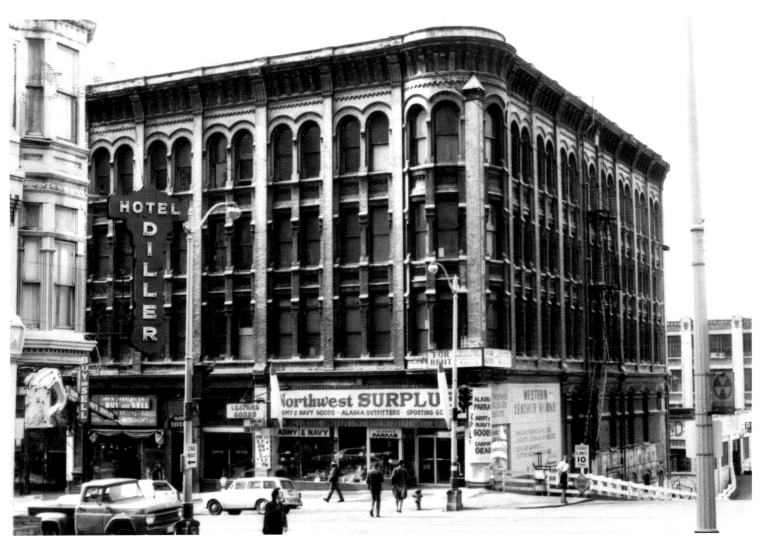

Around 1966, the Bay Building, also called the Gilmore and Kirkman Building and the Arlington Hotel, sits out its last days on First Avenue at University Street. Elmer Fisher designed the building in 1890 after the Great Seattle Fire. Fisher designed many important buildings downtown in the 1890s, but few survive.

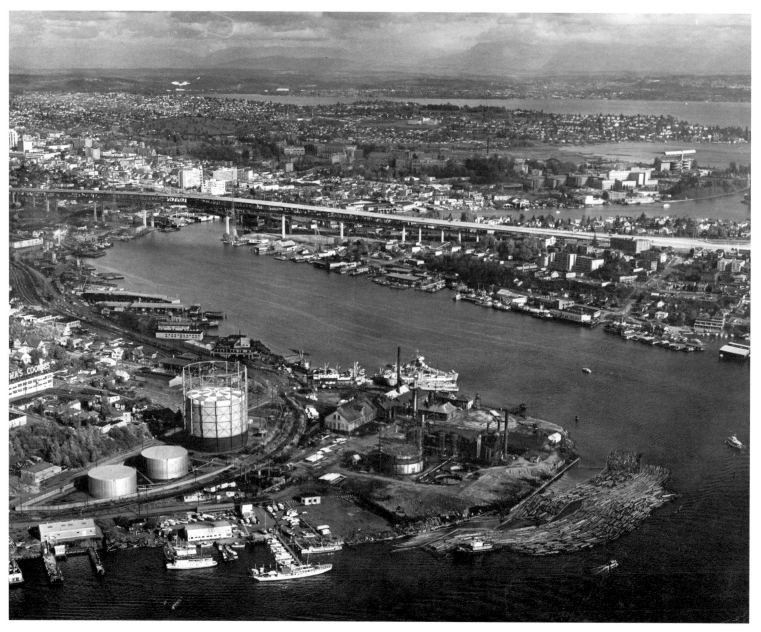

This view of the north end of Lake Union around 1965 has feet in two eras. The earlier time is represented by the Seattle Lighting Company's inactive coal gasification plant, which would become Gas Works Park in the 1970s. Booms of logs wait towing to almost-extinct sawmills. Across the distance the new Interstate 5 bridge arcs across Portage Bay.

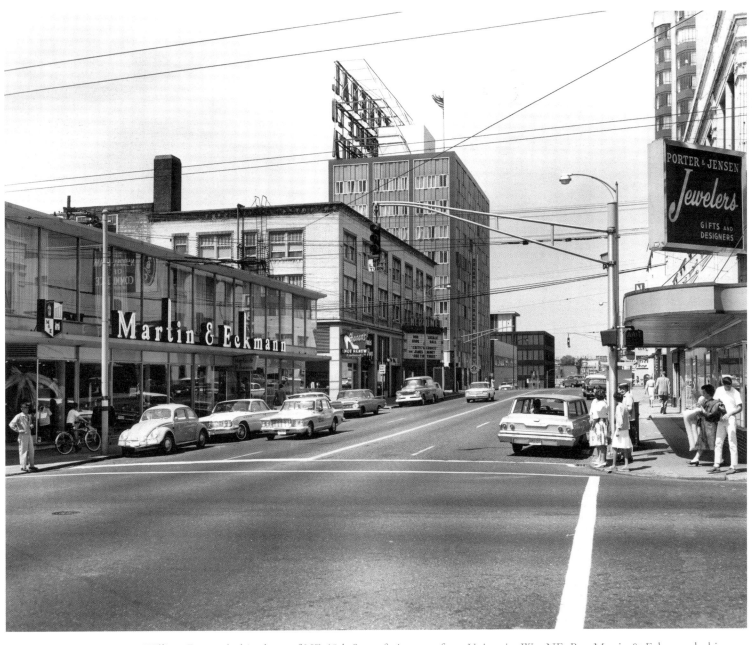

William Eng took this photo of NE 45th Street facing west from University Way NE. Past Martin & Eckman clothiers on the left is the Neptune Theater.

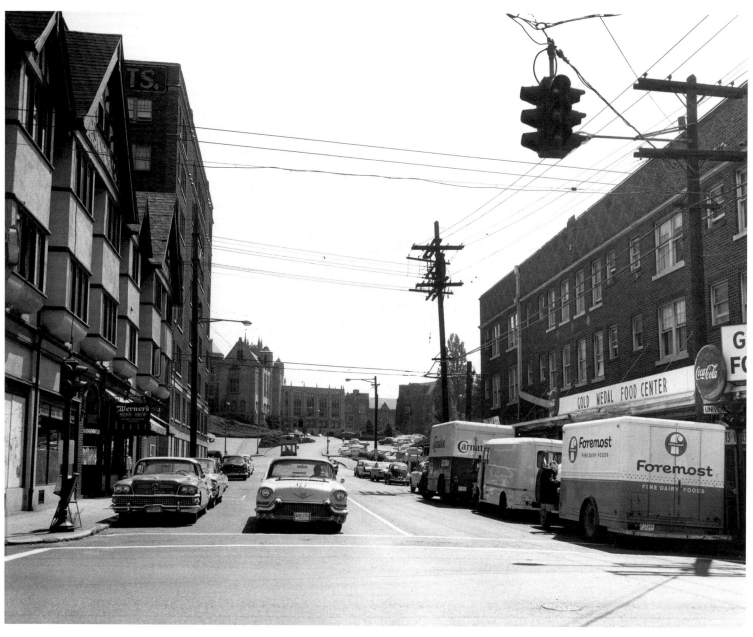

This 1963 view east on NE 40th Street includes the College Inn, a hotel and cafe that dated from the 1909 Alaska-Yukon-Pacific Exposition. On the right, the Gold Medal Food Center receives dairy products from competing suppliers. Up the street is one entrance to the University of Washington and the Administration Building (later Gerberding Hall). In 2010, the College Inn still operated a hotel and a pub.

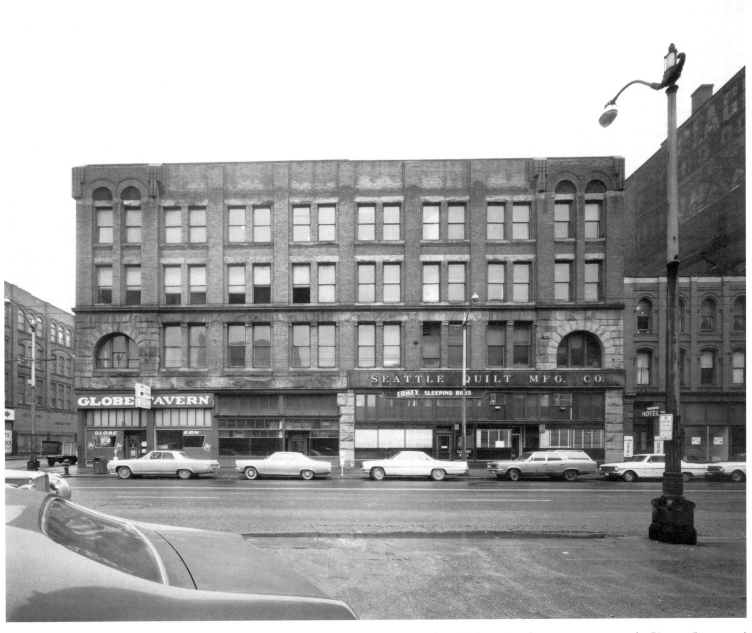

In 1969, University of Washington professor of architecture Victor Steinbrueck championed movements to save the Pioneer Square and Pike Place Market neighborhoods from redevelopment. His work led to ballot measures that preempted plans for demolition. As part of his work he took this photo of the 1905 Marshal Walker Building on First Avenue S, commonly known as the Globe Building or the Seattle Quilt Building. Steinbrueck saved the building, which would become a historic site.

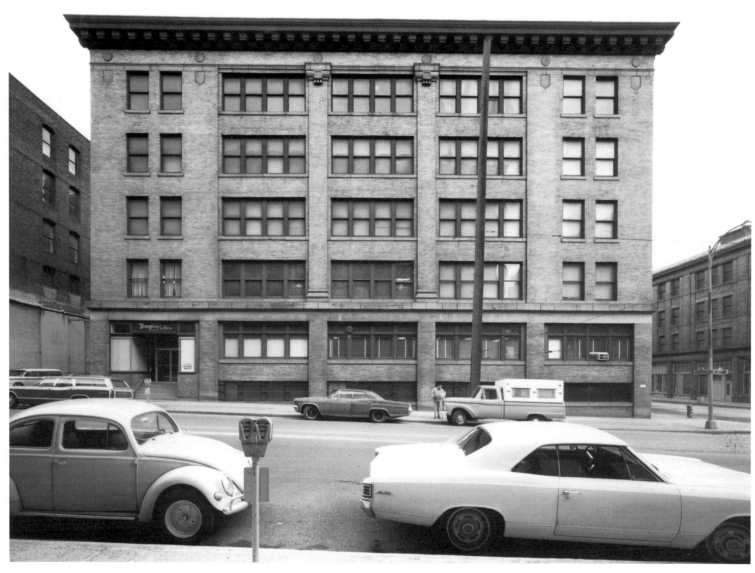

The Hambach Building at 419 First Avenue S in Pioneer Square was built as a warehouse for plumbing and heating wholesaler Albert Hambach. During its life it served as a motion picture theater, a carpentry shop, and a harness shop. In 1969, preservationist and architect Victor Steinbrueck took this photo as part of his effort to spare the neighborhood from the wrecking ball.

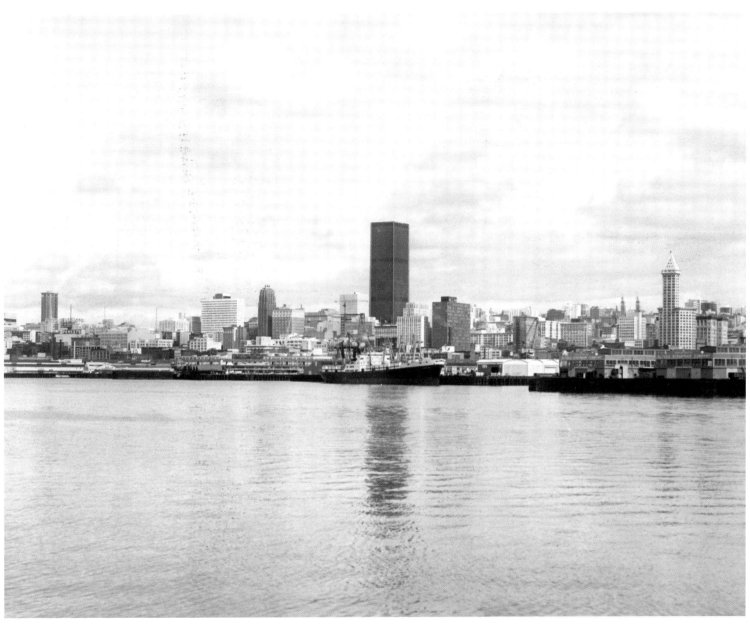

In 1968, the Seattle First National Bank completed its headquarters on Fourth Avenue downtown. The structure ended the Smith Tower's 54-year reign as the tallest building in Seattle. The roof featured a landing pad for helicopters. Its stark nature proved controversial, but subsequent projects would dwarf this one. Cab drivers told visitors it was "the box the Space Needle came in."

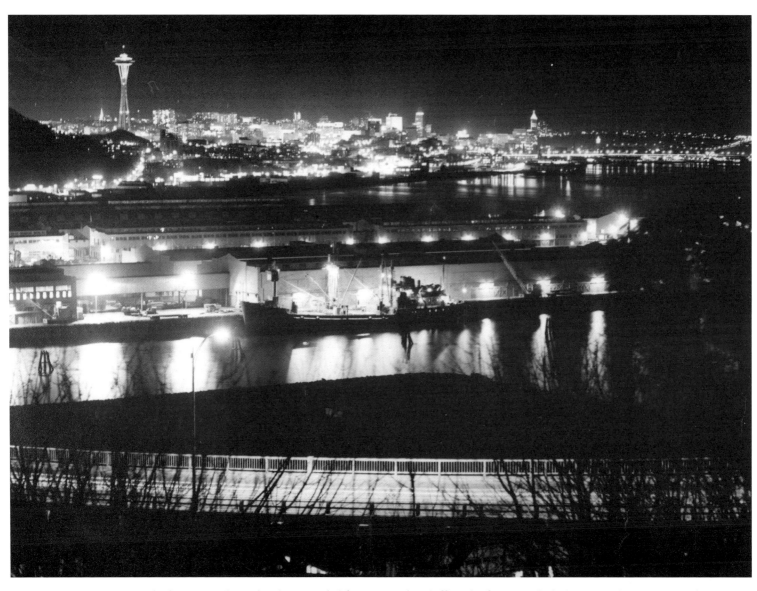

Seattle shines at night in this shot recorded from Magnolia Bluff. In the foreground, the U.S. Navy's Pier 91 complex moors a freighter. The presence of the Space Needle but absence of the Seattle First National Bank tower dates this view to sometime within the years 1962 to 1966.

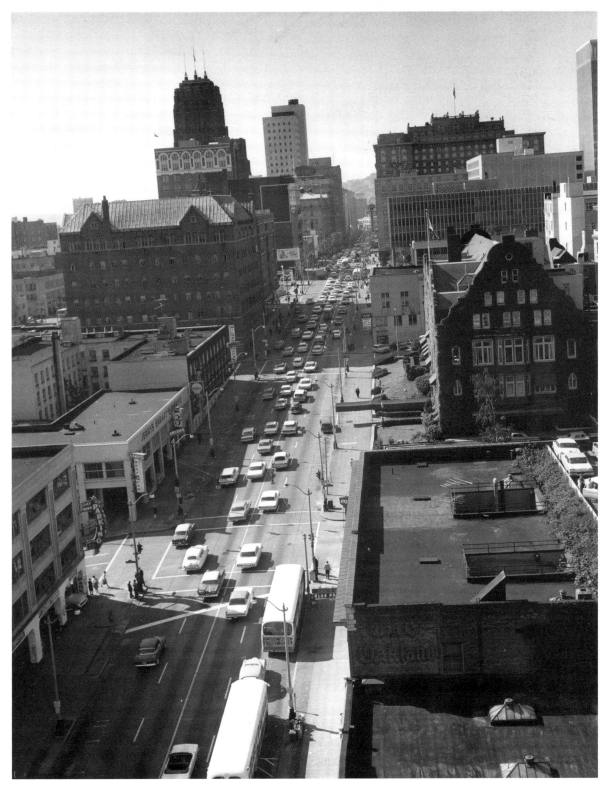

Seattle Engineering Department photographer William Dahl called this 1964 view up Fourth Avenue "Heart of Seattle." The canopied entrance and gabled roof of the Rainier Club are visible at right and the Seattle Public Library and the Olympic Hotel are farther up the street on the same side.

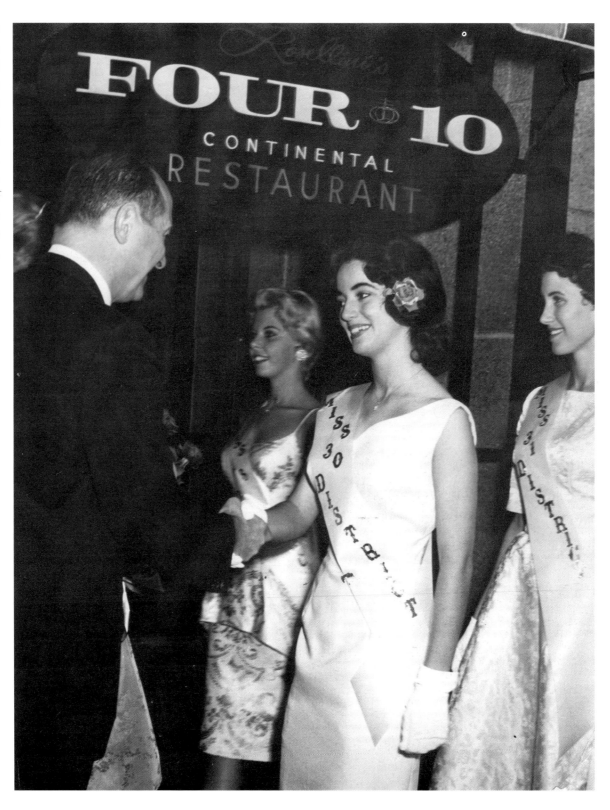

Beauty contestants representing Democratic legislative districts are greeted by Washington governor Albert D. Rosellini in 1964 at Rosellini's Four 10 restaurant (owned by the governor's brother Victor). Albert and Victor grew up in the Italian community of the Rainier Valley, giving that neighborhood the nickname Garlic Gulch.

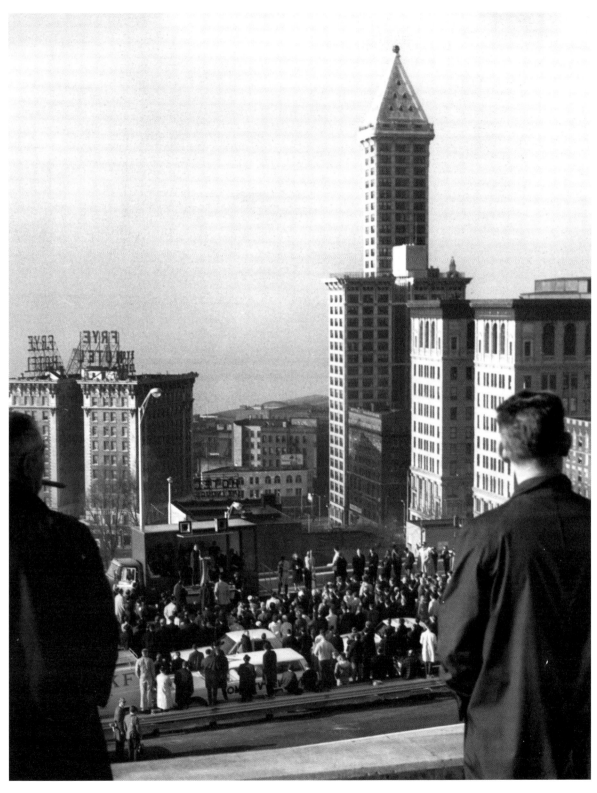

Interstate 5 first started chewing its way through Seattle in the late 1950s as the State Department of Highways bought up more than 4,500 parcels of land for the 20.5-mile right-of-way. The Seattle-to-Everett link was completed in 1965. The dedication ceremony here on January 31, 1967, marks the opening of the link through to Tacoma. Interstate 5 would contribute to the economic growth of Seattle as much as the railroads and the waterfront.

The space race pulled Seattle into the technological revolution and Boeing had the lead. Here Dr. Irving Streimer uses a metabolism recorder on a dummy to test tiny instrumentation no larger than a wristwatch to monitor human reactions to space travel. Dr. Streimer's work resulted in several devices to help save the lives of patients suffering heart attacks.

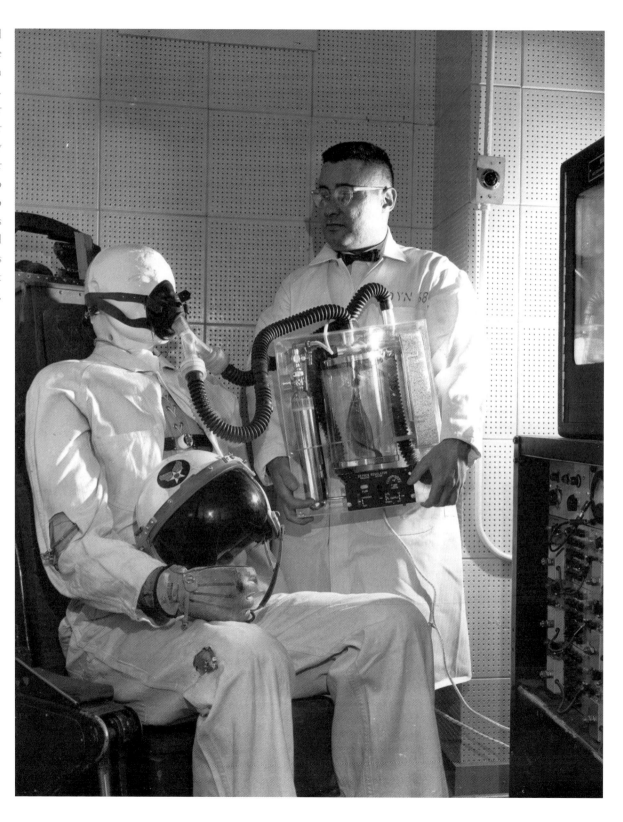

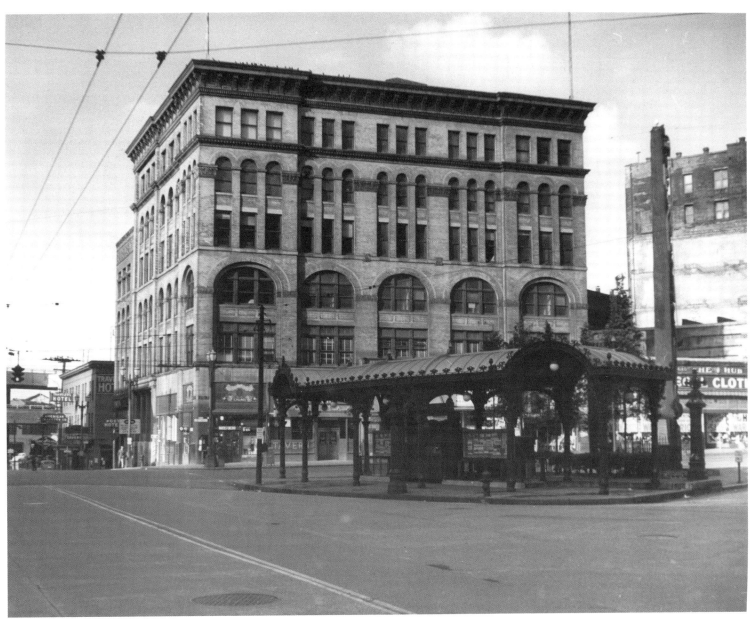

The Mutual Life Building, also called the Yesler Building, was one of three commissioned by Seattle pioneer Henry Yesler in 1890 with a design by Elmer Fisher. In front are the cast-iron pergola and a totem pole in the triangular Pioneer Place Park at the corner of First Avenue and Yesler Way. By the 1960s, the neighborhood had become rather seedy with low-rent hotels and taverns.

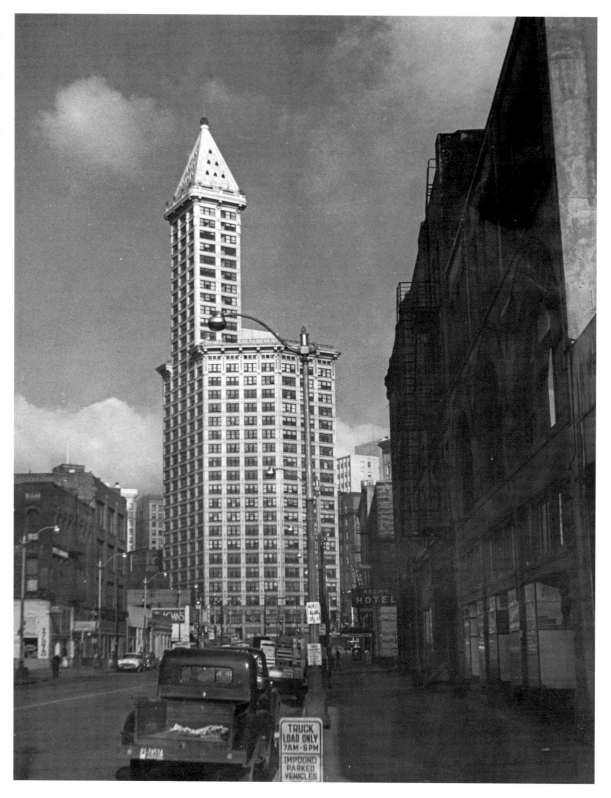

The Smith Tower, around 1960, in the last years as the tallest building in Seattle. Originally the 36-story building had 1,400 doors, 2,000 windows, and 40,000 feet of moldings. Attendants operated the elevators. Restaurateur Ivar Haglund would buy the building in 1976, because he always liked it.

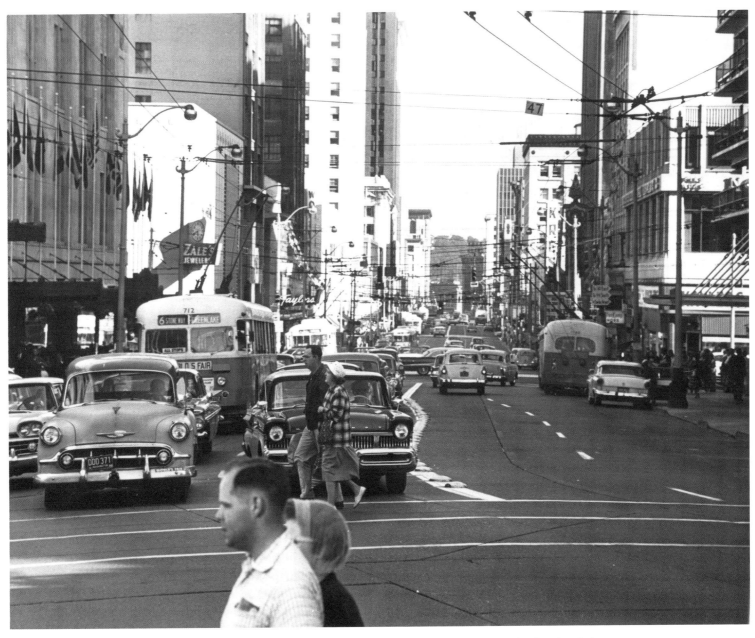

At 5:40 P.M. in August 1962, photographer Phil Webber stopped in a crosswalk on Third Avenue to take this shot facing south from Stewart Street. When city engineers converted downtown streets to one-way in 1955, Third Avenue was left two-way as a transit corridor.

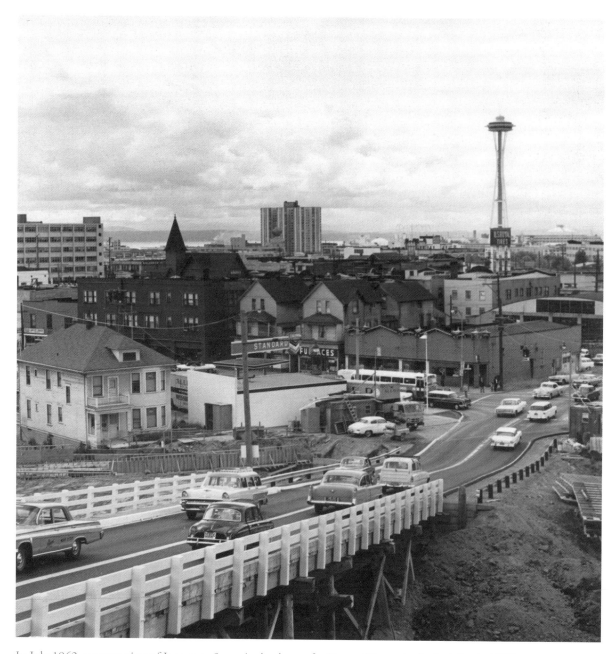

In July 1962, construction of Interstate 5 required a detour for Denny Way as it climbed Capitol Hill. This view faces west toward the brand-new Space Needle and Coliseum on the grounds of the Century 21 World's Fair.

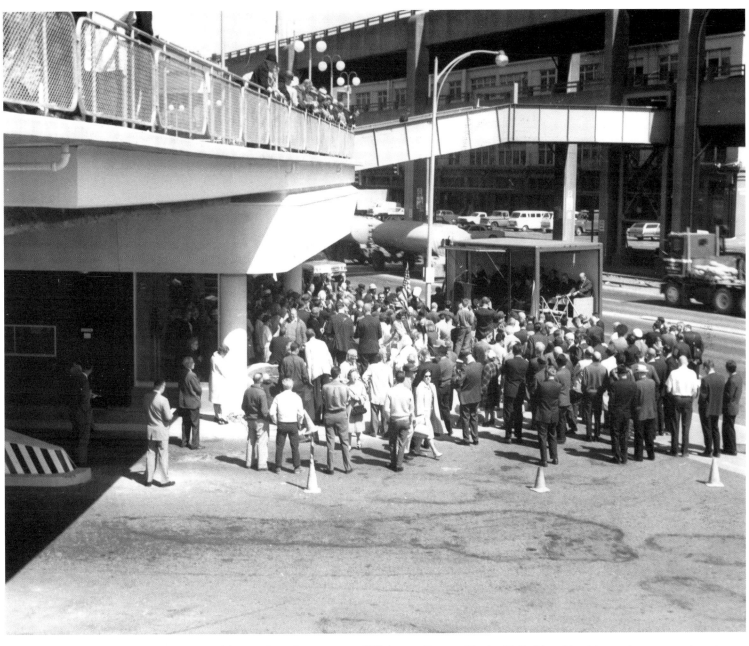

On May 18, 1966, Washington State Department of Highways director Charles G. Prahl and banking and transportation pioneer Joshua Green dedicate the new state ferry terminal at the Colman Ferry Dock. The State purchased the ferry system from Captain Alexander Peabody's Puget Sound Navigation Company—the Black Ball Line—after widespread dissatisfaction with Peabody's practices, which were labeled monopolistic. Joshua Green helped found the Black Ball Line in 1903.

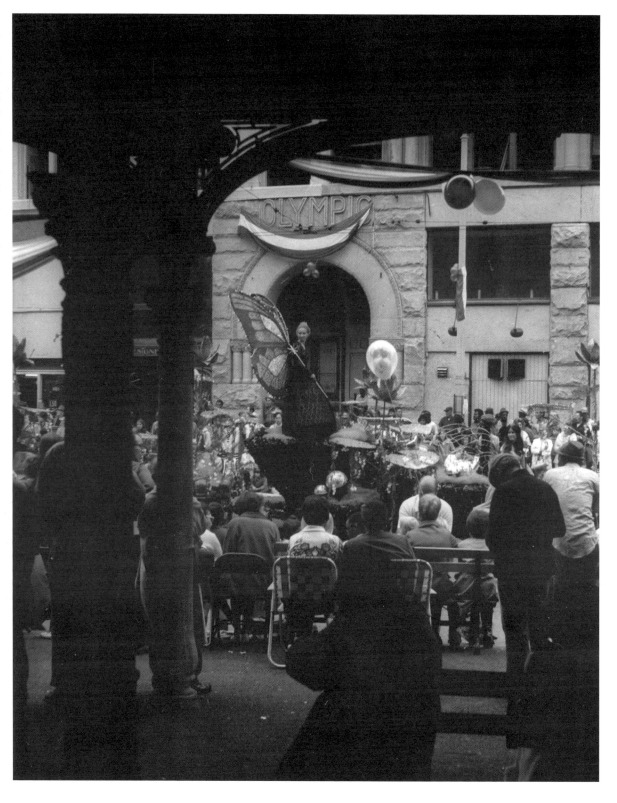

The Seafair parade through Pioneer Square one summer in the 1960s included this float, featuring a beauty dressed as a butterfly waving a star-topped wand. The Olympic Block on First Avenue was built after the Great Fire of 1889 and housed the Northern Pacific Railroad ticket office and Cooper and Levy outfitters. It would be demolished in the 1970s.

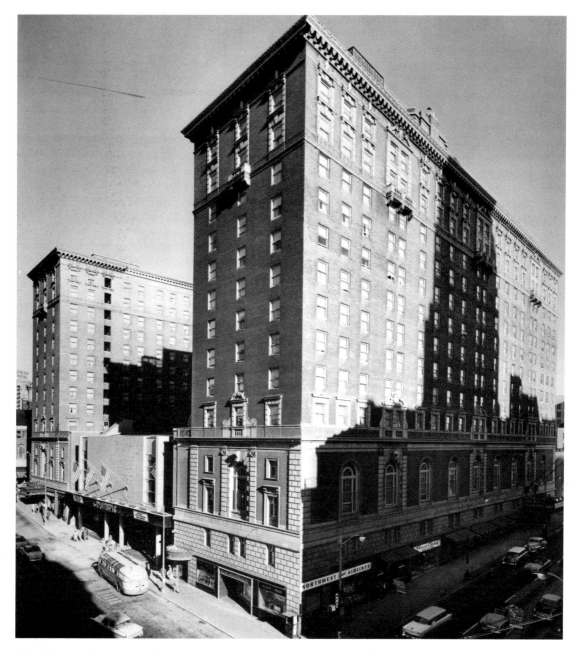

The Olympic Hotel opened in 1924 and immediately became Seattle's leading hostelry and celebration venue. The building sits on part of the site of the original University of Washington built in 1861. The university regents retained ownership of the land, which they leased to the hotel's owners. The hotel was originally built around the existing Metropolitan Theater, which was removed in 1955 to be replaced with a circular drive for automobiles dropping off hotel guests.

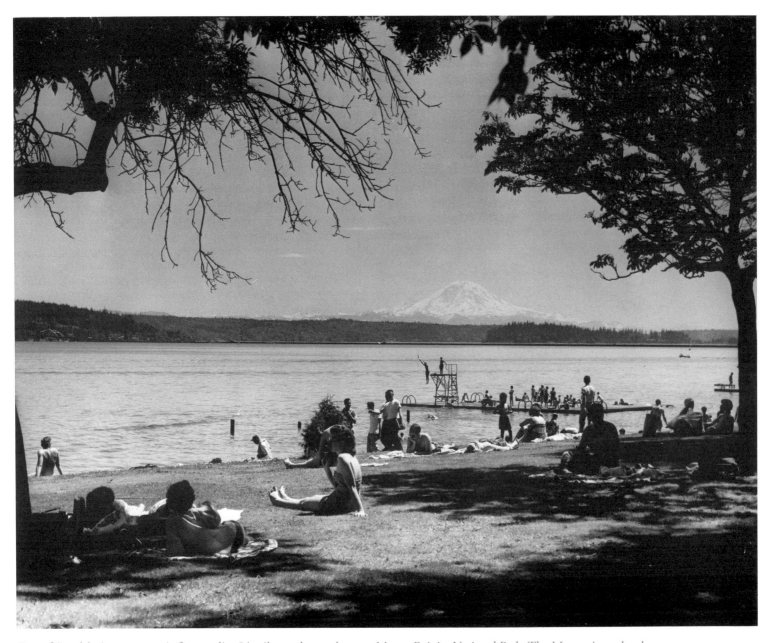

One of Seattle's signature scenic features lies 54 miles to the southeast at Mount Rainier National Park. The Mountain, as locals refer to it, was called Tahoma by Native Americans, but the name given by British explorer George Vancouver was the one that stuck. This view from Madrona Beach on Lake Washington shows how Seattleites of the 1960s enjoyed summers.

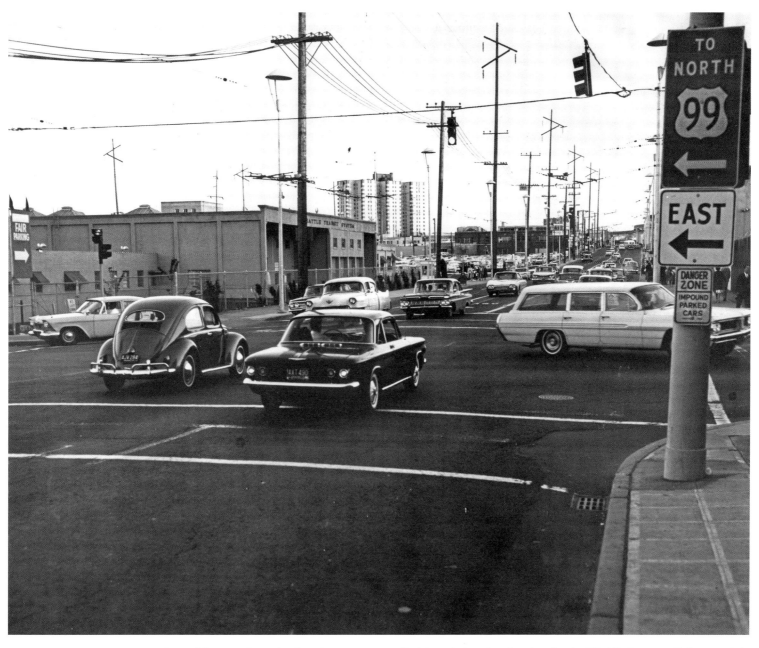

One of the complaints by the advocacy group Allied Arts during the planning for the World's Fair was all the unsightly wires and utility poles. Seattle City Light opposed placing the utilities underground in the firm belief that rate payers should not fund something simply for its beauty. Allied Arts won. This is Fifth Avenue and Mercer Street where the Bill and Melinda Gates Foundation is to make its home in 2011.

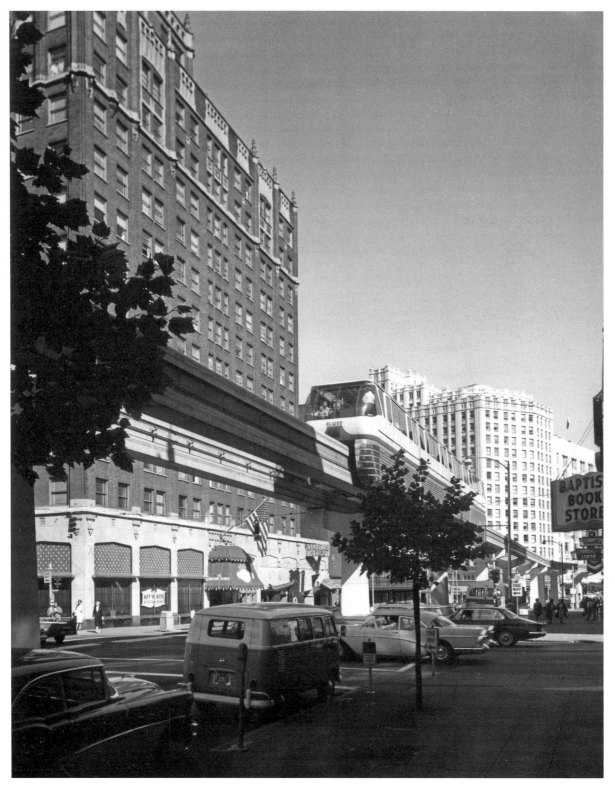

The Monorail started running from downtown to the site of the Century 21 World's Fair along Fifth Avenue just two days before the fair opened. Here it passes in front of the Benjamin Franklin Hotel, which would be demolished in 1980.

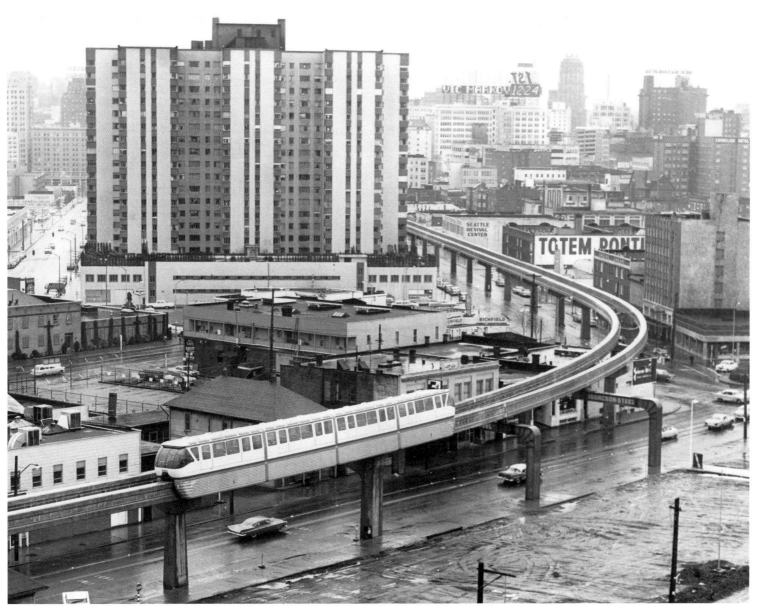

As the Monorail crossed Denny Way approaching the Century 21 World's Fair, it took a curve up Fifth Avenue past the Grosvenor House apartments and the Denny Triangle.

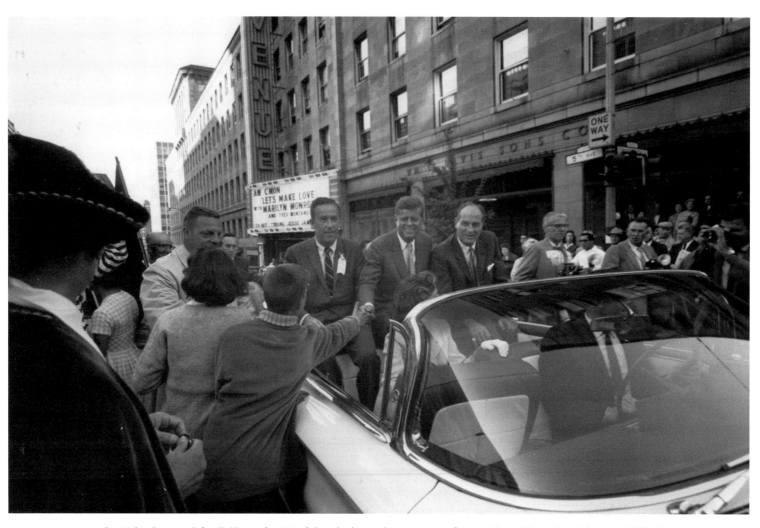

In 1960, Senator John F. Kennedy visited Seattle during his campaign for president. He took a ride down Fifth Avenue in an open car with fellow Democrats U.S. Senator Henry M. "Scoop" Jackson (left) and Governor Albert Rosellini (right). Kennedy and Rosellini both won their races, but Kennedy's opponent Richard Nixon carried the state of Washington. At the theater down the street, Marilyn Monroe was starring in the 1960 musical comedy *Let's Make Love*.

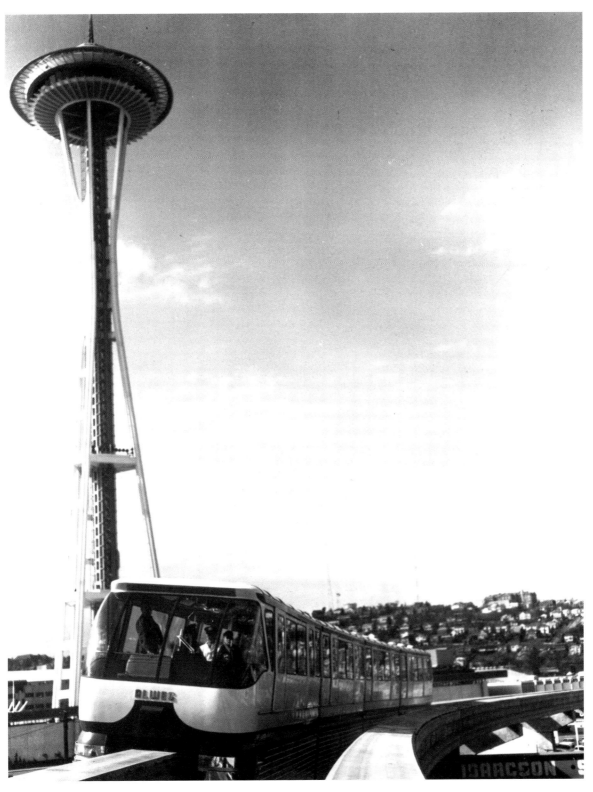

This classic image of the 1962 World's Fair was taken in 1964 after the fair closed and when Seattle accepted the grounds and improvements as the Seattle Center. Tourists continue to visit the site to attend cultural events, to ride the Monorail, to visit the Gayway amusement area, and just to enjoy the experience. In the distance atop Queen Anne Hill is Queen Anne High School.

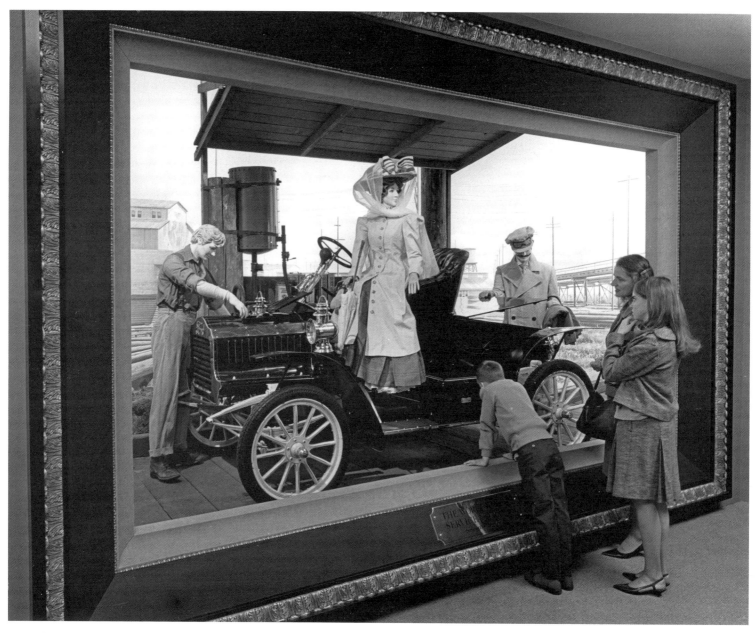

One of the exhibits from the World's Fair related not to the future, but to the past. In "The World of Oil," Seattle claimed credit for the first service station, a retail outlet where gasoline was dispensed directly to automobiles from dedicated storage tanks through calibrated measuring devices. The fueling system was built by John McLean of the Standard Oil Company at Holgate Street and Western Avenue in 1907.

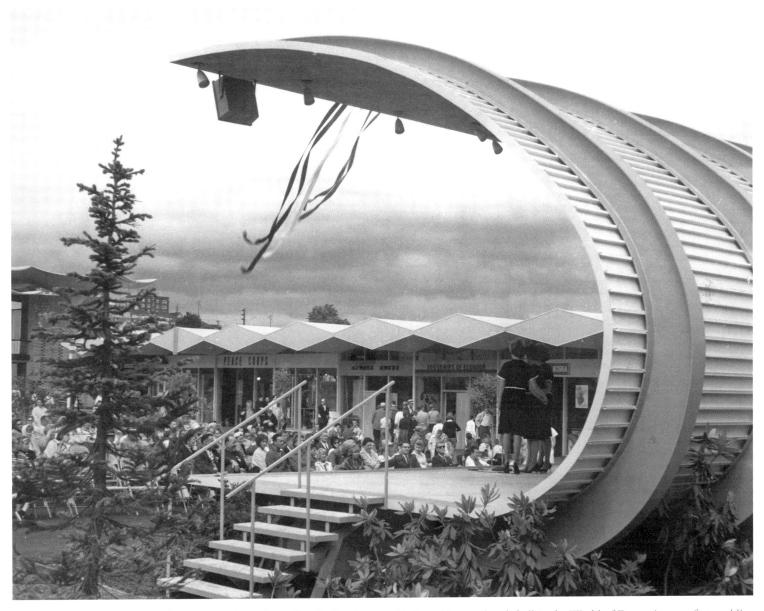

During the 1962 World's Fair—officially the Century 21 Exposition—a band shell in the World of Entertainment featured live performers like these three women. After the fair closed, the fairgrounds became the Seattle Center and the buildings and grounds became entertainment locations for annual events like Bumbershoot and the Folklife Festival.

The Space Needle started as a sketch on a napkin by Seattle businessman Eddie Carlson, who chaired the World's Fair Commission. He imagined a tower to symbolize the theme of the fair, looking forward to the future. John Graham, Jr.'s 605-foot-tall design included an observation platform and a revolving restaurant at the top. This 1962 view looks west past Pier 91 and off toward the Olympic Mountains.

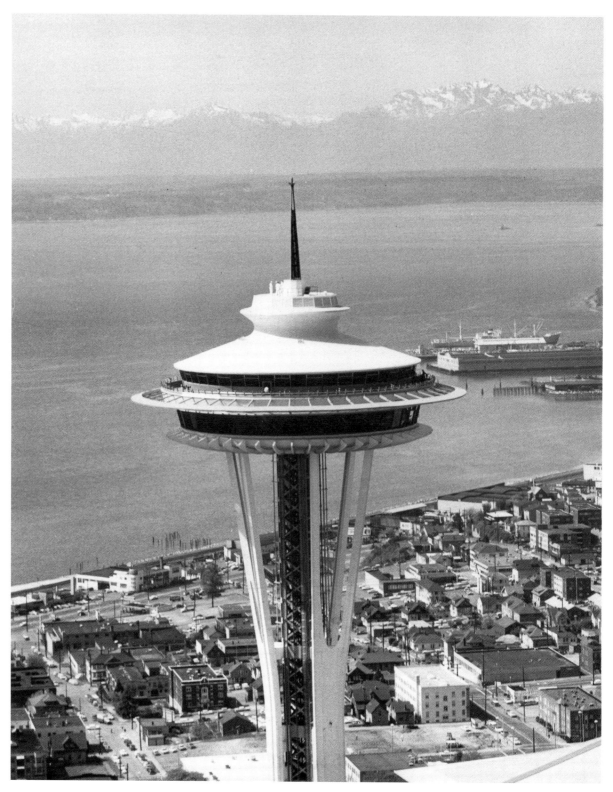

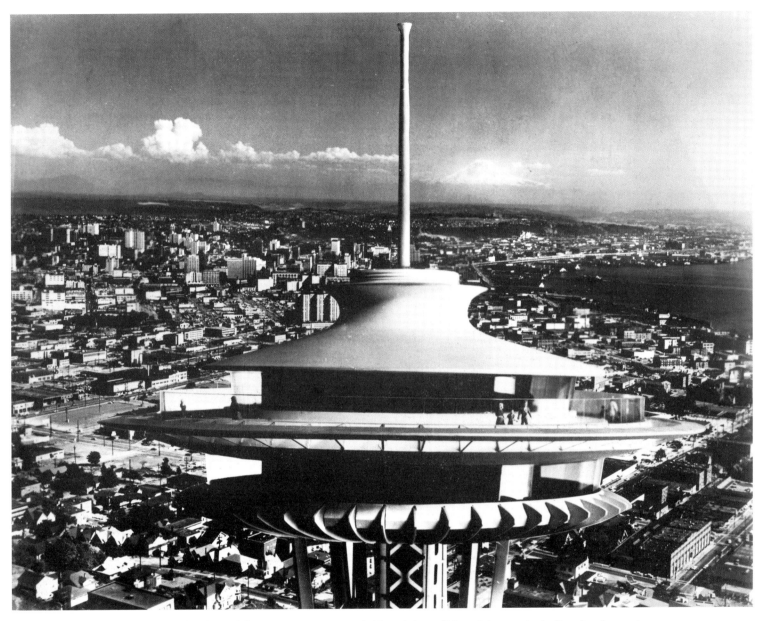

Before the Space Needle was completed, World's Fair promoters pasted this artist's rendition of the top, including the observation deck and the revolving restaurant, against an image of the Seattle skyline. Mount Rainier, the other most-recognizable image of the region, looms in the distance.

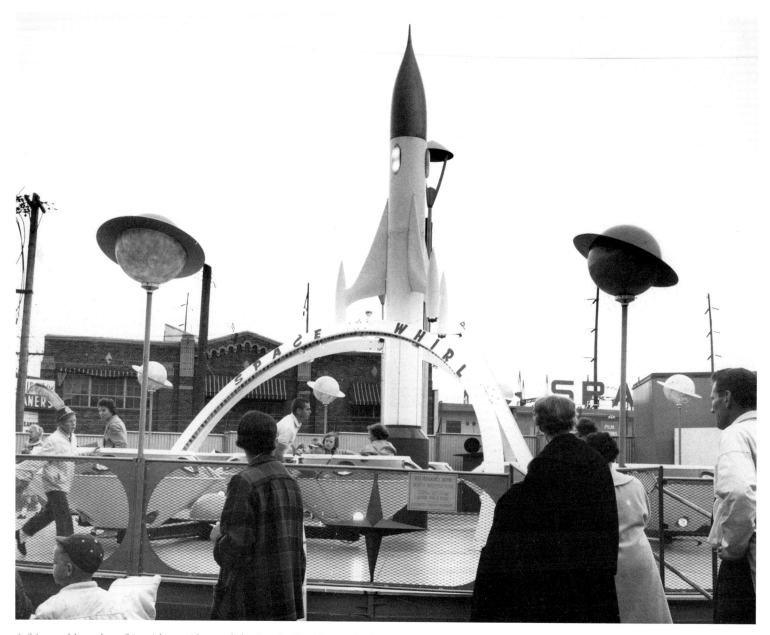

A fair would not be a fair without rides, and the Seattle World's Fair had them at the Gayway. In keeping with its futuristic theme, the Space Whirl thrilled young fair goers. The Food Circus, into which the National Guard Armory was converted, is visible in the background. After the fair closed, the rides would remain as the Fun Forest.

"What Are the Odds" taught young patrons of the 1962 World's Fair about probability. The interactive exhibit in the Junior Laboratory of Science at the U.S. Science Pavilion had visitors throw poker chips onto a table that was predominantly white. Three out of four times a chip would touch black. The Science Exhibit would become the Pacific Science Center and would continue this tradition of hands-on learning.

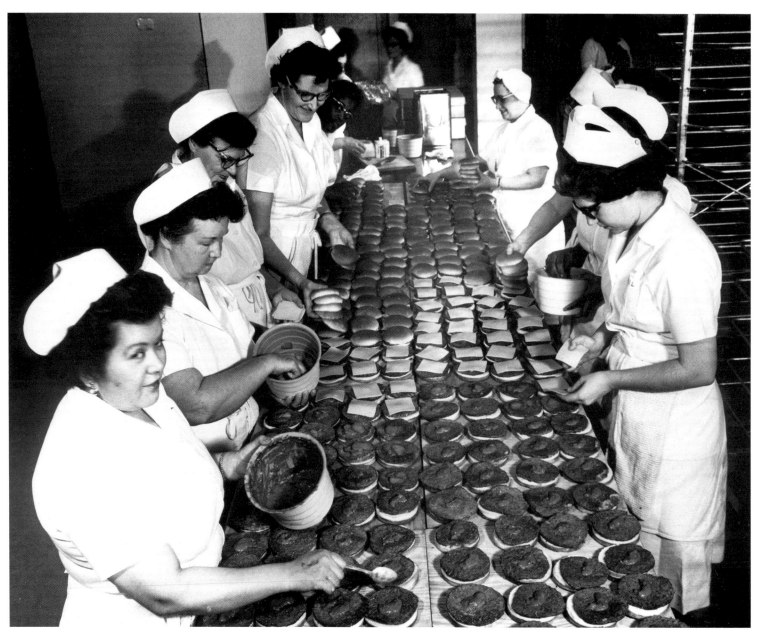

Visitors to the World's Fair must eat, and hamburgers, with and without cheese, were part of the fare. Here employees of Centuria food vendors mass-produce burgers most likely destined for the Food Circus. Fair planners converted the National Guard Armory into an immense dining hall with 52 food vendors around the edge. The same family could dine at one table with American, Chinese, Mexican, or other foods.

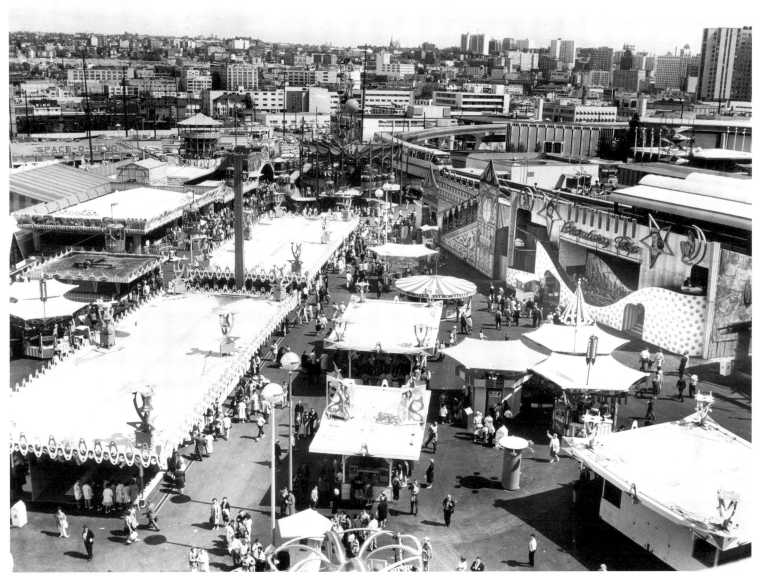

This view of the Gayway at the World's Fair shows the Shooter, the Skyride, the Broadway Trip, and the Monorail to downtown. There were 20 rides in the Gayway assembled by two veteran amusement park operators at a cost of $2 million. The Gayway would become the Fun Forest after the fair closed and would remain in operation until 2009.

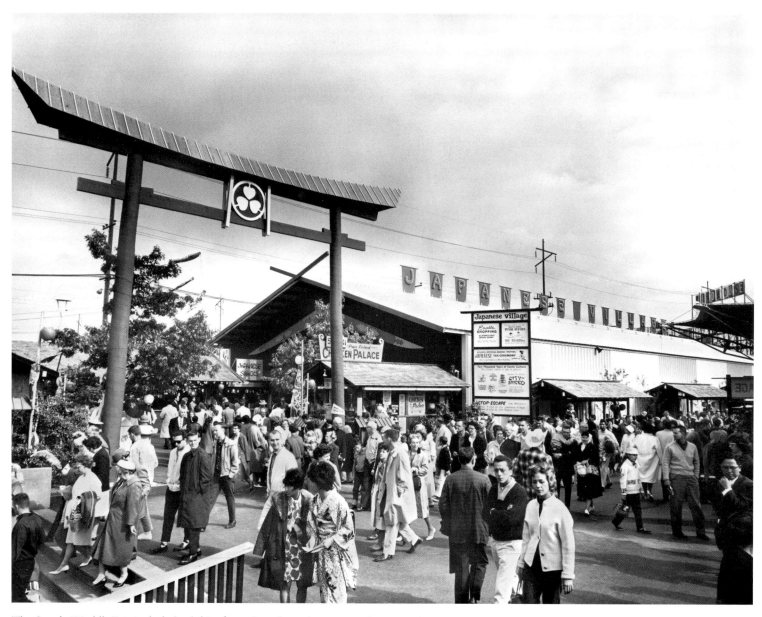

The Seattle World's Fair included exhibits from Canada, India, Japan, China, Sweden, France, and the United Arab Republic (Egypt and Syria) as well as from U.S. corporations. Here the Japanese Village provides authentic decor and cuisine for visitors near the Gayway and the Hawaiian Pavilion. Inside, pearl harvesters dive for real pearls.

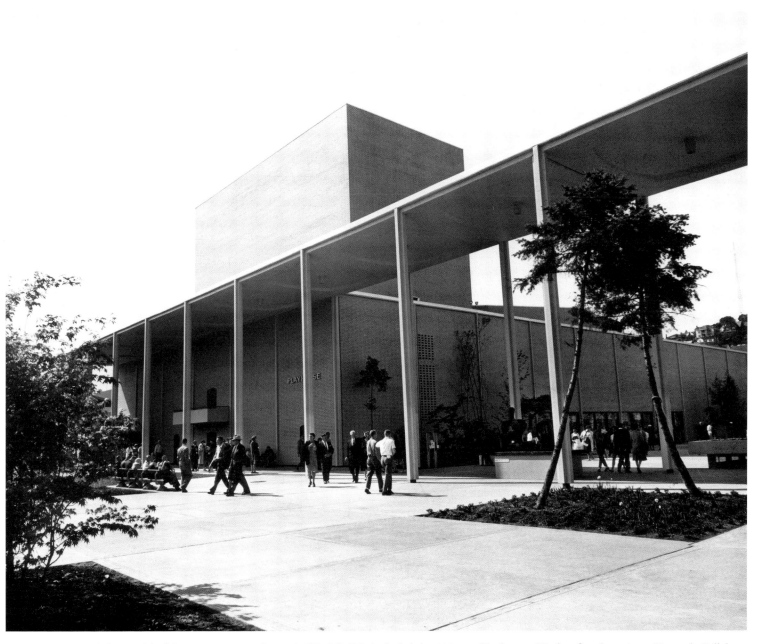

The World of Entertainment at the 1962 World's Fair included the 800-seat Playhouse. Works of art by painter Kenneth Callahan, sculptor James Fitzgerald, sculptor Philip McCracken, and painter Margaret Tomkins decorated the entrance and the interior. After the fair it would become the Seattle Repertory Theater and later the Intiman Theater.

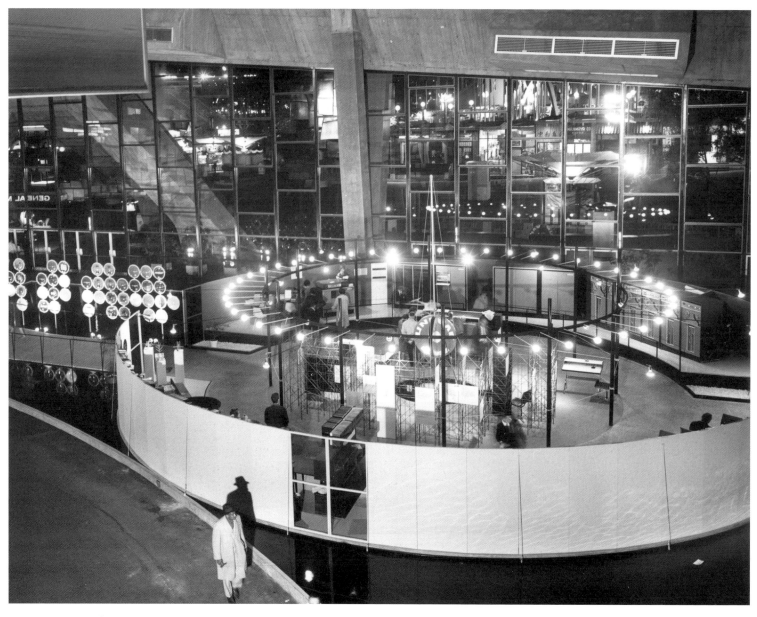

The American Library Association's exhibit at the Seattle World's Fair included a circular section with a Univac computer. A librarian took visitors' questions about famous quotations, biographies, and geography and extracted answers from the computer. In a 40-seat theater, a film described a means of storing information from the past called microfilm.

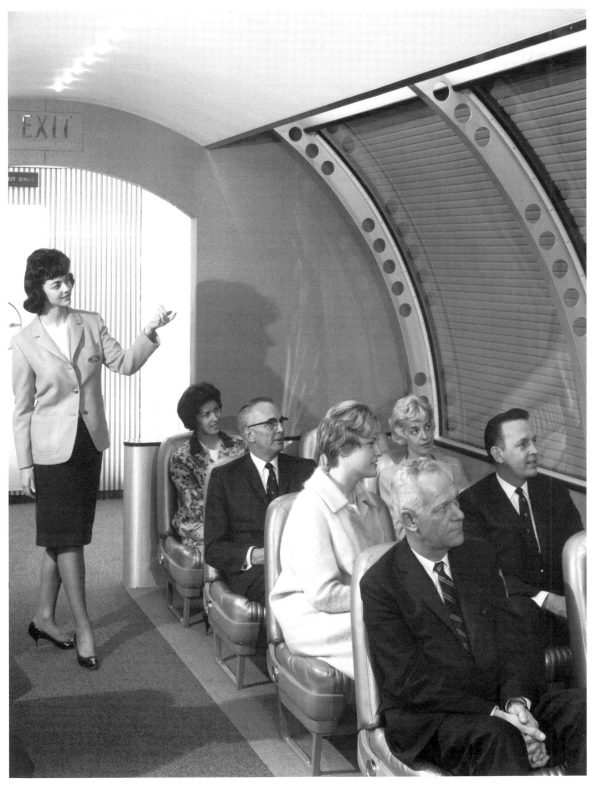

At the 1962 World's Fair, the Ford Motor Company presented "An Adventure in Outer Space" in which visitors experienced a simulated space journey. In 15 minutes, one hundred travelers at a time saw Earth, the moon, Saturn, Mars, and distant galaxies. A stewardess explained the preflight sounds of fueling and cabin pressurization.

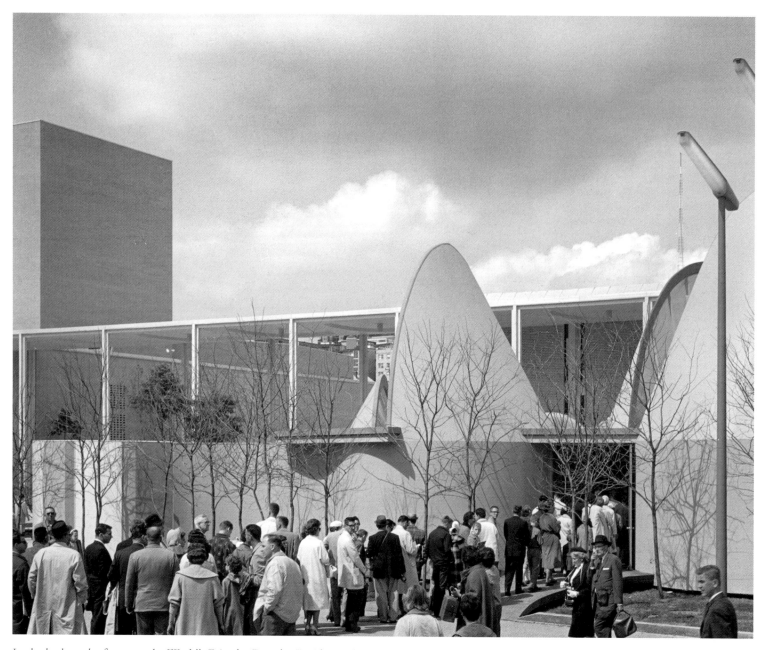

In the look to the future at the World's Fair, the Douglas Fir Plywood Association dramatized the potentials of innovative wood products in The Home of Living Light for Tomorrow. Wood paneling constructed like corrugated cardboard provided strength in one direction and flexibility in another. The exhibit stood on Freedom Way at the north end of Boulevards of the World. Boulevards was the shopping mall surrounding the International Fountain.

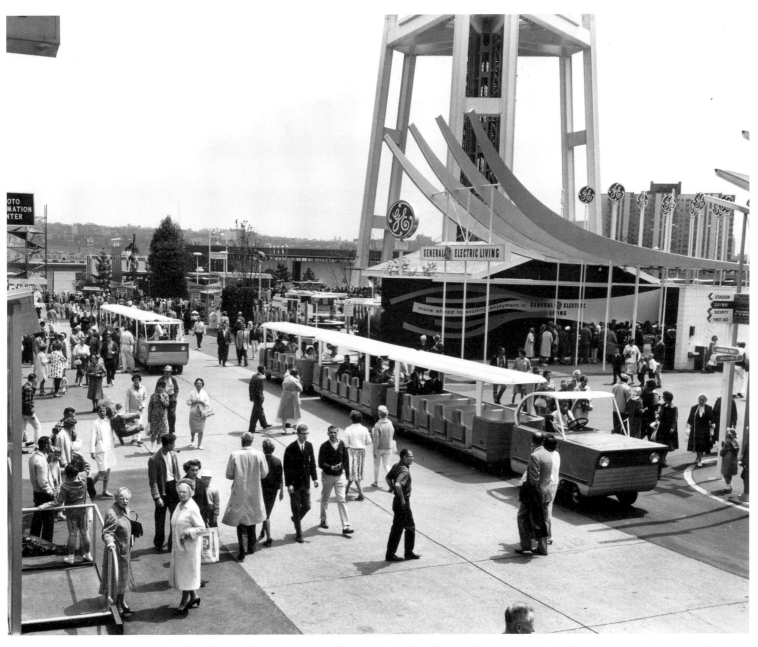
Visitors to the 1962 World's Fair did not have to walk everywhere. The Express Train was a series of rubber-tired shuttles that circulated throughout the fairgrounds. Here two trains stop in front of the General Electric exhibit at the foot of the Space Needle.

What is a World's Fair without a Ferris wheel? At Seattle in 1962 the Giant Wheel, sometimes called the Seattle Wheel, carried 30 passengers.

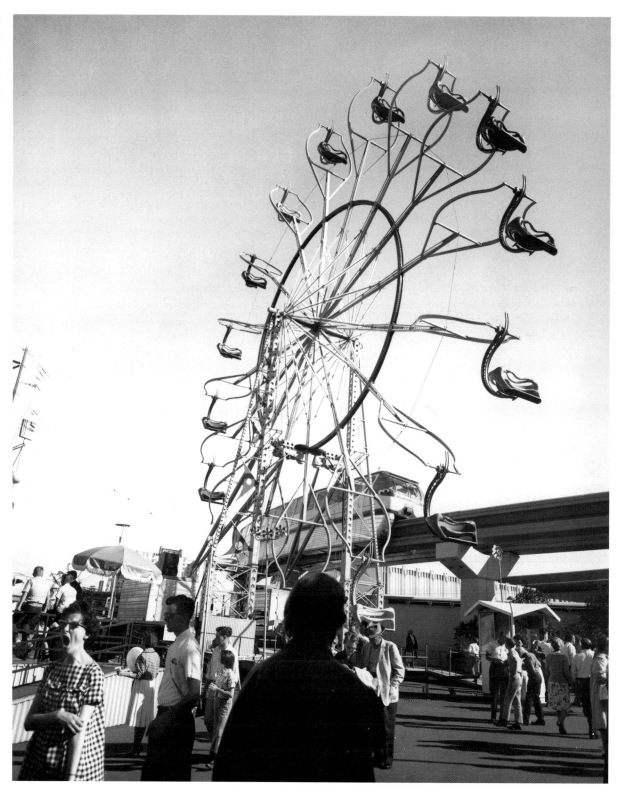

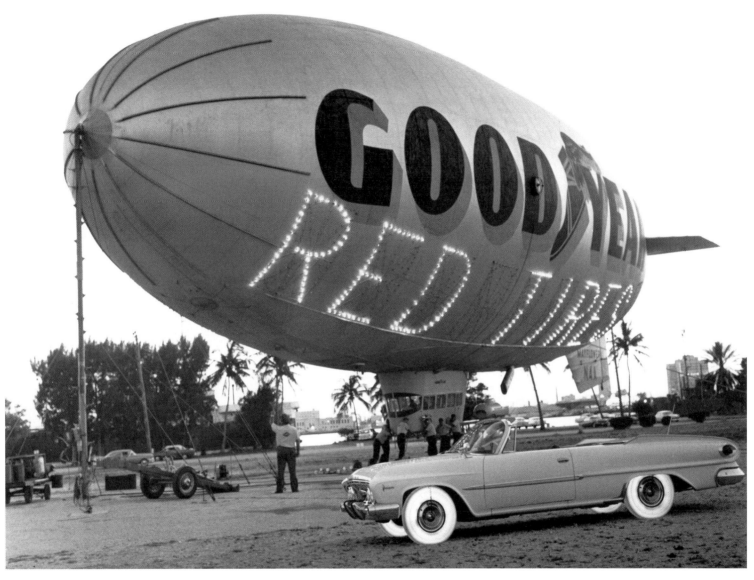

The future of automobile travel figured in the World's Fair of 1962. The Goodyear Tire and Rubber Company provided its blimp, the *Mayflower II,* with its novel electronic sign advertising a line of tires. Goodyear moored the blimp at Sea-Tac International Airport when it was not cruising overhead. Here Goodyear shows off a Dodge convertible with translucent tires.

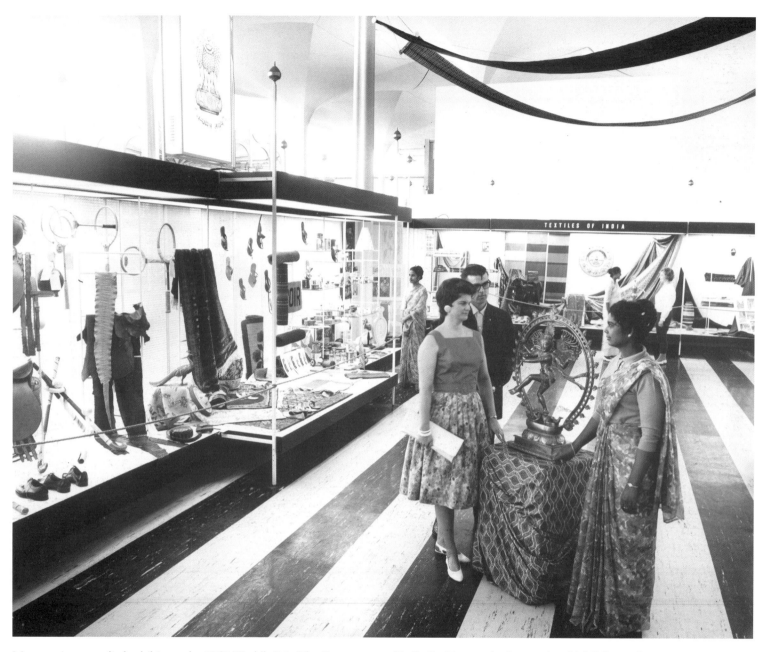

Many nations supplied exhibits to the 1962 World's Fair. The Government of India Pavilion on the International Mall featured bright, distinctive textiles readily visible through ceiling-high windows and through the wide entryways. Display cases here show off carpeting, consumer goods, and industrial goods all produced in India. Hostesses in traditional saris answer visitors' questions.

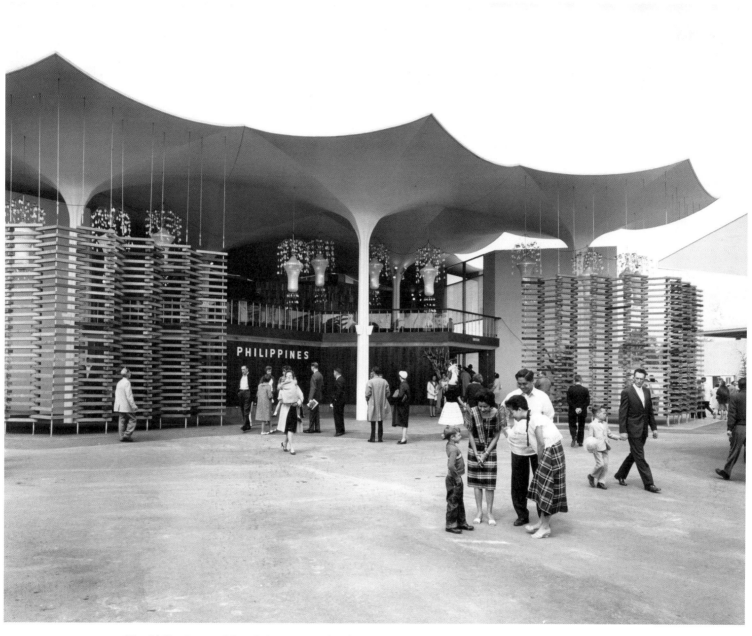

The Philippines and Seattle have enjoyed a close connection since the U.S. took control of the islands in 1899. Thousands of Filipinos immigrated to Seattle and became part of the city's diverse culture. At the north end of the World's Fair's International Mall, the Philippines Pavilion presented a portrait of the nation and its peoples. The exhibit was financed jointly by the Philippines government and Seattle's Filipino-American business community.

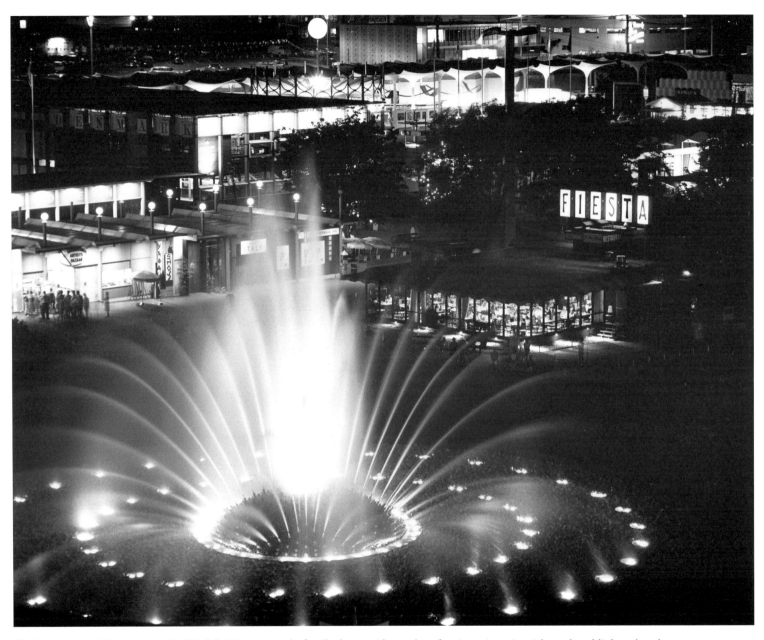

The International Fountain at the World's Fair consisted of a tile dome with nozzles of various sizes. At night, colored lights played upon the jets of water, which changed their patterns. The fountain would become a magnet for families in the coming years as the display was combined with music.

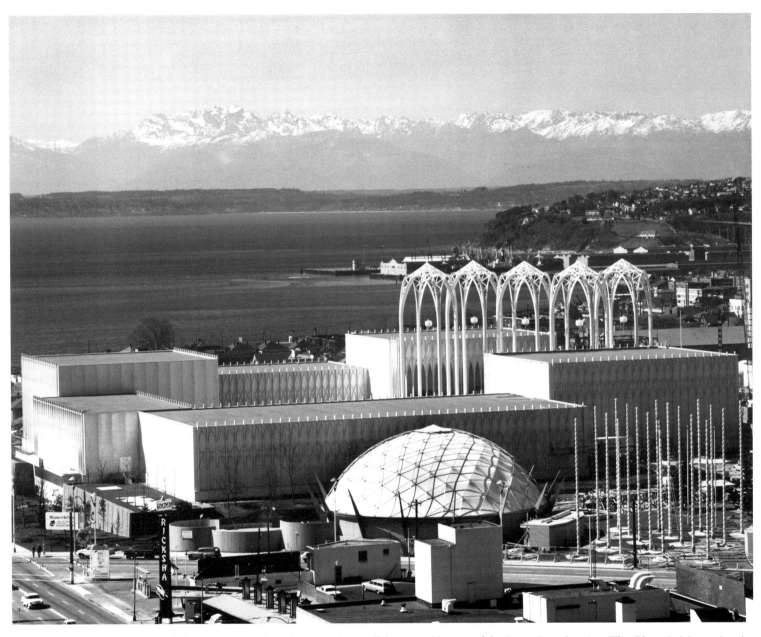

The 1962 World's Fair gave Seattle a chance to show off the natural beauty of the Puget Sound region. The Olympic Mountains rise in the distance to the west and the Cascades tower in the east. This shot over Elliott Bay shows the U.S. Science Pavilion (the future Pacific Science Center) and the Ford Motor Company Pavilion. Denny Way borders the grounds at lower-left.

The World's Fair gave Seattle's Scandinavian-American community an opportunity to honor explorer Leif Ericson. Many immigrants from Norway and Sweden settled in Ballard, home to Seattle's fishing fleet. Here in 1961, sculptor August Werner crafts a clay maquette to be transformed into a larger bronze. The statue would go to Shilshole Bay in Ballard, where the Port of Seattle was building a marina for pleasure boats.

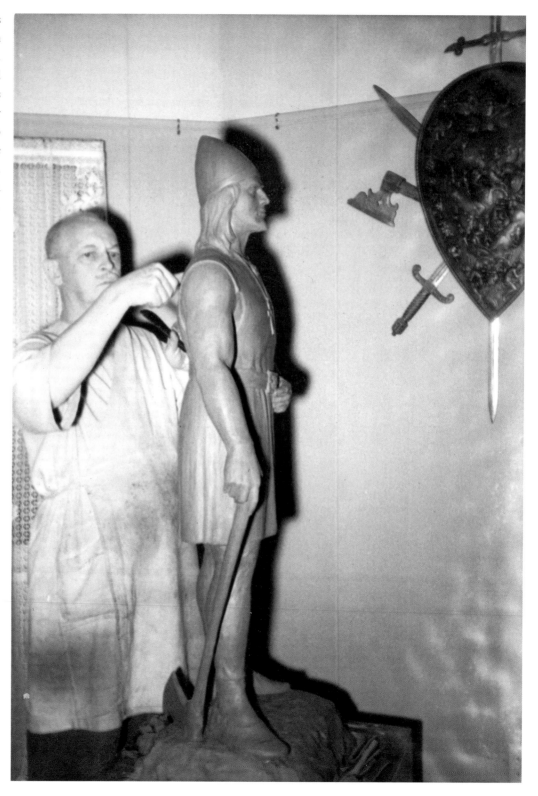

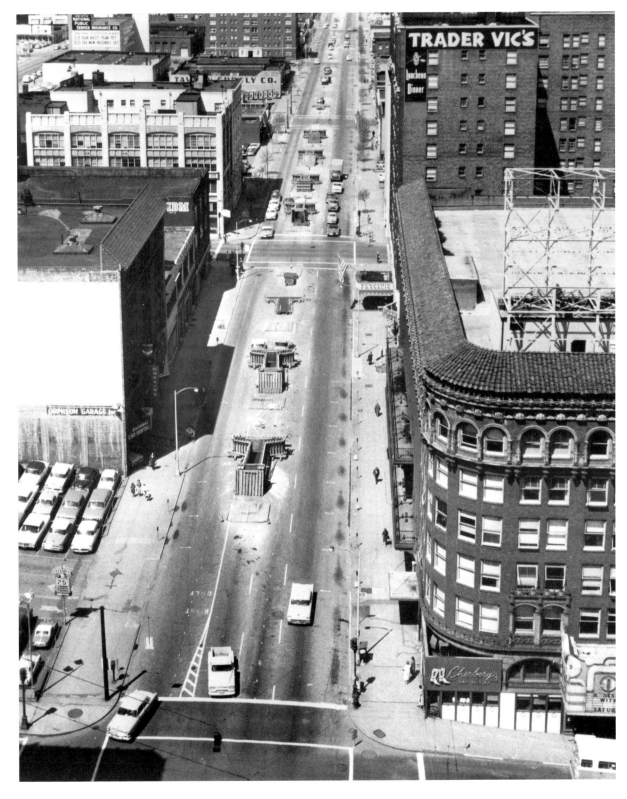

The Monorail was planned not just to show off transportation of the future, but to provide an easy connection for fair visitors between the World's Fair and the retail core of downtown Seattle. T-shaped concrete columns for the line, 85 feet apart, are shown here being built up Fifth Avenue. The Monorail and its technology would continue to operate into the twenty-first century, long after its designers and manufacturer disappeared.

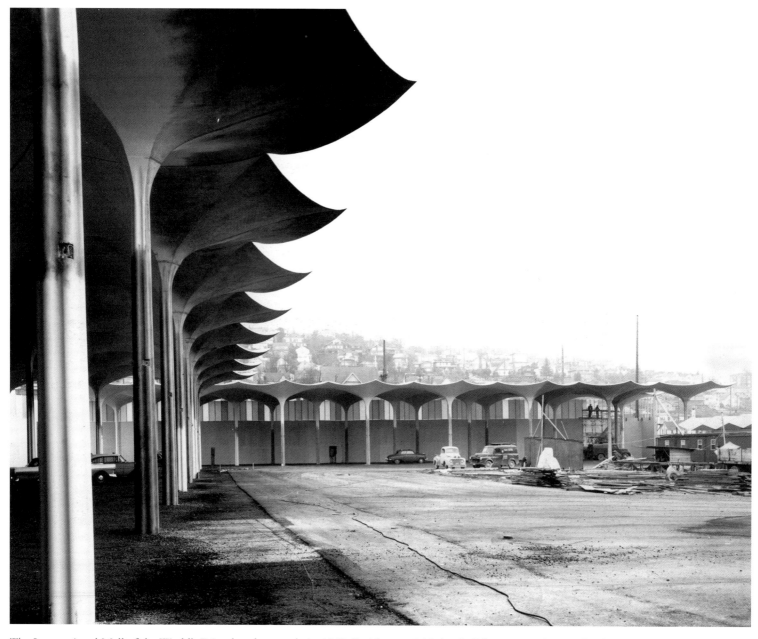

The International Mall of the World's Fair takes shape early in 1962. Residences yielded to bulldozers to make way for the fair, but the High School Memorial Stadium, the National Guard Armory, and the Civic Auditorium were incorporated into the plans. The stadium became the World of Entertainment, the armory became the Food Circus and Center House, and the auditorium became the Opera House.

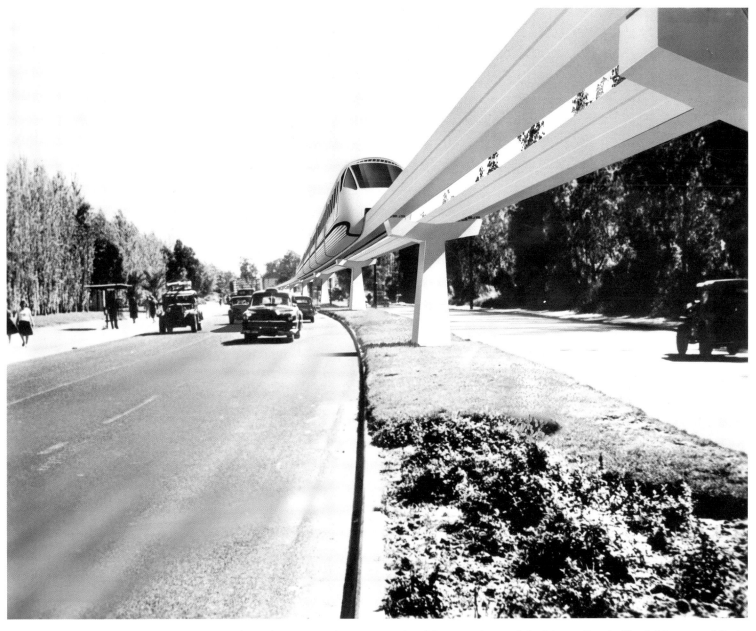

Alweg-Forschung, GmbH (Alweg Research Corporation), of Germany designed the Monorail and offered this proposal for its rubber tire mass transportation system similar to the one built in Disneyland in 1959. This particular view was labeled "Tel Aviv Proposal." Alweg licensed the technology to Hitachi, which built more monorails around the world.

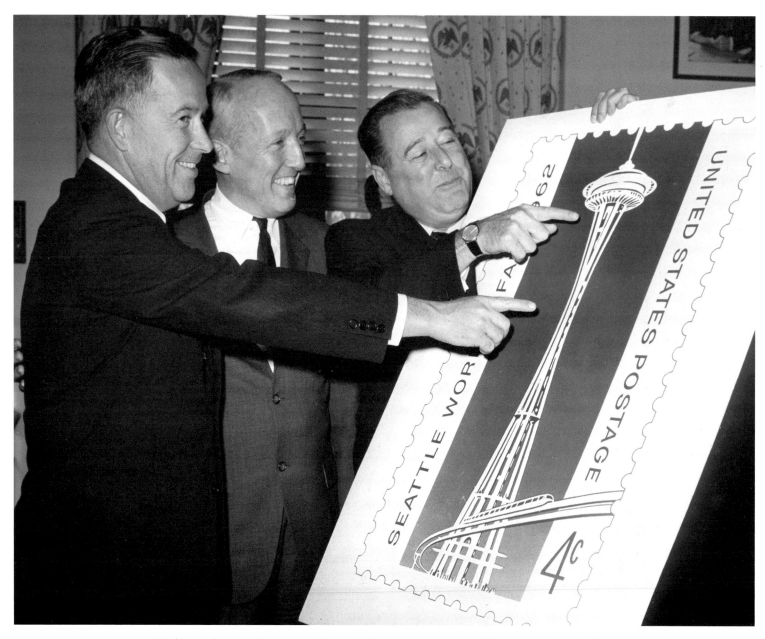

Washington's two U.S. senators, Warren G. Magnuson (right) and Henry M. Jackson (left) point to a U.S. postage stamp commemorating the 1962 World's Fair. "Maggie" and "Scoop" were beginning to enjoy greater influence in the Senate and would provide the state of Washington with unprecedented clout into the 1970s. In 1962, a 4-cent stamp mailed a first-class letter. Just months after the fair closed and after many decades at 3 cents and 4, the rate would climb by another penny.

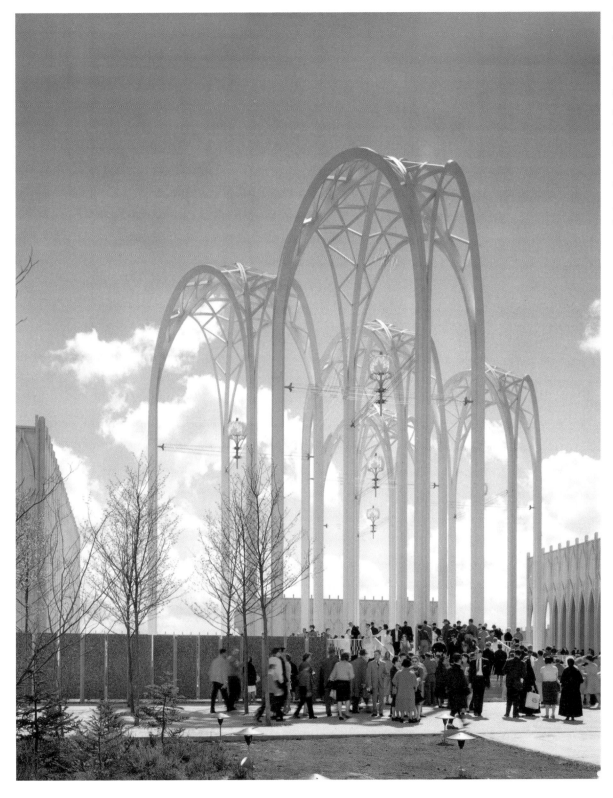

Minoru Yamasaki, who designed the World Trade Center's twin towers in New York, also designed these arches, which graced the entrance to the U.S. Science Pavilion at the World's Fair. The Science Pavilion would become the Pacific Science Center and the arches would remain as part of the Seattle Center.

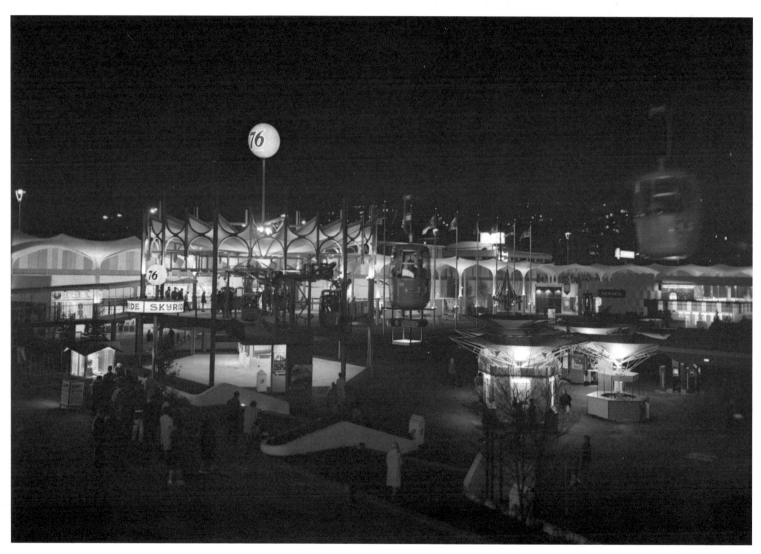

This view of the Seattle World's Fair at night includes the terminus of the Skyride, gondolas suspended from cables that crossed the fairgrounds. The Skyride would continue to carry passengers at the Seattle Center until 1980, when it was moved to the Washington State Fairgrounds in Puyallup.

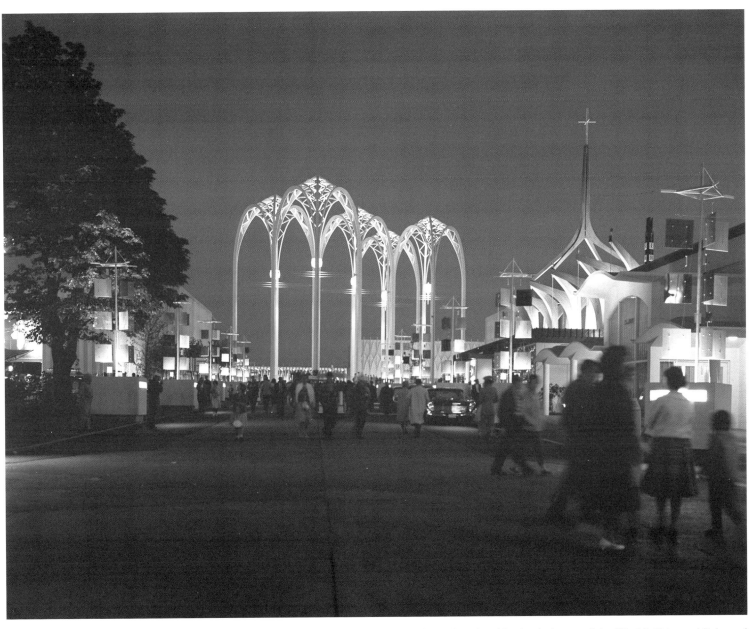

A night view of the U.S. Science Pavilion's arches shows how lavishly the designers of the World's Fair used light and cheap hydroelectric power.

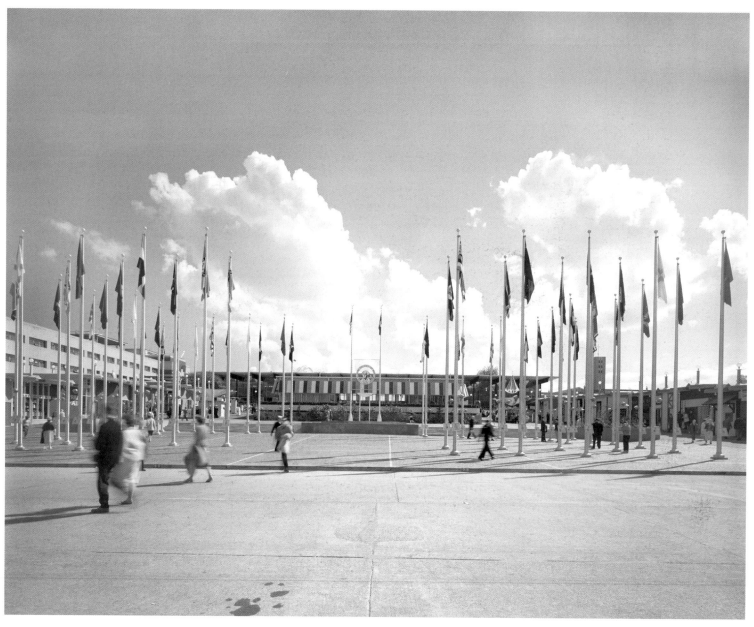

The Flag Plaza and Pavilion are seen here late one windless day in 1962, possibly after the close of the World's Fair, given the small number of people in view. Flags from participating countries hang from poles. As part of the Seattle Center, the plaza would become a concert and fair venue and the pavilion would host indoor events.

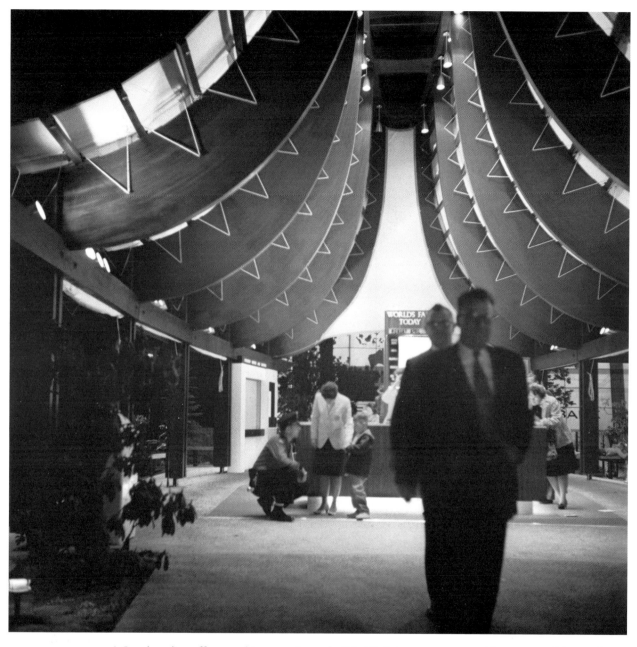

A Seattle police officer working security at the World's Fair greets a young visitor at one of the entries on a Monday in April 1962.

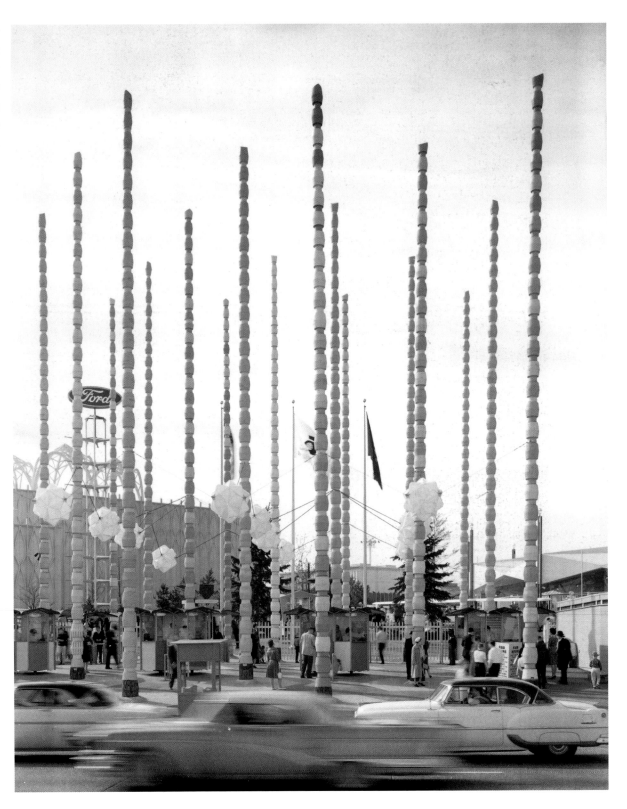

This forest of sculptures greets visitors arriving at the Seattle World's Fair through the Broad Street entrance. Behind is the Ford Motor Company's pavilion.

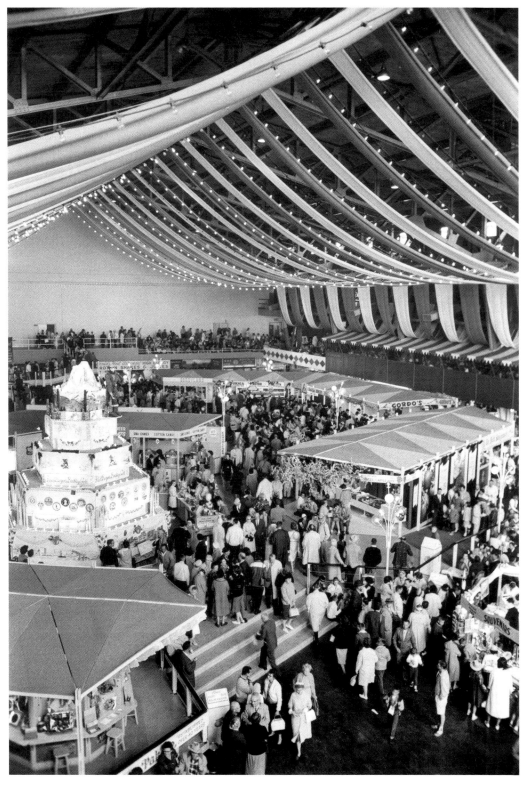

Making the most of existing facilities, Seattle World's Fair planners transformed the National Guard Armory into the Food Circus where visitors could enjoy food from any of 52 different vendors. The building was big enough, once the fair closed, to house shopping, entertainment, the Seattle Center's administrative offices, and even a 300-student high school.

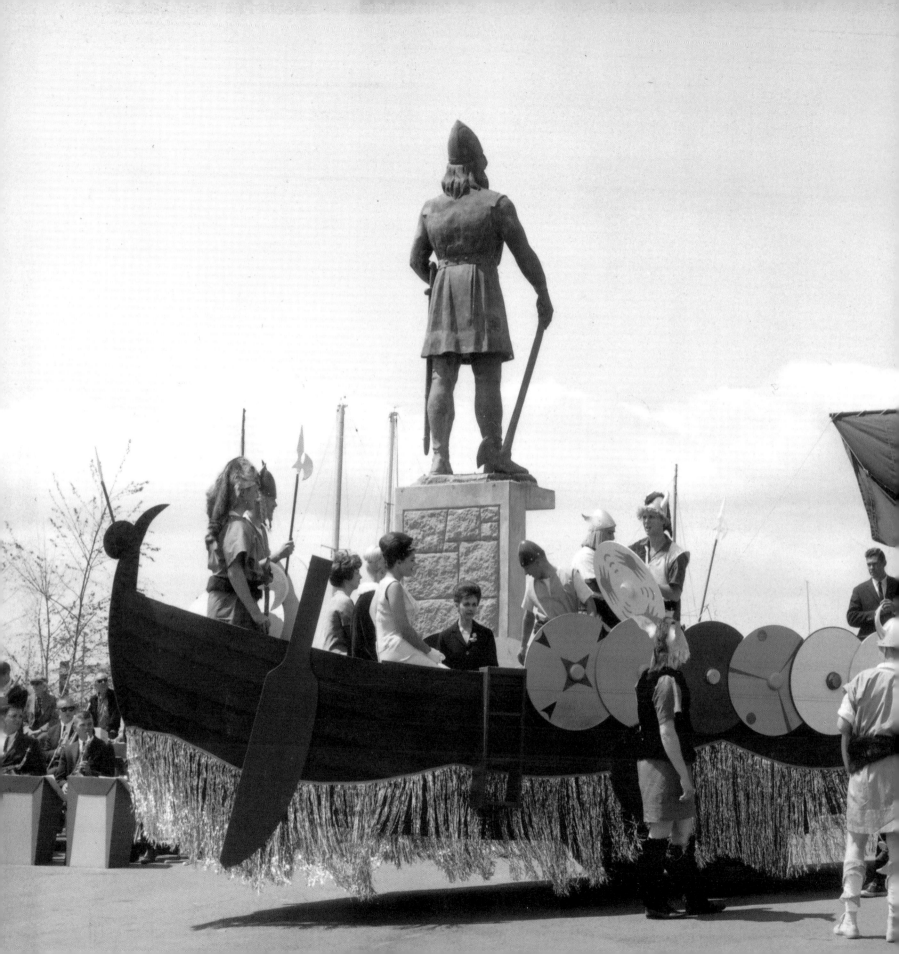

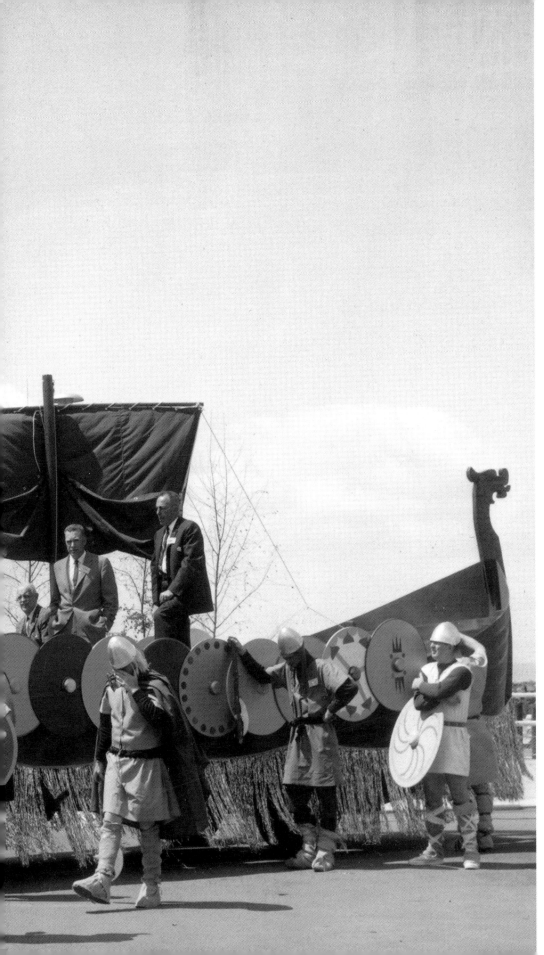

Seattle's Scandinavian-American community dedicated a statue to explorer Leif Ericson at the Port of Seattle's Shilshole Bay Marina on June 17, 1962. The ceremonies included a float decked out as a Viking ship, beauty contestants, local dignitaries, and descendants of Vikings. Many Norwegian and Swedish immigrants settled in nearby Ballard and took employment in Seattle's seafood industry.

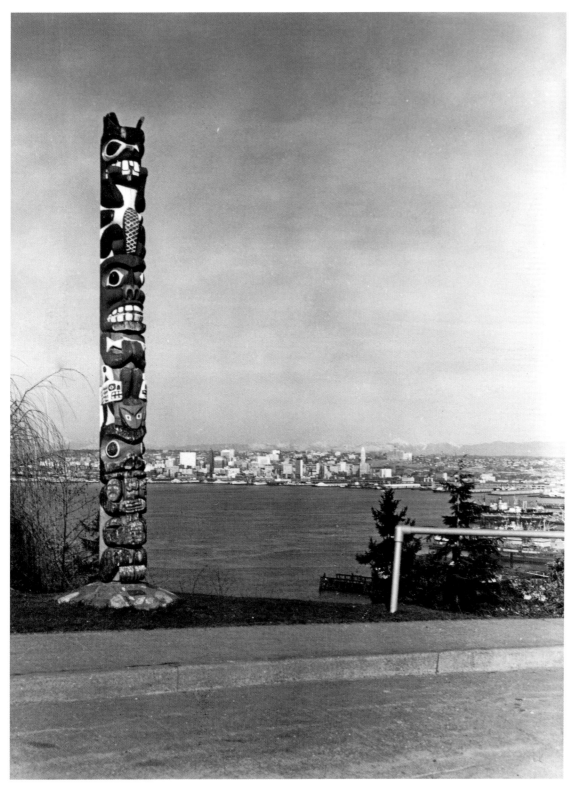

The Belvedere Place viewpoint on Admiral Way SW in West Seattle offered this stunning view of Seattle on March 9, 1965. The totem pole was an import from farther up the coast in British Columbia and Alaska. Puget Sound tribes did not carve totem poles.

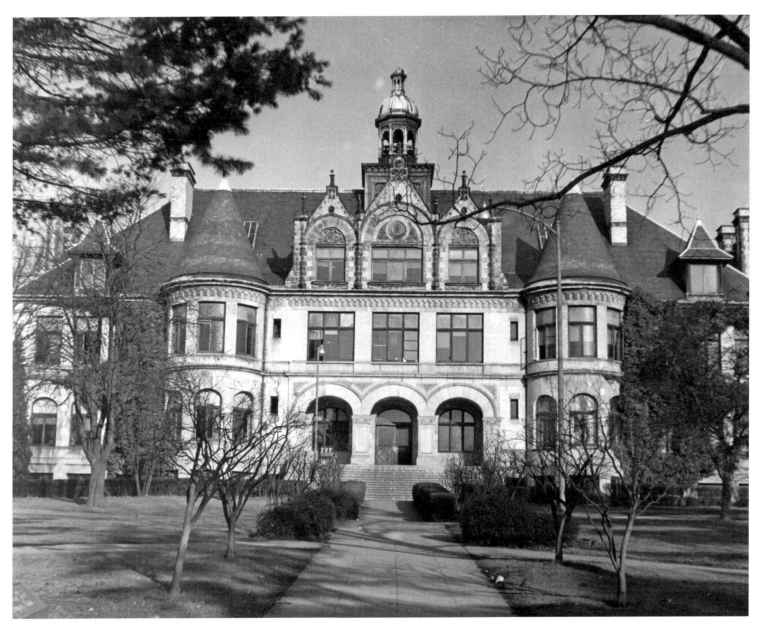

When the University of Washington moved from its original location downtown to Portage Bay in 1895, the first building to be erected was the Administration Building, designed by architect Charles W. Saunders and later known as Denny Hall. The building housed all classes, administrative offices, and a student bookstore. Here in the 1960s, Denny Hall, many times remodeled, still serves the university's central role of teaching.

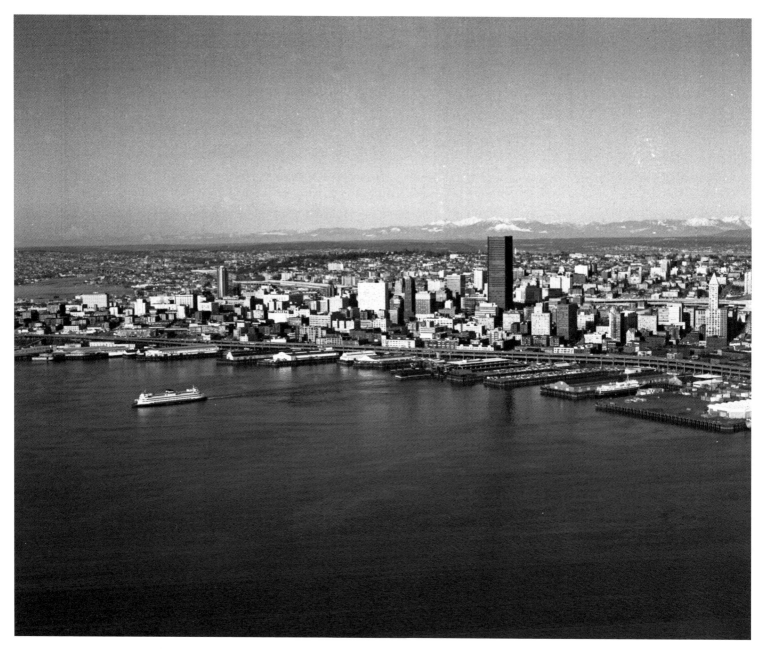

In 1969, the Seattle skyline featured the 50-story Seattle First National Bank Building, later the SeaFirst Tower, at 1001 Fourth Avenue. It featured a helipad on the roof marked with the bank's logo. In 1986, after SeaFirst was acquired by Bank of America, the building would become 1001 4th Avenue Plaza.

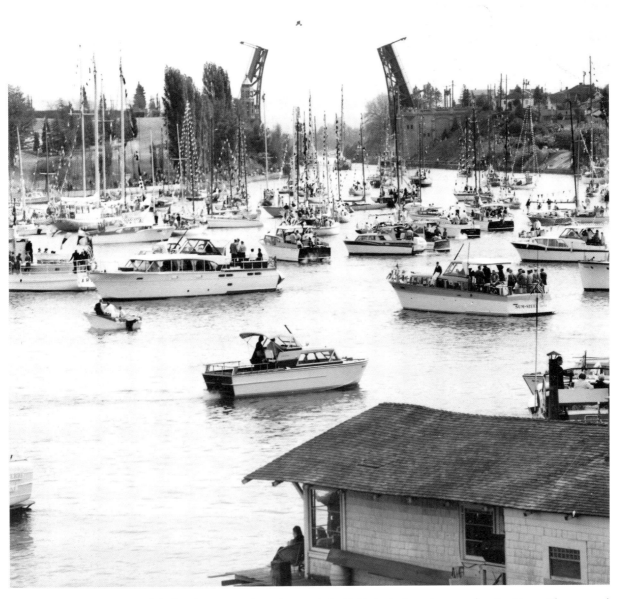

Opening Day of the boating season drew thousands in 1962, including photographer Art Hupy. Pleasure and work boats, some gaily decorated, wait in Portage Bay before motoring through the Montlake Cut to Lake Washington. The University Bridge stands open for the afternoon as the procession passes through. In the foreground is a houseboat whose occupant is enjoying the pageant.

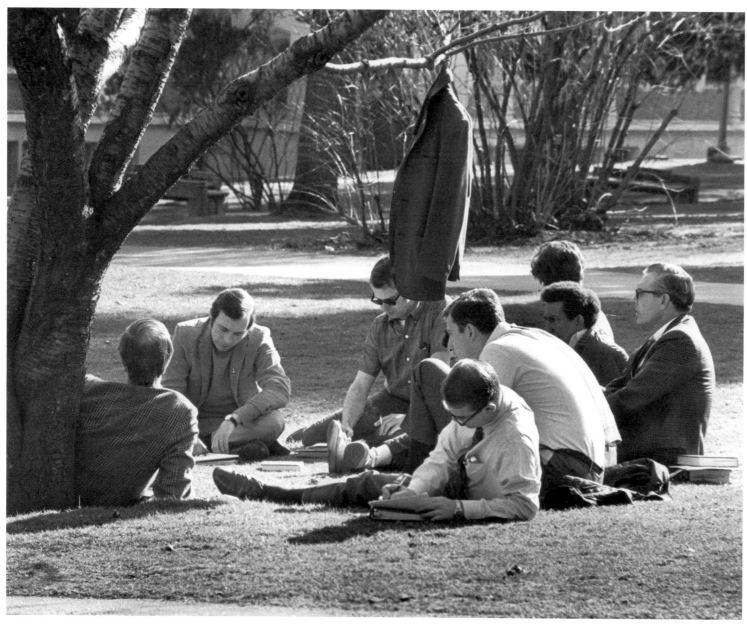

After long, gray winters, students at the University of Washington are loath to waste sunlight. Sometime in the spring of 1969, this psychology class moved outdoors in front of Denny Hall to continue the business of instruction.

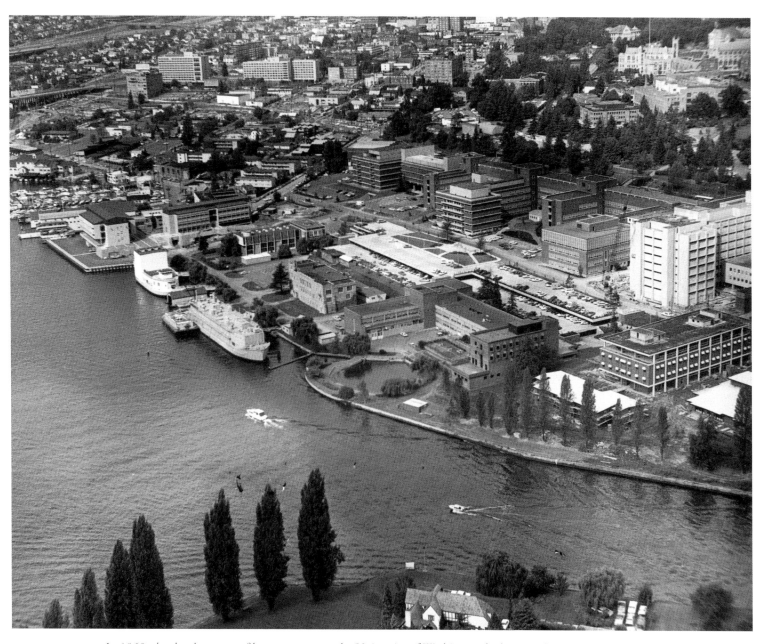

In 1968, the development of lower campus at the University of Washington had come a long way in 15 years. The Health Sciences complex now included University Hospital at right, the Fisheries buildings, and an Oceanography building and dock. Space was at such a premium that the university spilled over into Portage Bay with the Showboat Theater and the Oceanography Barge, a surplus U.S. Navy floating barracks transformed into offices.

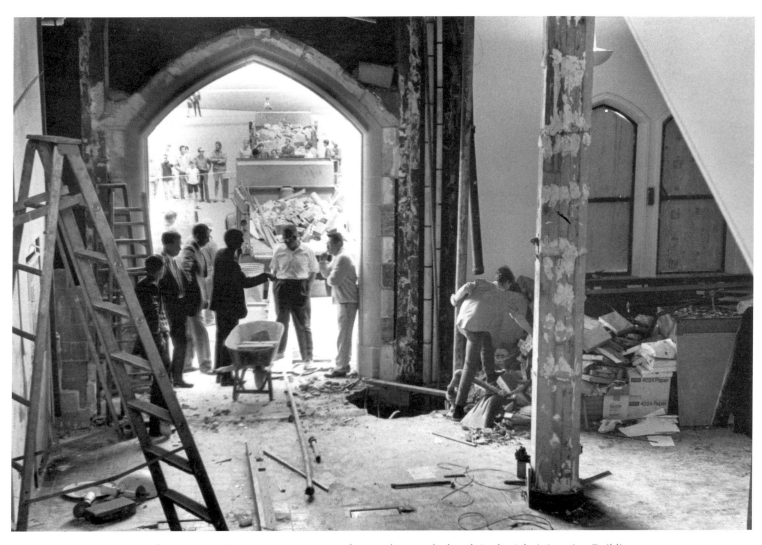

In the early morning hours of June 29, 1969, a person or persons unknown detonated a bomb in the Administration Building (Gerberding Hall) at the University of Washington. The blast did more than $100,000 damage, but no one was injured. In 1969, as activism across the nation turned violent, Seattle endured 69 bombings, making it second for bombings in the United States and highest in number of bombings in the United States per capita.

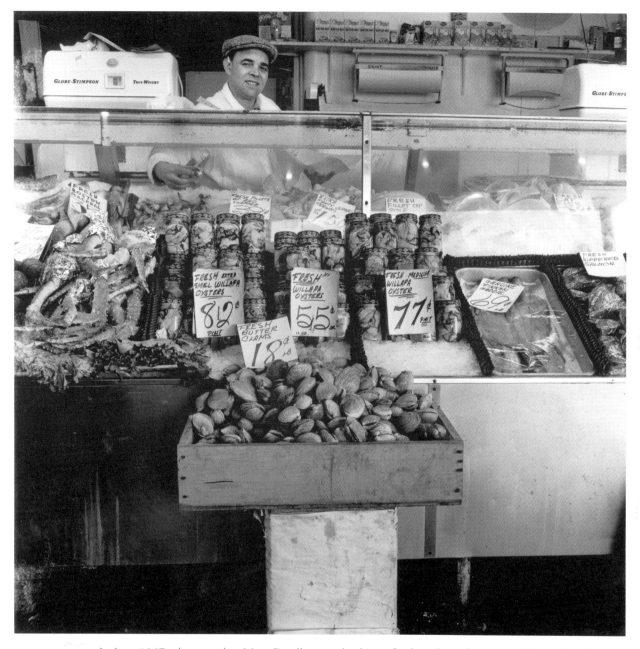

In June 1967, photographer Mary Randlett caught this seafood vendor as he manned his stand at the Pike Place Market. The market, a Seattle institution since 1907, was slated to be destroyed to make way for urban development. But Seattleites led by people like architect and preservationist Victor Steinbrueck formed Friends of the Market to block the plans. The Friends prevailed and the Market thrives into the twenty-first century.

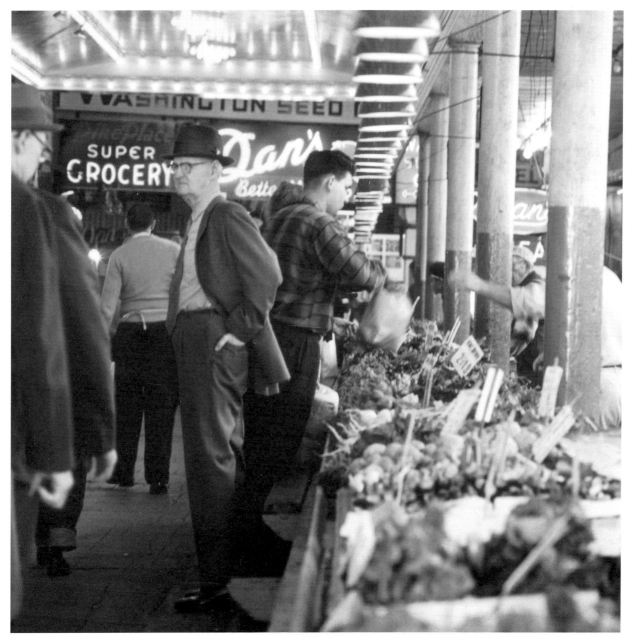

Art Hupy snapped this shot of a typical transaction at the Pike Market in 1965, one customer and one vendor. The mayor of Seattle called the market "a decadent, somnolent firetrap." Architect and preservationist Fred Bassetti called it "an honest place in a phony time." The preservationists would win and the market would flourish.

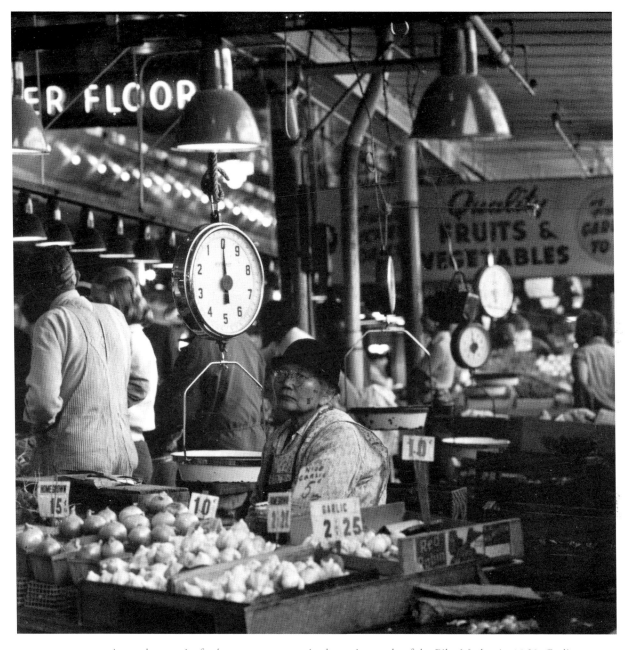

A merchant waits for her next customer in the main arcade of the Pike Market in 1965. Garlic was two bunches for 25 cents and onions appear to have been 10 cents a pound. The market was originally founded in 1907 to allow Seattleites to buy directly from the farmers who grew the food.

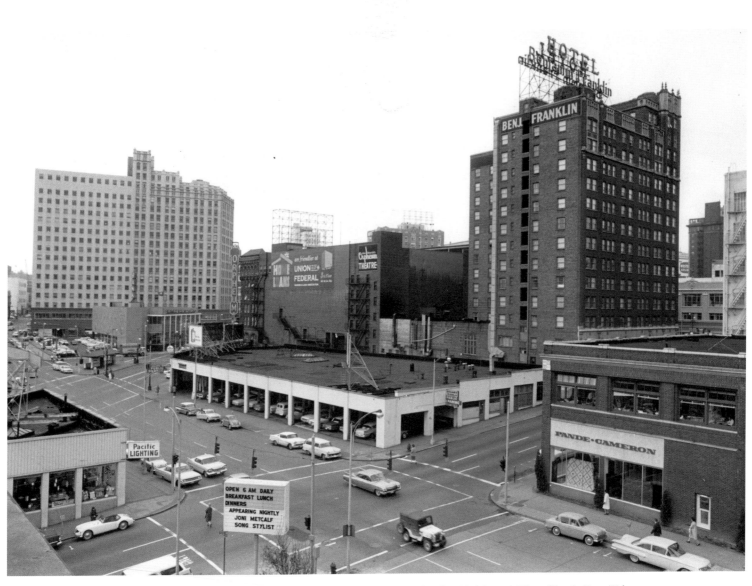

Sometime prior to 1967 when the Orpheum Theater was demolished to make way for the Washington Plaza Hotel, Gary Tolman took this shot of Sixth Avenue and Virginia Street. Both the Orpheum and the Benjamin Franklin Hotel would make way for newer buildings. The Medical Dental Building on the left would remain standing.

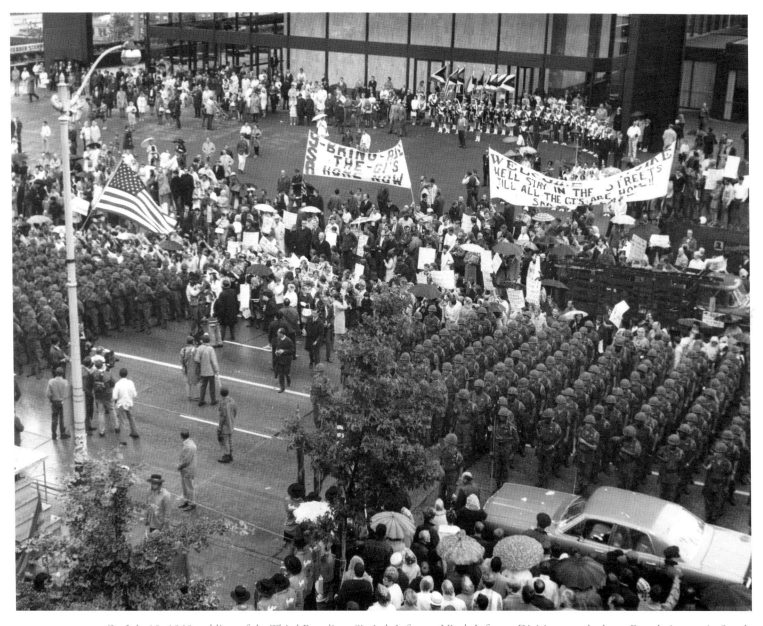

On July 10, 1969, soldiers of the Third Battalion, Sixtieth Infantry, Ninth Infantry Division parade down Fourth Avenue in Seattle in a symbolic beginning to the U.S. withdrawal from Vietnam. The men were greeted with both flowers and cheers and by protesters who pledged to stay on the streets until all the troops were home. Fewer than 200 of the men were actually from the battalion, the rest having been transferred from other units.

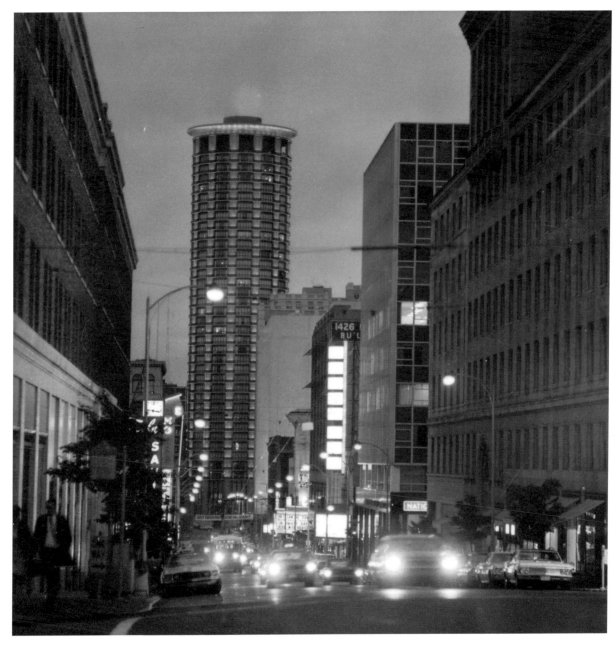

The new Washington Plaza Hotel dominates the north end of the retail core of downtown in this evening view from 1969, the year it opened. John Graham and Associates designed the building, which would be joined by a twin, the North Tower, in 1982. Hotel advertising promised that every room had a view.

A Bust and Bouncing Back

(1970s)

The 1970s in Seattle opened drearily. Opposition to the Vietnam War brought protests, mostly peaceful, but some disruptive and even violent. The Boeing Company, the cornerstone of the local economy, dumped tens of thousands of jobs, which plunged the region into a recession called the Boeing Bust. Double-digit unemployment hung over the region for more than four years. Two real estate agents posted a sign near Sea Tac International Airport reading, "Will the last person leaving Seattle—turn out the lights." The Police Department found itself embroiled in a corruption scandal. The new mayor, Wes Uhlman, began to open city government to more citizen participation and minority hiring. His style bothered public employee groups enough to spark a recall drive, which he survived.

Citizens celebrated the first Earth Day in 1970 with rallies and exhibits. This built easily upon citizen campaigns to preserve Pioneer Square and the Pike Place Market, to block construction of the R. H. Thomson Freeway through the Washington Park Arboretum, and creation of Metro, which cleaned up Lake Washington. When City Light proposed to raise Ross Dam on the Skagit River and to build a nuclear power plant, citizen groups and politicians blocked both. For the first time in its history, the utility, a model of public service, began to promote energy conservation. Fort Lawton, Sand Point Naval Air Station, and Pier 91 closed as military installations. Everywhere residents looked things in Seattle were changing.

The economy of the city bounced back in 1974 in a traditional way. Construction of the $8 billion Trans-Alaska oil pipeline meant that every dollar and every worker had to pass through Seattle just as they had during World War II and during the Klondike Gold Rush. Seattle took title to Fort Lawton and made it Discovery Park. Sand Point became Magnuson Park, another outdoor jewel in the crown of public spaces that included the University of Washington and the boulevard system crafted by John Olmsted in the 1900s.

Major league sports landed this decade. The Sonics (in 1967), the Mariners, and the Seahawks signified Seattle's arrival as a player on the national cultural scene. U.S. senators Warren Magnuson and Henry Jackson reached the zenith of their influence in the other Washington, seeing to it that their constituents got their share of federal tax dollars (and then some). The University of Washington continued its dramatic construction program to complement new community colleges, and tens of thousands of students and professionals flocked to Seattle to add to the city's cultural and economic character.

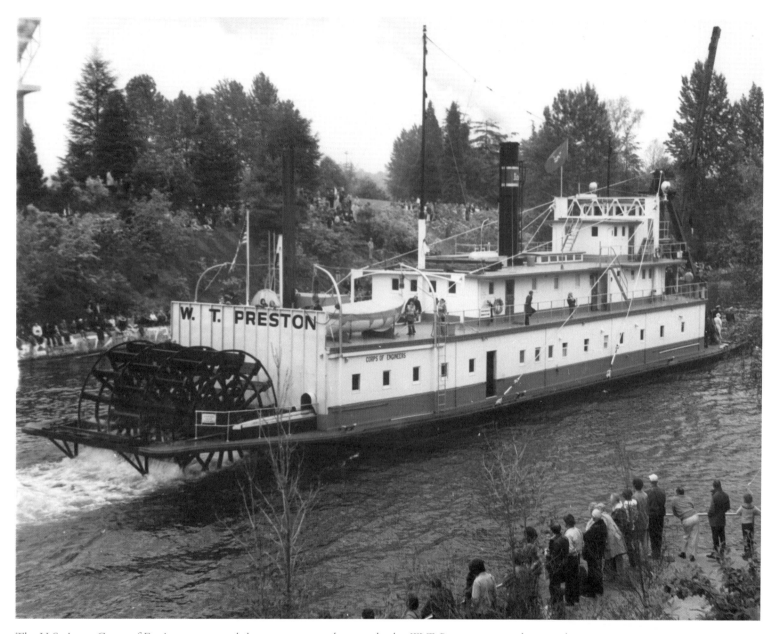

The U.S. Army Corps of Engineers operated the steam-powered stern-wheeler *W. T. Preston* as a snag boat to clear waterways of obstacles from Olympia to the Canadian border. Its shallow draft allowed it up rivers and estuaries. Here in 1976, it passes through the Montlake Cut. The boat would be placed on the National Historic Register while still in active service, retiring in 1981 to house a museum in Anacortes.

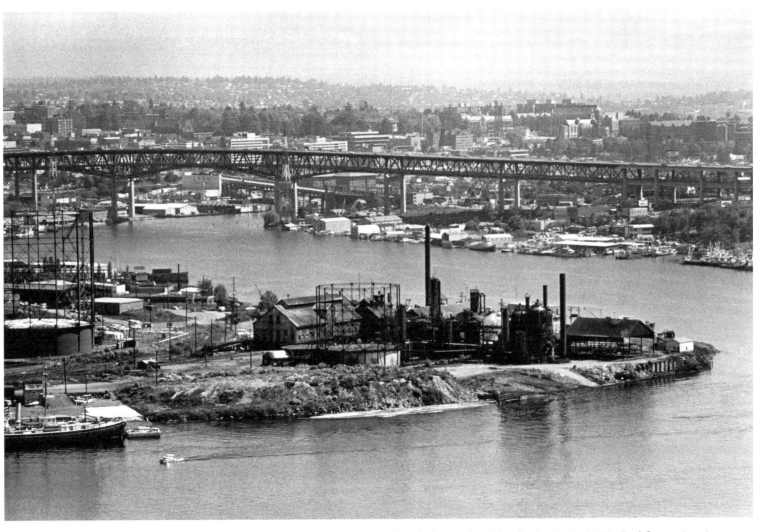

The Seattle Lighting Company operated a gas works in Wallingford on Lake Union beginning in 1907. Coal from mines in eastern King County moved along a Northern Pacific branch to be distilled into cooking gas. Neighbors complained of the noxious odors and operations ended in 1956. In this 1970 view, the plant is about to be transformed into Gas Works Park.

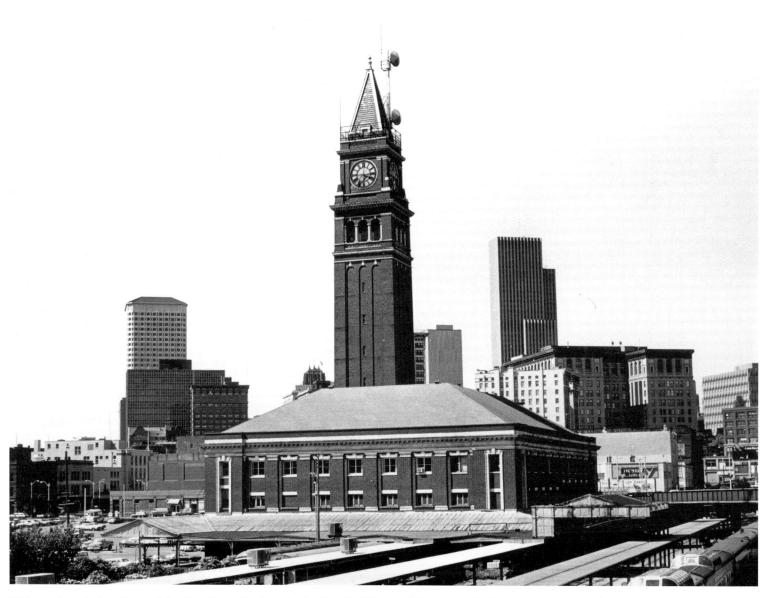

Rick Leach took this photo of the King Street Station, the SeaFirst Building, and the new Federal Building in 1970. That year, the transcontinental railroads, which helped build Seattle, started giving up their passenger service to government-operated Amtrak. Amtrak would abandon Union Station to the east in favor of the King Street Station.

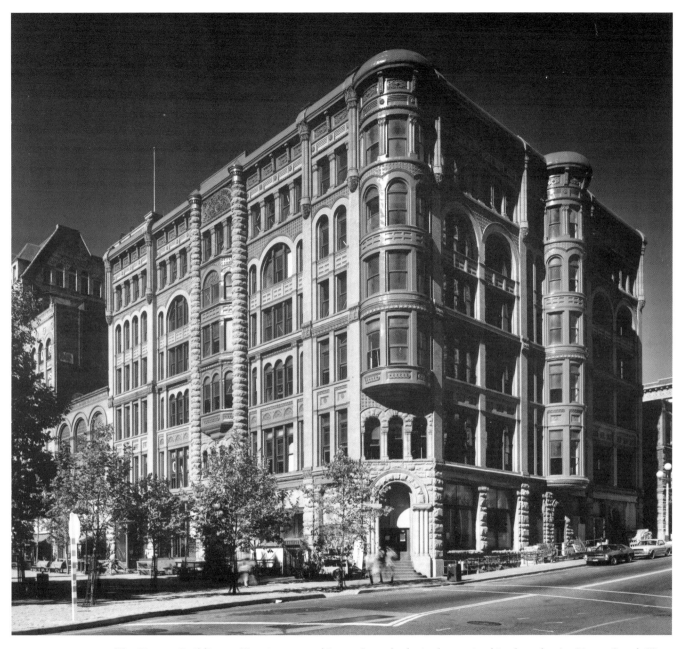

The Pioneer Building at First Avenue and James Street basks in the sun in this photo by Art Hupy. *Seattle Times* columnist Bill Speidel based his Underground Tours out of the building, which fronts on Pioneer Square and the Pergola. Speidel's tour leaders take visitors through Pioneer Square where streets were regraded leaving storefronts underground. Another tenant is the regional transit system, Metro.

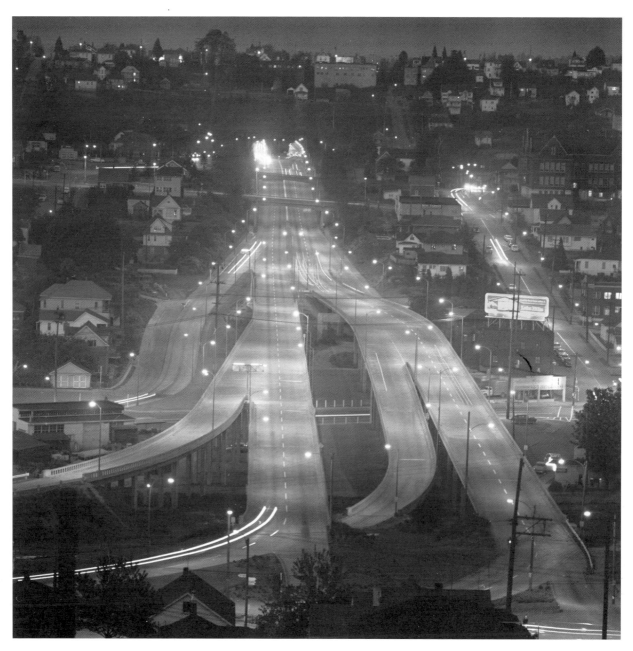

The first Lake Washington Floating Bridge entered Seattle through a tunnel dug underneath the Mount Baker neighborhood. The highway connected to Rainier Avenue South and Dearborn Street with these on-ramps and off-ramps. In the 1990s, a second bridge and tunnel system would bypass the surface streets along elevated structures.

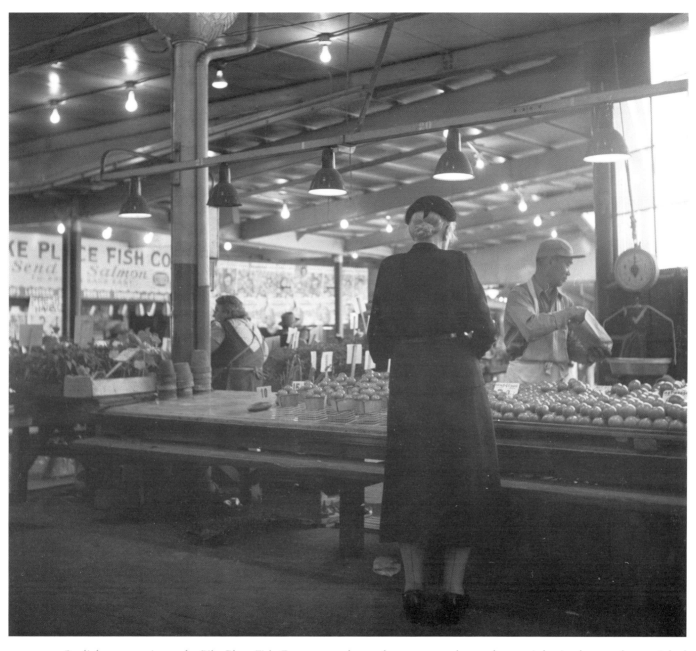

Sunlight streams in on the Pike Place Fish Company and a produce counter where a shopper is having her purchase weighed and bagged. These were the days before computerized scales. The Pike Place Fish Company would become world famous for apron-clad employees throwing whole fish to each other to entertain tourists.

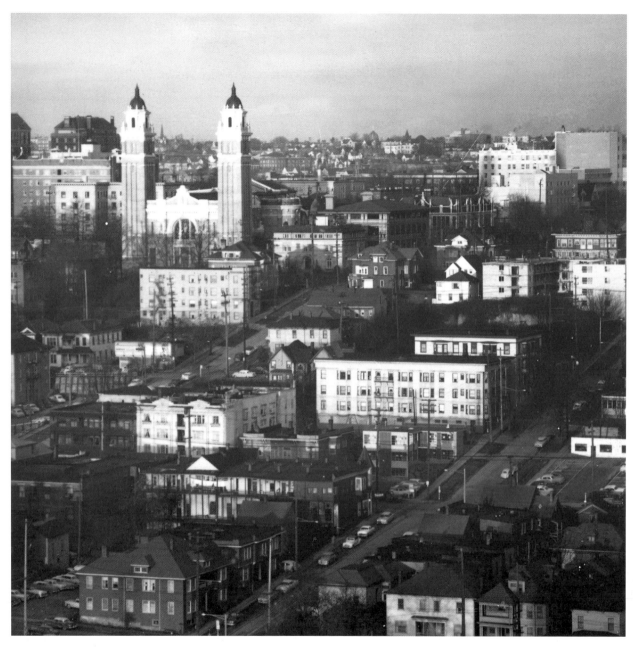

Up the hill from downtown is First Hill and St. James Cathedral. Beginning in the 1880s this was Seattle's fashionable neighborhood. By the time of this view in the 1970s, the area was about to become Pill Hill as Swedish Medical Center and Harborview Medical Center expanded. Related clinics and businesses and apartment buildings would replace the old homes. Preservationists would manage to save a few structures such as the venerable Stimson-Green Mansion.

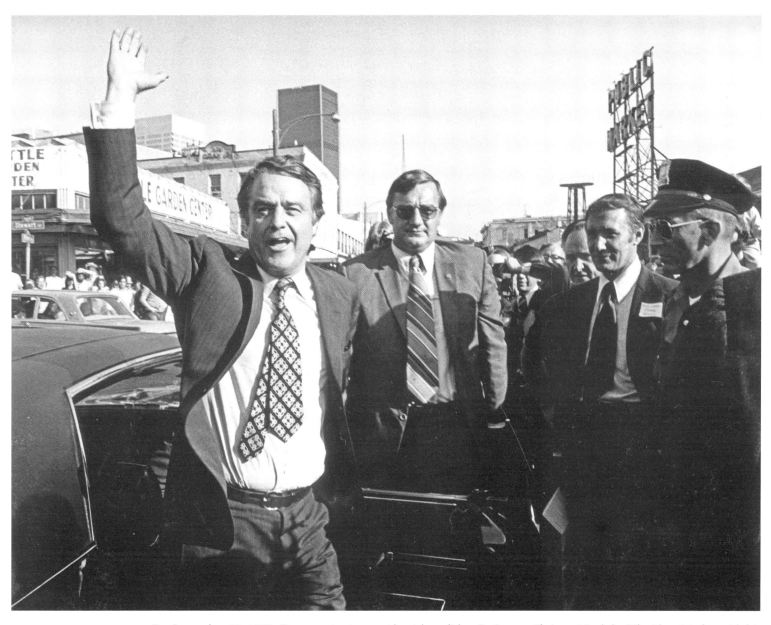

On September 12, 1972, Democratic vice-presidential candidate R. Sargent Shriver visited the Pike Place Market with his security detail. Shriver and his running mate George McGovern would not carry Washington state and would lose the national election to Richard Nixon.

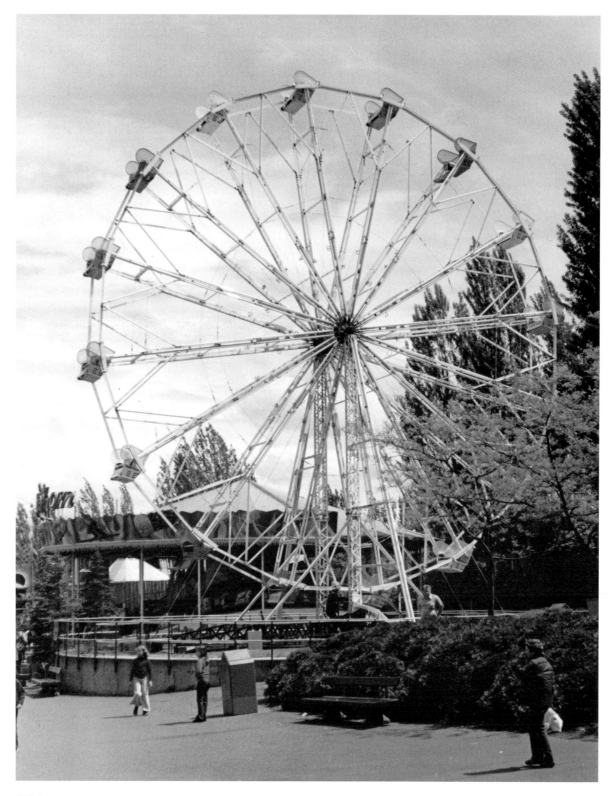

In 1970, the Seattle Wheel is still going strong at the Fun Forest at the Seattle Center. The first Ferris Wheel appeared at the Chicago Columbian Exposition of 1893.

After the World's Fair closed in 1962, the property was transferred to the City of Seattle, which operated the buildings and grounds as the Seattle Center. The Gayway became the Fun Forest. Here in 1970, riders on the carousel at Fun Forest blur as they ride by.

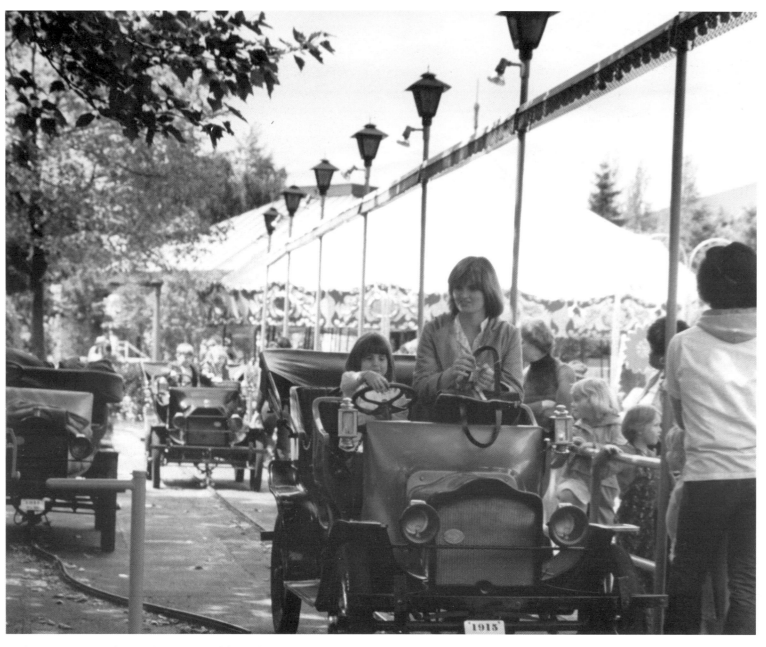

In the Fun Forest at the Seattle Center, Kiddieland appealed to the younger visitors. A parent and her children ride an old-fashioned automobile safely kept on course by steel tracks.

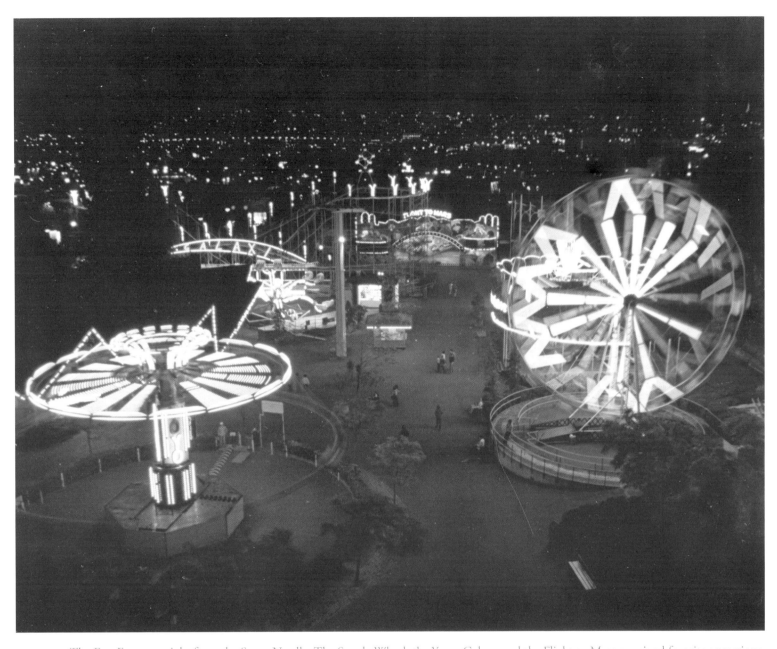
The Fun Forest at night from the Space Needle. The Seattle Wheel, the Yo-yo Galaxy, and the Flight to Mars remained favorite attractions.

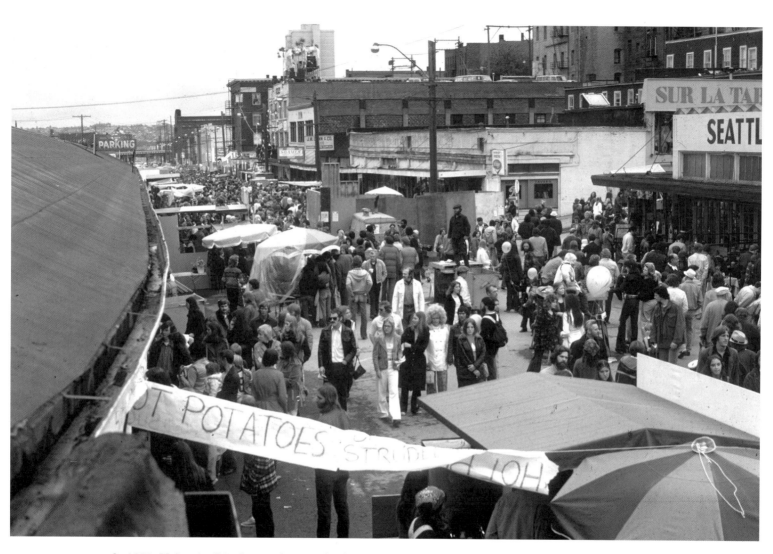

In 1970, University District merchant Andy Shiga proposed a street fair to help ease the tensions of the time. The first University street fair opened that year with 300 vendors. Its success proved contagious and other neighborhood street fairs grew up, including this one in 1975 in the Pike Place Market.

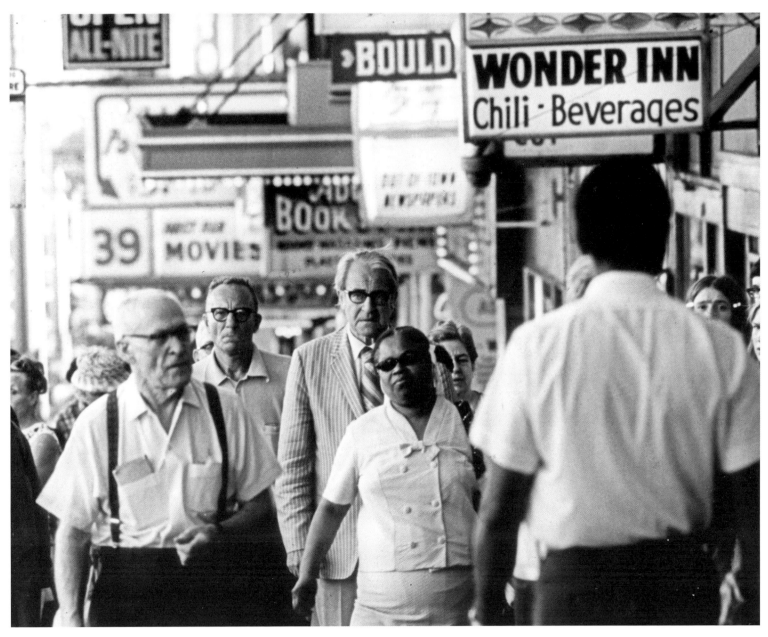

In 1972, First Avenue between Union Street and Pike Street was taverns, lunch counters, low-rent hotels like the Newport, and adult book stores. Redevelopment would eventually overtake this prime real estate with upscale condominiums and the Seattle Art Museum. One adult entertainment tradition, the Lusty Lady, would not close its doors until 2010.

Following Spread: In 1972, City of Seattle photographer Gordon Gould snapped this Pike Place Market vendor offering his customer a free sample.

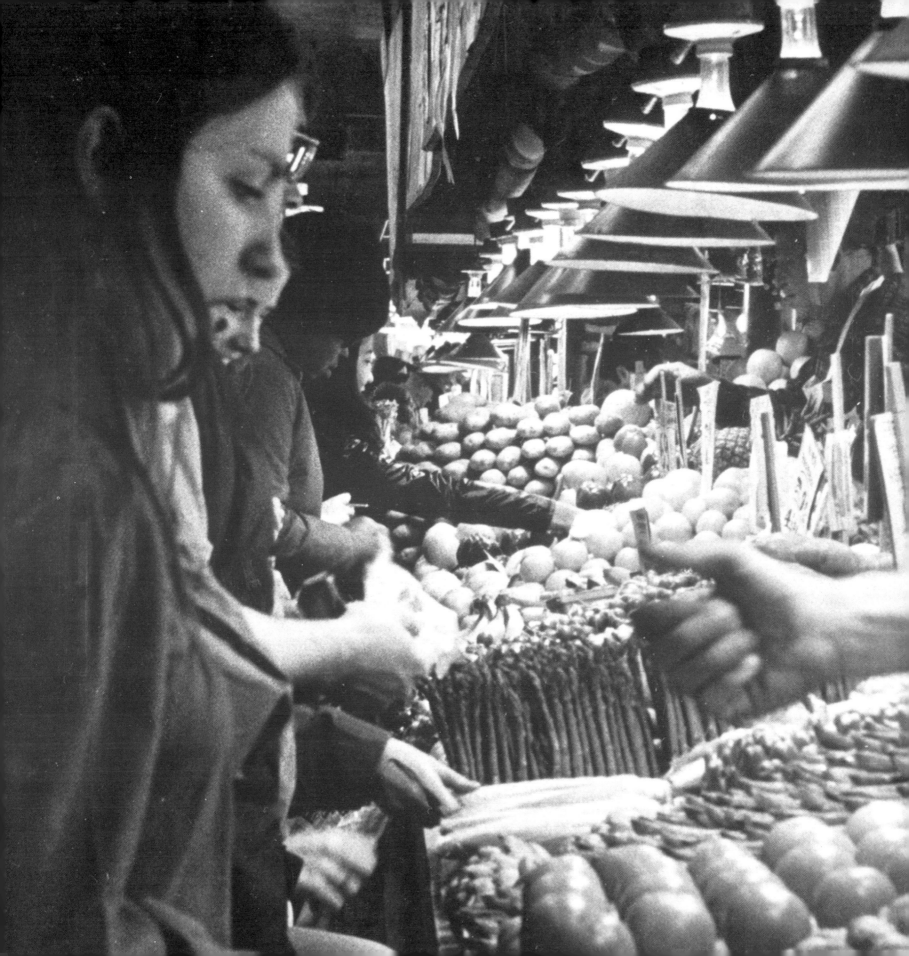

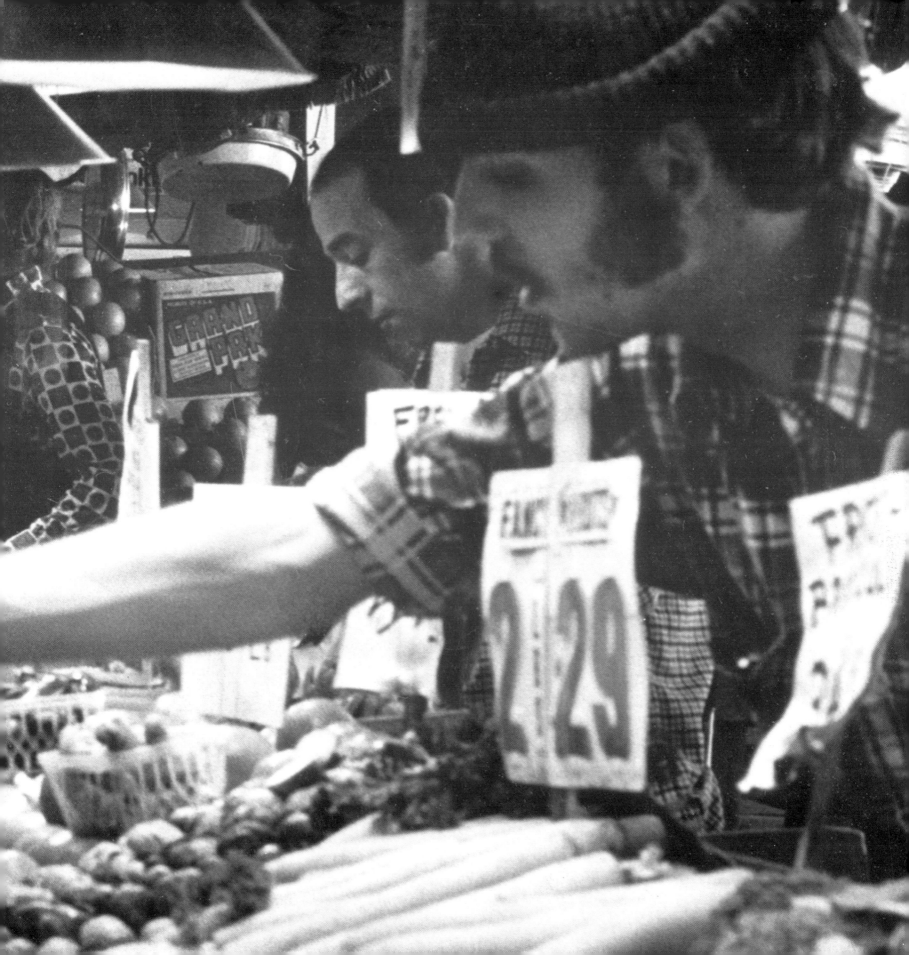

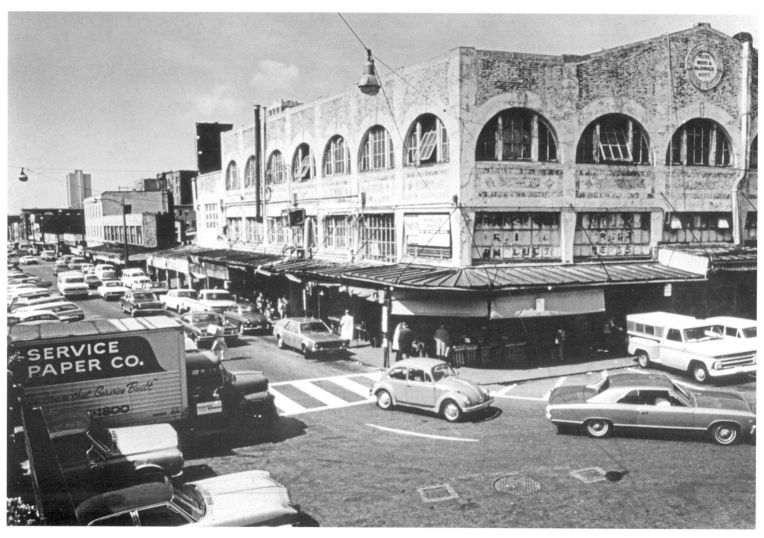

After the voters saved the Pike Place Market neighborhood in 1971, there was a lot of work to do. Most of the buildings needed serious renovation including the Corner Market here. This shot was probably taken from the office of the Market Master.

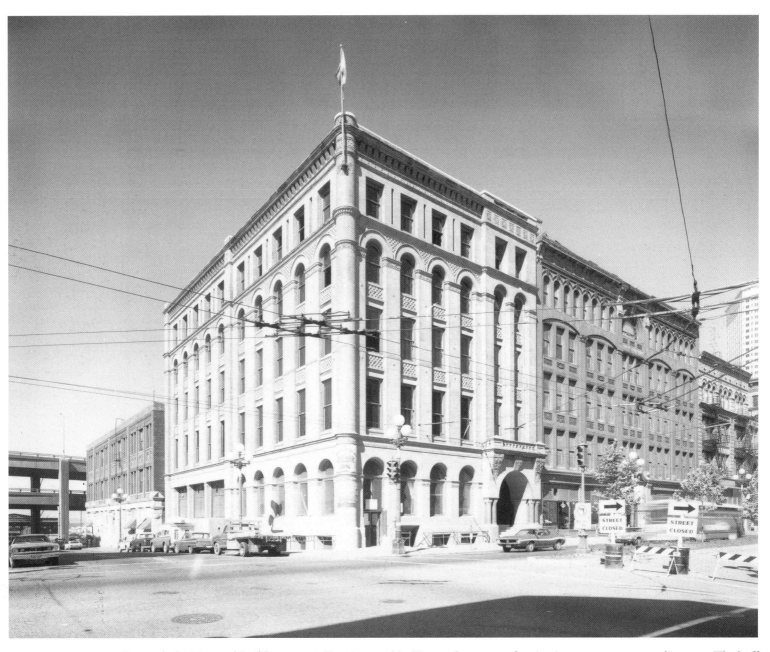

In 1974, the Maynard Building at 119 First Avenue S in Pioneer Square was showing improvement over earlier years. The buff brick and sandstone exterior stands out in the sunlight. Work on First Avenue S indicates that the City was spending money in the area designated a historic district.

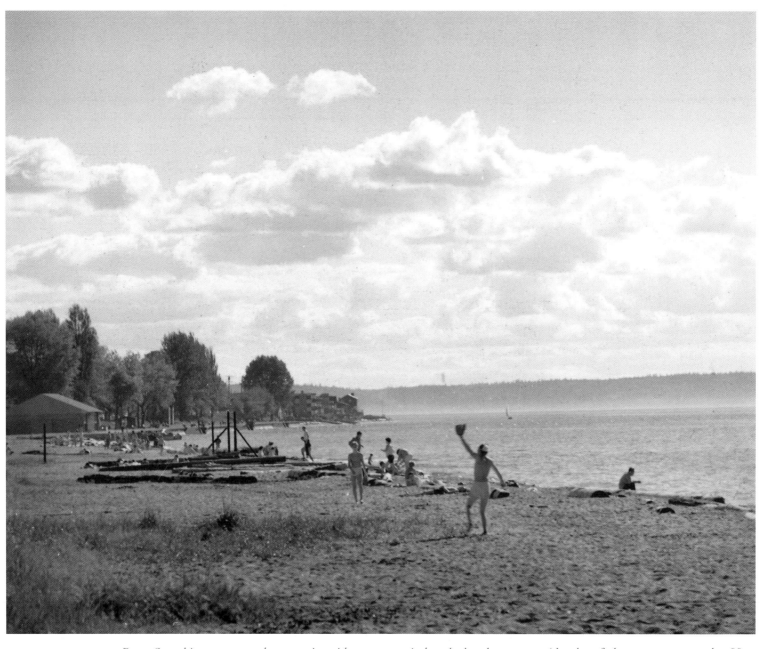

Puget Sound is not a great place to swim without a wet suit, but the beaches can provide a lot of pleasure on a warm day. Here sun worshipers at Alki Beach enjoy a game of catch beside the waters.

The Financial Center Building at 1215 Fourth Avenue opened its doors in 1972 on the original grounds of the University of Washington. The center has 28 stories and a rooftop garden. In 2010, it would be managed by Unico Properties.

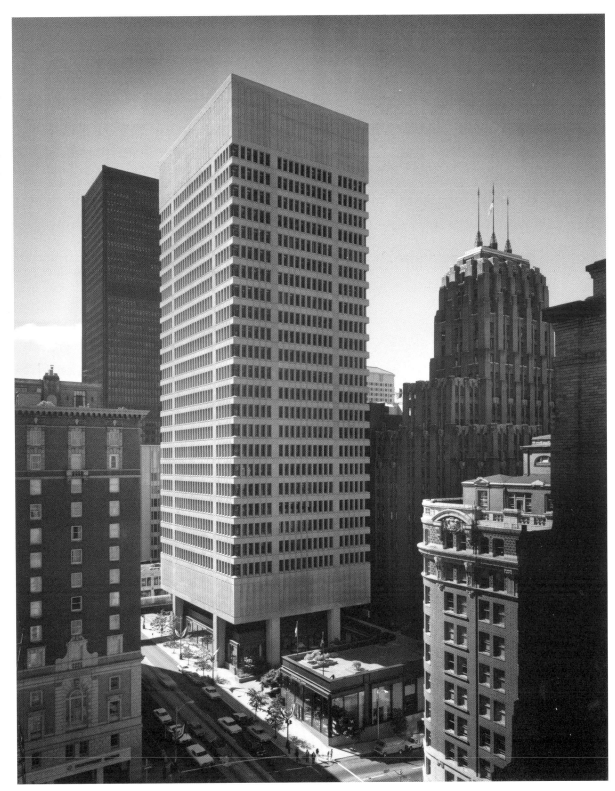

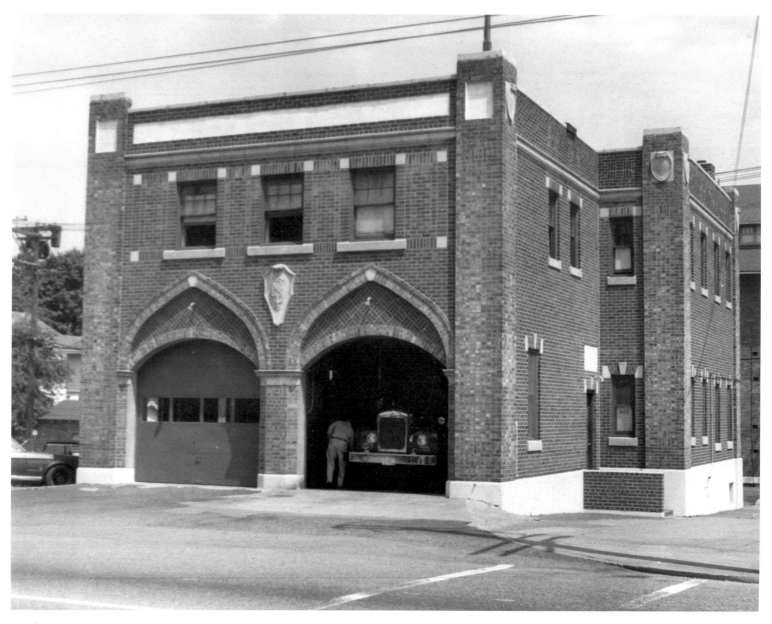

Seattle Fire Department Station No. 7 at 15th Avenue E and E Harrison Street was built in 1921. In the 1970s, it was still in use, but would become just too old and too small for the fire department. It would be sold off and become a video rental store.

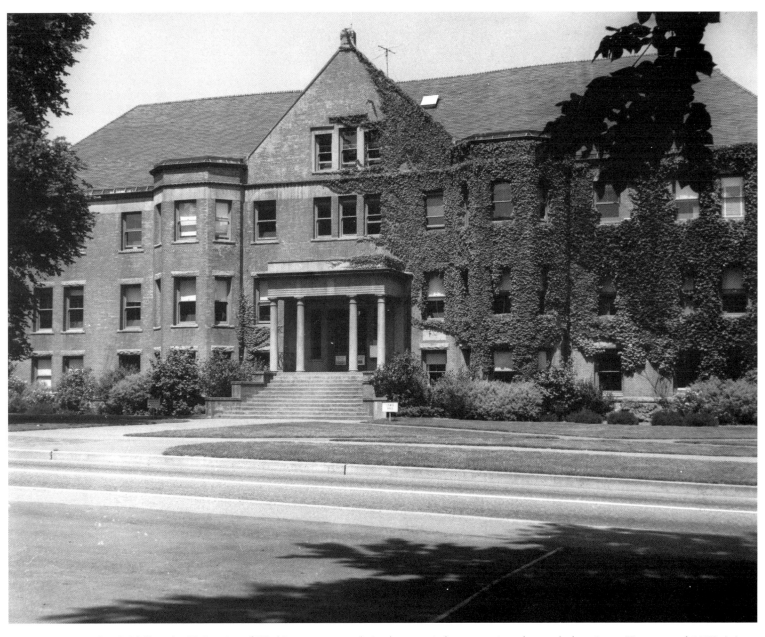

Lewis Hall at the University of Washington was, early in the twentieth century, just the men's dormitory. Here around 1972, it is an office and classroom building.

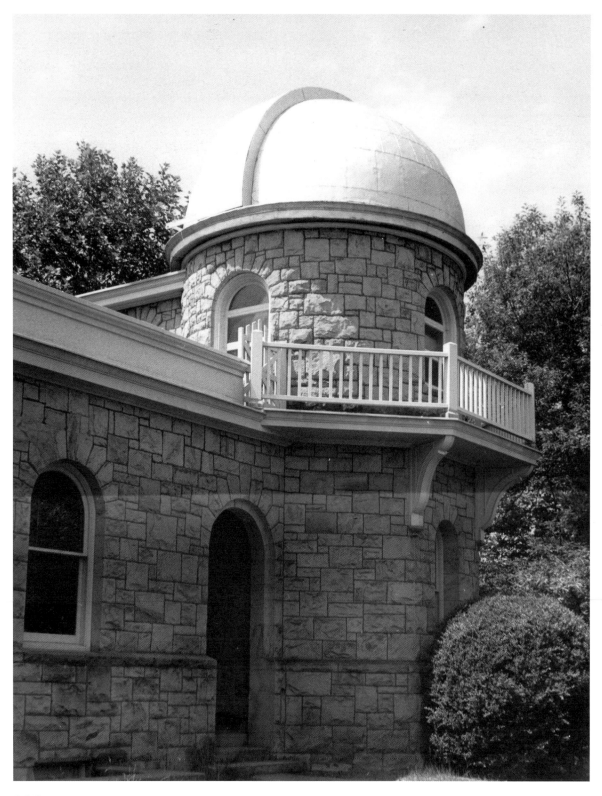

In 1895, the Observatory at the University of Washington became the second building built on campus, near Denny Hall, the first. The bearings of the movable telescope were Civil War cannonballs. In those days, trees did not crowd out the stars and urban light pollution did not impair observations. The original six-inch refractory telescope was still operational in 2010. The observatory is named after Theodor Jacobsen, head of the Astronomy Department for 40 years.

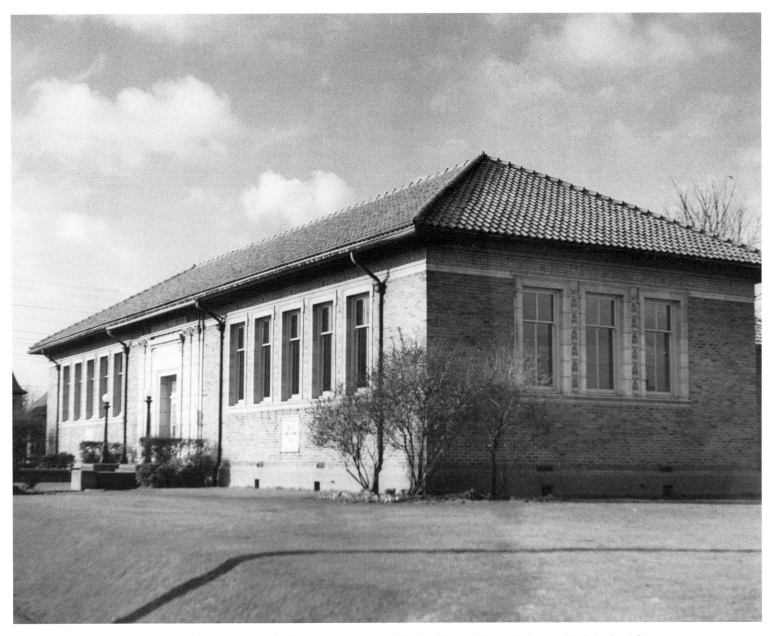

The Yesler Branch of the Seattle Public Library was built at 23rd Avenue and Yesler. Pioneer Henry Yesler provided the land for the first public library in Seattle. Until World War II, it housed Japanese language books and magazines. In 1975, the branch would be named the Douglass-Truth Branch after African-American heroes Frederick Douglass and Sojourner Truth. In a naming contest both persons received equal votes.

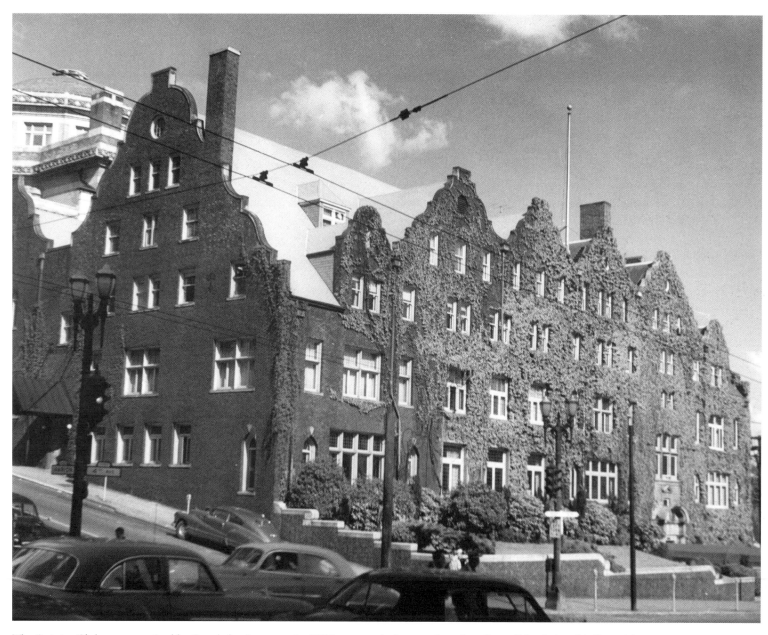

The Rainier Club was organized by Seattle businessmen in 1888 as an exclusive meeting place for well-heeled and influential Seattleites. In 1904, the club moved to a building on Fourth Avenue designed by Kirtland Cutter.

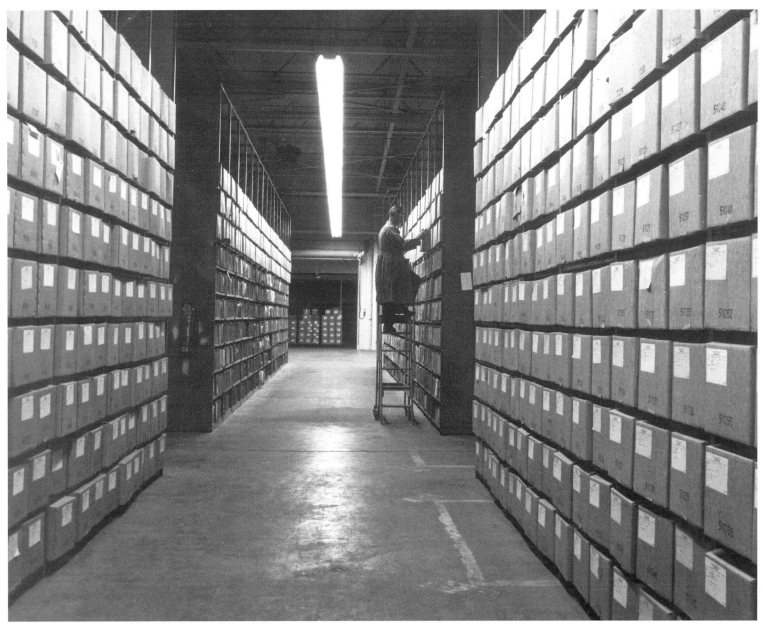

The National Archives and Records Administration operates its Northwest regional facility on Sand Point Way NE. Records of the U.S. courts, Bureau of Indian Affairs, and Department of Defense, as well as microfilm copies of census records are available for public access. The specially designed building provides a climate controlled environment that preserves paper and photographs.

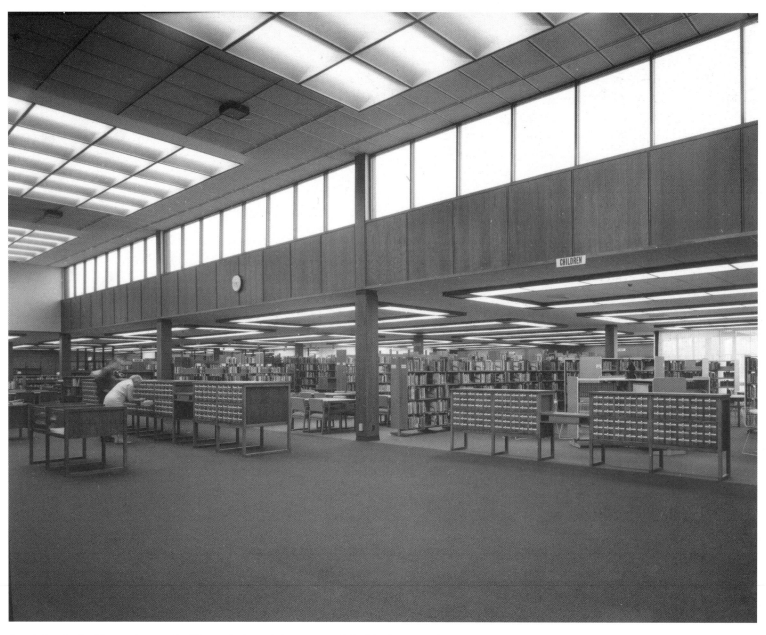

Seattle has had a library since 1868. The main branch has occupied the block at Fourth Avenue and Spring Street since 1906. A new steel and concrete building replaced the original in 1960, and the card catalog here on the main floor provided access to all the library's holdings. A third building replaced this one in 2004, but without the card catalog. By that time the card file had gone digital.

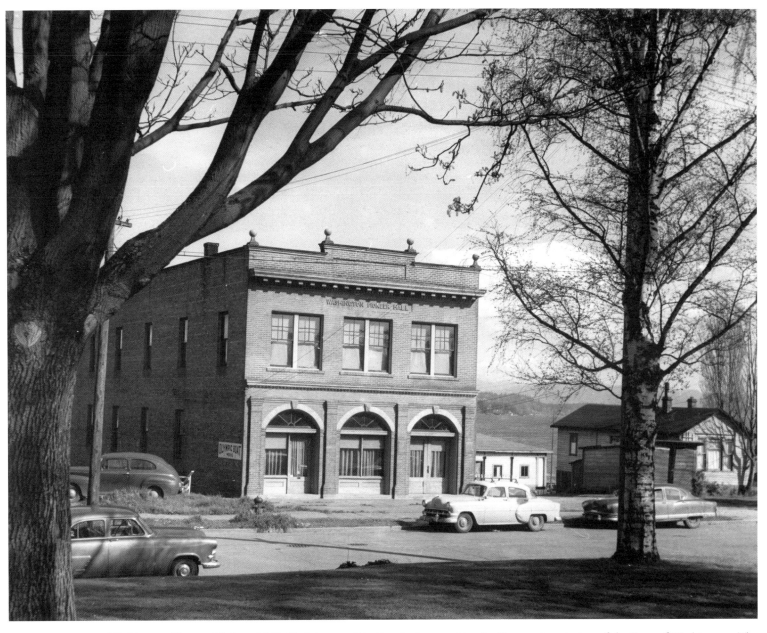

Washington Pioneer Hall, at 1642 43rd Avenue E in Seattle, is owned by the Pioneer Association of the State of Washington. The association preserves family heritage and the history of Washington state. The building was built in 1910 in the Madison Park neighborhood and also serves as a venue for banquets.

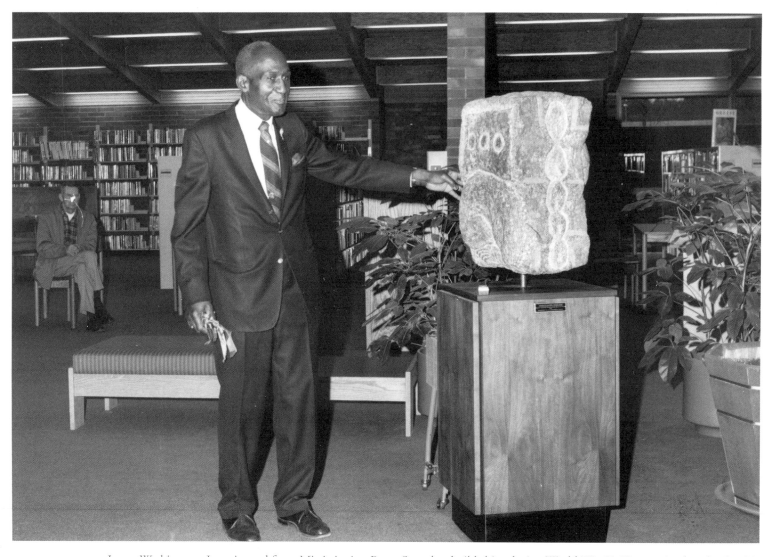

James Washington, Jr., migrated from Mississippi to Puget Sound to build ships during World War II. He remained to develop his talent and passion for painting and sculpture. His works appear in public spaces throughout Seattle including the Intiman Theater and the old Seattle First National Bank Building. His home and studio in Seattle's Central Area are designated landmarks. Here the artist discusses some of his work at the Bothell Library in 1970.

In 1900 when it was built, the Hotel Stevens at First Avenue and Marion Street offered comfortable rooms close to the waterfront and the railroad terminal. By 1970, it was home to OK Loans, a pawn shop, and the Golden Apple Restaurant. The Stevens, the 1891 Burke Building, and the Tivoli Theatre would all be razed to make way for the new 37-story Federal Building, completed in 1974 and later renamed for Senator Henry M. Jackson.

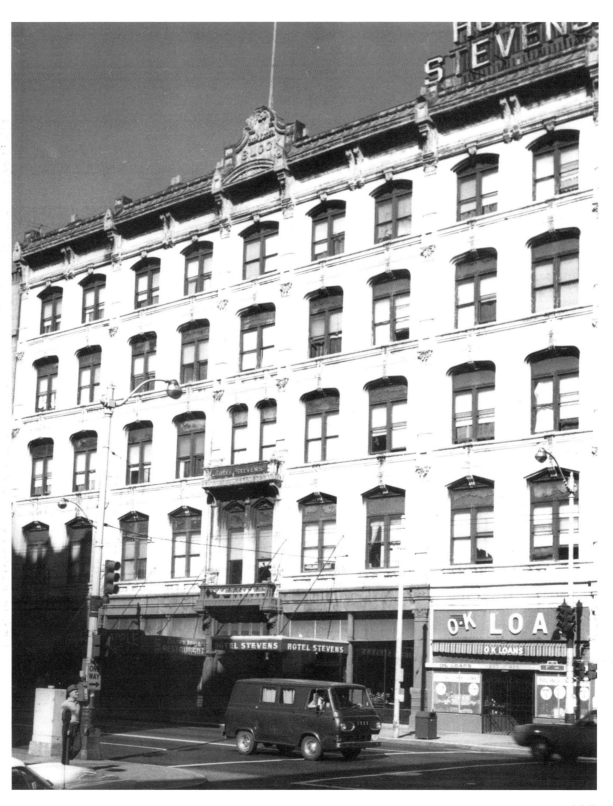

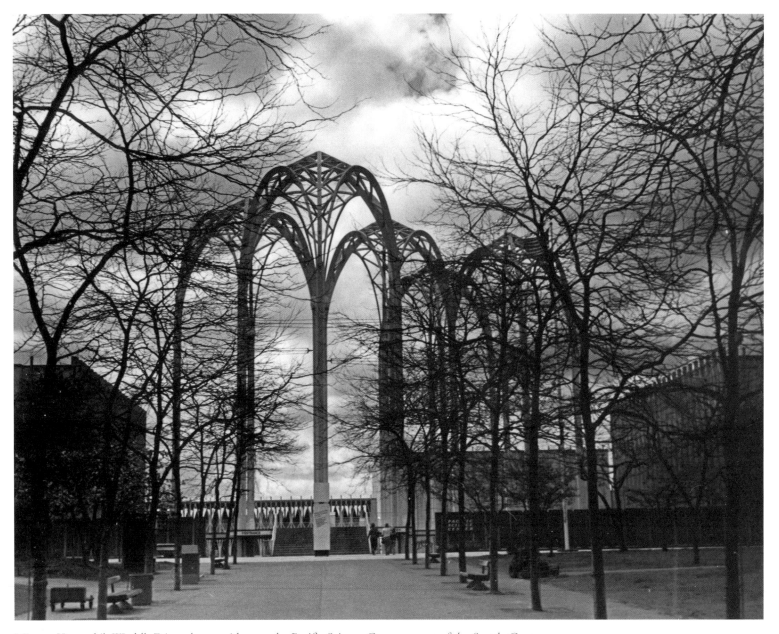
Minoru Yamasaki's World's Fair arches preside over the Pacific Science Center as part of the Seattle Center.

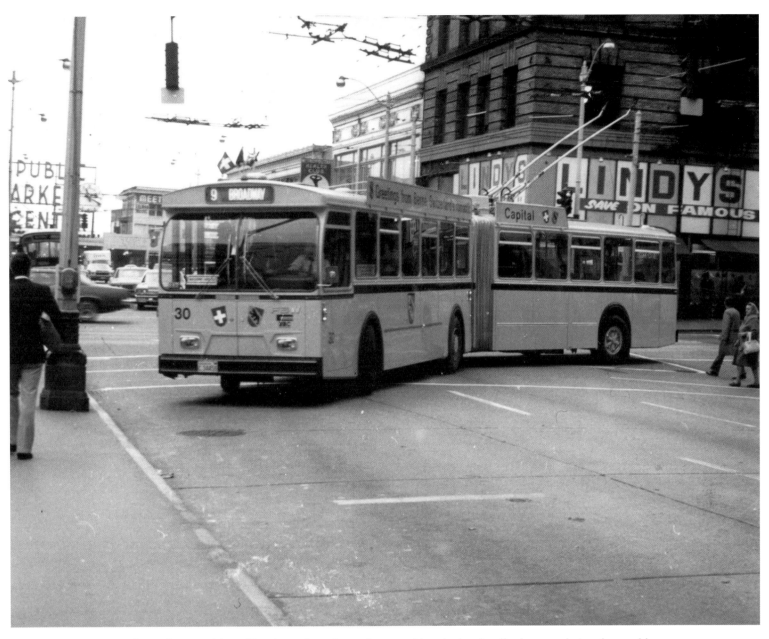

In the mid-1970s, Metro Transit conducted experiments with articulated trolley buses, a design that could carry more passengers and still negotiate city streets. In this pilot project, a bus manufactured in Berne, Switzerland, assigned to the Number 9 Broadway run, turns from Second Avenue east onto Pike Street.

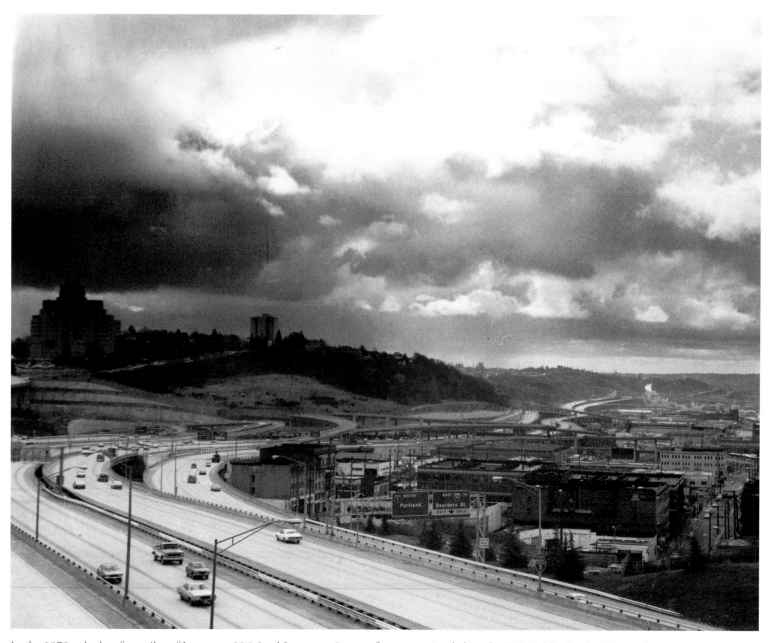

In the 1970s, the last few miles of Interstate 90 joined Interstate 5 on surface streets just below the U.S. Public Service Hospital on Beacon Hill. The junction is in an area graded in the early twentieth century to give trolley lines access to the Rainier Valley from downtown. At right is the International District. Interstate 5 runs from the foreground to hug Beacon Hill in the distance on its way to Tacoma, Olympia, and the south.

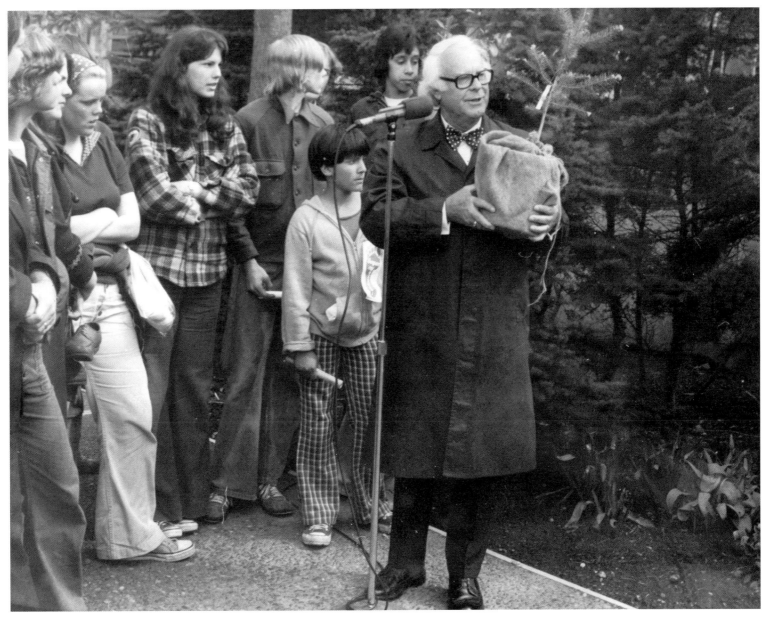

In 1971, a Douglas fir seed made the trip from Earth to the moon and back again aboard Apollo 14. The seed sprouted into this 20-inch seedling, called the Moon Tree, which was planted at the Flag Plaza in the Seattle Center on April 24, 1976. Washington State Commissioner of Public Lands Bert Cole addresses the crowd as young environmentalists look on.

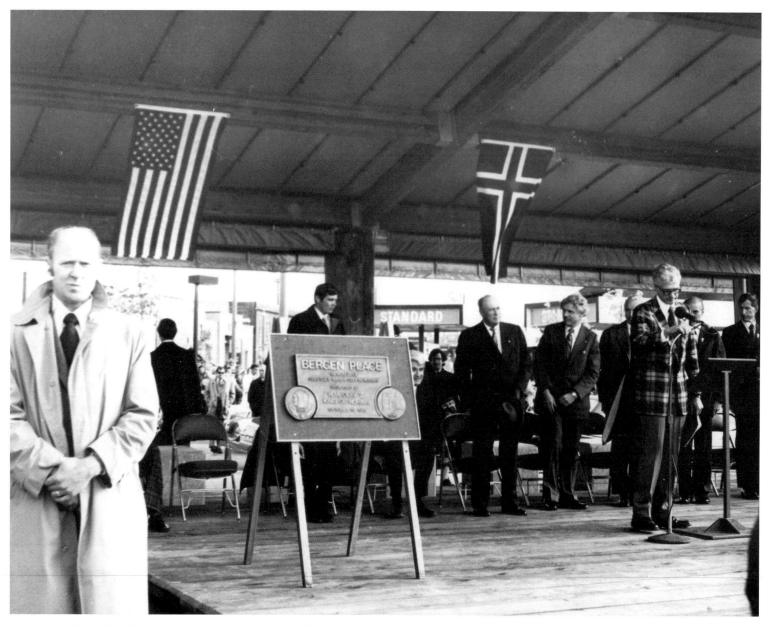

His Majesty King Olav V of Norway waits under the flag of Norway to address a crowd attending the dedication of Bergen Place in Ballard on October 19, 1975. Bergen Place commemorates 150 years of Norwegian immigration to Ballard and the United States.

Notes on the Photographs

These notes, listed by page number, attempt to include all aspects known of the photographs. Each of the photographs is identified by the page number, photograph's title or description, photographer and collection, archive, and call or box number when applicable. Although every attempt was made to collect all data, in some cases complete data may have been unavailable due to the age and condition of some of the photographs and records.

II **Scene Outside the Olympic and Metropolitan**
Seattle Municipal Archives
25551

VI **World's Fair Booth Space**
Washington State Archives
AR-28001001-ph002081

X **Black Sun**
Washington State Archives
AR-07809001-ph00479

2 **The Skagit Chief in 1952**
Washington State Archives
AR-07809001-ph005055

3 **Pleasure Boaters at Chittenden Locks**
Washington State Archives
AR-28001001-ph000127

4 **Flying Boats at Sand Point**
University of Washington Libraries, Special Collections
UW28975z

5 **Sailboat Parade at Montlake Cut**
Washington State Archives
AR-28001001-ph002131

6 **Tennis in Madison Park**
Washington State Archives
AR-28001001-ph001174

7 **Anglers on Elliott Bay**
Washington State Archives
AR-28001001-ph000706

8 **Best Lighted City in the World**
University of Washington Libraries, Special Collections
UW22202

9 **Scene at Pier 59, 1957**
University of Washington Libraries, Special Collections
UW3335

10 **Diver at Colman Pool in Lincoln Park**
Seattle Municipal Archives
29733

11 **Denny Party Reenactment**
Seattle Municipal Archives
43478

12 **Unsafe for Bathing**
Seattle Municipal Archives
101715

13 **William H. Seward Memorial**
Seattle Municipal Archives
30509

14 **The Leschi on Lake Washington**
Washington State Archives
AR-07809001-ph001796

15 **Windy Day at West Point Lighthouse**
Washington State Archives
AR-07809001-ph003663

16 **Boatload of Tourists Admiring the Skyline**
Washington State Archives
AR-28001001-ph002142

17 **Lake Washington Floating Bridge**
University of Washington Libraries, Special Collections
UW28969z

18 **Fishermen at the Arboretum**
University of Washington Libraries, Special Collections
UW19986z

19 **Princess Marguerite II at Pier 64**
Washington State Archives
AR-28001001-ph002196

20 **University of Washington Air-raid Drill**
University of Washington Libraries, Special Collections
UW19682z

21 **Relaxing at Green Lake**
Washington State Archives
AR-28001001-PH000956

23 **FEEDING THE DUCKS, 1952**
University of Washington Libraries, Special Collections
UW28968z

24 **READYING HYDROPLANE SLO-MO-SHUN IV**
University of Washington Libraries, Special Collections
Hupy6199b

25 **BON ODORI FESTIVAL AT SEAFAIR**
University of Washington Libraries, Special Collections
Hupy232_7

26 **CROWDS AT THE BALLARD LOCKS**
Washington State Archives
076E94A955E1F6FF0100CD19C2B7716E

27 **SPECTATORS AT SEAFAIR HYDROPLANE RACES**
University of Washington Libraries, Special Collections
Hupy0243_4

28 **JOHN OLMSTED'S VISION**
University of Washington Libraries, Special Collections
UW19070z

29 **ROOFTOP PANORAMA, 1950**
University of Washington Libraries, Special Collections
UW28842z

30 **LAST OF THE MOSQUITO FLEET**
University of Washington Libraries, Special Collections
UW28974z

32 **CREW ABOARD THE SHANTY-I, 1956**
University of Washington Libraries, Special Collections
Hupy6199a_19

33 **GOLF COMPETITOR IN SAND TRAP**
Washington State Archives
AR-28001001-ph001840

34 **THE LACEY V. MURROW FLOATING BRIDGE**
Seattle Municipal Archives
61475

35 **MONTLAKE DUMP ON UNION BAY**
University of Washington Libraries, Special Collections
UW19649z

36 **THE VIEW FROM KERRY PARK**
University of Washington Libraries, Special Collections
UW28972z

37 **THE VIEW FROM KERRY PARK NO. 2**
University of Washington Libraries, Special Collections
UW24240

38 **BEAN PICKERS BOUND FOR THE FIELDS**
Washington State Archives
AR28001001-ph000672

39 **AERIAL VIEW OF THE MEDICAL SCHOOL**
University of Washington Libraries, Special Collections
UW2356

40 **HUSKY STADIUM AND THE EDMUNDSON PAVILION**
University of Washington Libraries, Special Collections
UW19945z

41 **"THE BON" PARKING GARAGE SKYBRIDGE**
University of Washington Libraries, Special Collections
UW28593z

42 **THE BON MARCHE SNACK BAR**
University of Washington Libraries, Special Collections
Hupy0237_11

43 **THE SEATTLE ART MUSEUM**
Seattle Municipal Archives
61742

44 **DOWNTOWN FROM WEST SEATTLE, 1952**
Seattle Municipal Archives
23798

45 **FIFTH AVENUE NEAR YESLER WAY**
Seattle Municipal Archives
44570

46 **BEFORE THE BATTERY STREET TUNNEL**
Seattle Municipal Archives
44008

47 **THE BATTERY STREET TUNNEL**
Seattle Municipal Archives
53994

48 **DOWNTOWN FROM ATOP THE MARINE HOSPITAL**
Seattle Municipal Archives
45545

49 **RESURFACING THE SPOKANE STREET BRIDGE**
Seattle Municipal Archives
58833

50 **ROADWORK IN WEST SEATTLE**
Seattle Municipal Archives
42132

51 **SW SPOKANE STREET AT 11TH AVENUE SW**
Seattle Municipal Archives
59849

52 **WEST SEATTLE HOME ECONOMICS CLASS**
Seattle Municipal Archives
26837

53 **THE SCENE AT BETHLEHEM STEEL, 1950**
Washington State Archives
AR-28001001-ph001425

54 **FUN IN THE SUN AT MADRONA PARK**
Washington State Archives
AR-28001001-ph001169

55 **BOEING SUB-ZERO SIMULATOR**
Washington State Archives
AR-28001001-ph001083

56 **THE SMITH TOWER AT EVENING**
University of Washington Libraries, Special Collections
UW23405z

57 **PACIFIC NATIONAL BANK UNIVERSITY BRANCH, 1957**
University of Washington Libraries, Special Collections
UW4610

58 **MYSTIC CALLAHAN AMID SWASH**
University of Washington Libraries, Special Collections
Hupy0121_33

59 **AERIAL VIEW OF UNIVERSITY OF WASHINGTON, 1955**
University of Washington Libraries, Special Collections
UW28973z

60 **BUSINESSES ON SOUTH JACKSON STREET**
University of Washington Libraries, Special Collections
UW26323z

61 **Clothiers Martin & Eckman**
University of Washington Libraries, Special Collections
UW4536

62 **Great Northern Railway Clock Tower**
University of Washington Libraries, Special Collections
Hupy6248_10

63 **Bon Marche Parking Garage at Night**
University of Washington Libraries, Special Collections
UW28611z

64 **The Low Cost of Hydroelectric Power**
University of Washington Libraries, Special Collections
Hupy5224_1

65 **Berliners' on Fifth**
University of Washington Libraries, Special Collections
Hupy5194_2

66 **Vann Brothers Restaurant**
Seattle Municipal Archives
23351

67 **Netting a Salmon in Elliott Bay**
Washington State Archives
AR-28001001-ph000718

68 **Chuck and Terry's Fish and Chips**
Seattle Municipal Archives
24460

70 **Rocky the Mountain Goat**
University of Washington Libraries, Special Collections
Hupy2104_2

71 **Smith Tower and the Pioneer Building**
Washington State Archives
AR-07809001-ph002113

72 **The Austin A. Bell Building**
Washington State Archives
AR-07809001-ph002126

73 **Last Days of the Seattle Hotel**
Seattle Municipal Archives
66611

75 **At the Corner in Pioneer Square**
Seattle Municipal Archives
30003

76 **Seattle Hotel Abandoned**
Seattle Municipal Archives
66610

77 **Traffic Congestion, 1960**
Seattle Municipal Archives
63434

78 **Wesley Wehr at Golden Gardens Park, 1966**
University of Washington Libraries, Special Collections
UW28998z

79 **Newsstand at Fifth Avenue and Pine Street**
University of Washington Libraries, Special Collections
Hupy0187_4

80 **NE 45th Street and University Way NE**
University of Washington Libraries, Special Collections
UW28962z

81 **The University District, 1960s**
University of Washington Libraries, Special Collections
UW4609

82 **Businesses on University Way NE**
University of Washington Libraries, Special Collections
UW24307

83 **Businesses on University Way NE no. 2**
University of Washington Libraries, Special Collections
UW4606

84 **Businesses on University Way NE no. 3**
University of Washington Libraries, Special Collections
UW28965z

85 **Businesses on University Way NE no. 4**
University of Washington Libraries, Special Collections
UW28963z

86 **Tracie's Folklore Center**
University of Washington Libraries, Special Collections
UW28964z

88 **Aerial View of Downtown Skyline, 1960s**
University of Washington Libraries, Special Collections
UW26331

89 **The Maynard Building, 1960**
University of Washington Libraries, Special Collections
UW7284b

90 **J&M Cafe and Hotel**
University of Washington Libraries, Special Collections
UW7283a

91 **Central Tavern and Cafe**
University of Washington Libraries, Special Collections
UW7283b

92 **The Alaskan Way Viaduct**
University of Washington Libraries, Special Collections
UW7286a

93 **The Bay Building, 1966**
University of Washington Libraries, Special Collections
UW28988z

94 **North End of Lake Union**
University of Washington Libraries, Special Collections
UW28971z

95 **NE 45th Street from University Way NE**
University of Washington Libraries, Special Collections
UW367

96 **College Inn and Gold Medal Food Center**
University of Washington Libraries, Special Collections
UW5688

97 **The Globe Building**
University of Washington Libraries, Special Collections
UW28966z

98 **The Hambach Building**
University of Washington Libraries, Special Collections
UW28967z

99 **First National Bank Tower**
University of Washington Libraries, Special Collections
UW25985z

100 **Seattle from Magnolia Bluff**
Washington State Archives
DE9608BCE52C7DD8E5D2DABEFC88EC20

101 **Heart of Seattle**
Washington State Archives
AR-28001001-ph002166

102 **Beauty Contestants at the Four 10**
Washington State Archives
AR-28001001-ph002569

103 **Interstate 5 Dedication Ceremony**
Washington State Archives
AR-7809001-ph001064

104 **Boeing Instrumentation Test**
Washington State Archives
AR-07809001-ph000182

105 **The Yesler Building**
Washington State Archives
AR-07809001-ph002136

106 **The Smith Tower, 1960**
Washington State Archives
AR-07809001-ph002130

107 **Third Avenue at Stewart Street**
Washington State Archives
AR-28001001-ph002160

108 **Detour for Denny Way**
Washington State Archives
AR-28001001-ph002170

109 **Dedication at Colman Ferry Dock**
Washington State Archives
AR-07809001-ph001822

110 **Seafair Parade Through Pioneer Square**
Washington State Archives
7C51A2E06A014589B35143CA2F2BD46B

111 **The Olympic Hotel**
Washington State Archives
90367F30085C31E3A59EC8F7C5BC95AC

112 **Mount Rainier from Madrona Beach**
Washington State Archives
6AD1BF6A4985EF1DE8F69DDB4119B61F

113 **Wires at Fifth Avenue and Mercer Street**
Washington State Archives
9409643A5A67AA370E8D797D74D1C308

114 **The Monorail at Benjamin Franklin Hotel**
Washington State Archives
FC6B8F90737700A130DC7F48ABE1FDC0

115 **The Monorail at Denny Way**
Washington State Archives
02FF8068D134022EEA4948B6D665E452

116 **Kennedy with Jackson and Rosellini**
Washington State Archives
074DE3A04E91783F94C01561C11C2748

117 **A Look Back at the 1962 World's Fair**
Washington State Archives
186C7AFA626AF45B578BE6DE69EBC798

118 **World's Fair First Service Station**
Washington State Archives
9F0B1823AB73C12B727807F7C41C9F4F

119 **World's Fair Band Shell**
Washington State Archives
12245B78278A9DB03A82074AEF668D2A

120 **Aerial View of the Space Needle**
Washington State Archives
E9EA98833B584D39AEB7BFE8C779905F

121 **Artist's Rendition of the Space Needle**
University of Washington Libraries, Special Collections
UW15543

122 **World's Fair Gayway Space Whirl**
University of Washington Libraries, Special Collections
UW28995z

123 **What Are the Odds Science Exhibit**
University of Washington Libraries, Special Collections
UW28994z

124 **World's Fair Burgers and Cooks**
University of Washington Libraries, Special Collections
UW28993z

125 **Bird's-eye View of the Gayway**
University of Washington Libraries, Special Collections
UW28991z

126 **World's Fair Japanese Village**
University of Washington Libraries, Special Collections
UW28992z

127 **World of Entertainment Playhouse**
University of Washington Libraries, Special Collections
UW28970z

128 **American Library Association Exhibit**
University of Washington Libraries, Special Collections
UW28990z

129 **An Adventure in Outer Space**
University of Washington Libraries, Special Collections
UW28989z

130 **Home of Living Light for Tomorrow**
University of Washington Libraries, Special Collections
UW28987z

131 **World's Fair Express Train**
University of Washington Libraries, Special Collections
UW28986z

132 **World's Fair Giant Wheel**
University of Washington Libraries, Special Collections
UW28985z

133 **Mayflower II and Dodge Convertible**
University of Washington Libraries, Special Collections
UW28984z

134 GOVERNMENT OF INDIA PAVILION
University of Washington Libraries, Special Collections
UW28983z

135 THE PHILIPPINES PAVILION
University of Washington Libraries, Special Collections UW925

136 WORLD'S FAIR INTERNATIONAL FOUNTAIN
University of Washington Libraries, Special Collections
UW28982z

137 BIRD'S-EYE VIEW OF THE FAIR AND ELLIOTT BAY
University of Washington Libraries, Special Collections
UW28981z

138 WERNER'S MAQUETTE OF LEIF ERICSON
University of Washington Libraries, Special Collections
UW29001z

139 FIFTH AVENUE CONSTRUCTION OF THE MONORAIL
University of Washington Libraries, Special Collections
UW28980z

140 INTERNATIONAL MALL CONSTRUCTION
University of Washington Libraries, Special Collections
UW28929z

141 THE MONORAIL FROM BELOW
University of Washington Libraries, Special Collections
UW28977z

142 WORLD'S FAIR COMMEMORATIVE POSTAGE STAMP
University of Washington Libraries, Special Collections
UW28976z

143 U.S. SCIENCE PAVILION ARCHES
University of Washington Libraries, Special Collections
Hupy2152_9

144 THE SKYRIDE AT NIGHT
University of Washington Libraries, Special Collections
Hupy2147_30

145 EVENING VIEW OF THE ARCHES
University of Washington Libraries, Special Collections
Hupy2147_32

146 THE FLAG PLAZA AND PAVILION
University of Washington Libraries, Special Collections
Hupy2154_1

147 WORLD'S FAIR SECURITY
University of Washington Libraries, Special Collections
Hupy2147_4

148 FOREST OF SCULPTURES AT BROAD STREET ENTRANCE
University of Washington Libraries, Special Collections
Hupy2154_4

149 WORLD'S FAIR FOOD CIRCUS
University of Washington Libraries, Special Collections
Hupy2171_3

151 DEDICATION OF LEIF ERICSON STATUE, 1962
University of Washington Libraries, Special Collections
UW29002z

152 BELVEDERE PLACE VIEWPOINT
Seattle Municipal Archives 28835

153 DENNY HALL, 1960S
Washington State Archives B489D49D7046E5BF982F49E93F74A827

154 SEATTLE SKYLINE, 1969
Seattle Municipal Archives 73166

155 BOATING SEASON OPENING DAY, 1962
University of Washington Libraries, Special Collections
Hupy2191_7

156 OUTDOORS PSYCHOLOGY CLASS
University of Washington Libraries, Special Collections
UW20210z

157 LOWER CAMPUS AT THE UNIVERSITY, 1968
University of Washington Libraries, Special Collections
UW19716z

158 BOMB BLAST AFTERMATH AT THE UNIVERSITY, 1969
University of Washington Libraries, Special Collections
UW5694

159 SEAFOOD VENDOR AT PIKE PLACE MARKET
University of Washington Libraries, Special Collections
UW29000z

160 PIKE MARKET TRANSACTION
University of Washington Libraries, Special Collections
Hupy1171_11

161 MERCHANT IN MAIN ARCADE AT PIKE MARKET
University of Washington Libraries, Special Collections
Hupy1171_5

162 SIXTH AVENUE AND VIRGINIA STREET
Washington State Archives D486CB46215E798C5FE1839891FF846B

163 SOLDIERS IN PARADE ON FOURTH AVENUE
Washington State Archives 2E0B73E7F7D5EE0D5A152C366B90F1C5

164 WASHINGTON PLAZA HOTEL
University of Washington Libraries, Special Collections
Hupy69161_16

166 THE W. T. PRESTON
Washington State Archives 84E79B6462061959473600654E5BD2FE

167 SEATTLE LIGHTING COMPANY GAS WORKS
University of Washington Libraries, Special Collections
UW29003z

168 KING STREET STATION, 1970
University of Washington Libraries, Special Collections
UW28996z

169 PIONEER BUILDING AT FIRST AVENUE
University of Washington Libraries, Special Collections
Hupy74213_1

170 FLOATING BRIDGE HIGHWAY RAMPS
University of Washington Libraries, Special Collections
Hupy0108_4

171 PIKE PLACE FISH COMPANY AND PRODUCE COUNTER
University of Washington Libraries, Special Collections
Hupy5151_7

172 FIRST HILL AND ST. JAMES CATHEDRAL
University of Washington Libraries, Special Collections
Hupy6248_11

173 SHRIVER AND THE MCGOVERN TICKET
Seattle Municipal Archives 33401

174 THE SEATTLE WHEEL, 1970
Seattle Municipal Archives 73179

175 FUN FOREST CAROUSEL
Seattle Municipal Archives 73188

176 KIDDIELAND AT SEATTLE CENTER
Seattle Municipal Archives 73175

177 THE FUN FOREST AT NIGHT
Seattle Municipal Archives 73169

178 PIKE PLACE MARKET STREET FAIR, 1975
Seattle Municipal Archives 36570

179 SCENE ON FIRST AVENUE, 1972
Seattle Municipal Archives 32526

180 FREE SAMPLE AT PIKE PLACE MARKET
Seattle Municipal Archives 32350

182 THE CORNER MARKET, 1971
Seattle Municipal Archives 32028

183 HISTORIC DISTRICT RENOVATION IN PROGRESS
University of Washington Libraries, Special Collections
Hupy74213_4

184 RECREATION AT ALKI BEACH
University of Washington Libraries, Special Collections
Hupy1175_1

185 FINANCIAL CENTER BUILDING ON FOURTH AVENUE
University of Washington Libraries, Special Collections
Hupy76184_2

186 FIRE DEPARTMENT STATION NO. 7
Washington State Archives
7A5DDFDC6C055B32A5CD8278A8E39874

187 LEWIS HALL
Washington State Archives
3C16A72E51EAF60C0626A11531A5DF08

188 OBSERVATORY AT THE UNIVERSITY
Washington State Archives
D26C460AA2D27292599753165A330A5F

189 SEATTLE PUBLIC LIBRARY, YESLER BRANCH
Washington State Archives
5296CD47A88F4D8EABA371667BCD6246

190 THE RAINIER CLUB
Washington State Archives
6B5DF6621EC225C1E154D2C196EAF3DC

191 NATIONAL ARCHIVES REGIONAL FACILITY
Washington State Archives
FDB096A4DEF318C86B430A4BF0962C4D

192 PUBLIC LIBRARY CARD CATALOGS
Washington State Archives
388C6CDFD3CFA93F5FFC2EE619B7DB31

193 WASHINGTON PIONEER HALL
Washington State Archives
918697F6CC3A7D584B320AD4A2A3F877

194 ARTIST WASHINGTON WITH SCULPTURE
Washington State Archives
3EBEC85C0859CA99D1C31AEAAD53E96F

195 LAST DAYS FOR HOTEL STEVENS
Washington State Archives
13E8D200D40458BACD571BE1A566C724

196 THE ARCHES
Washington State Archives
0B6C1C06BC531C8A861A7BB012582D64

197 ARTICULATED TROLLEY-BUS EXPERIMENT
Washington State Archives
9038877B4500E178AAE82DFC782F8522

198 INTERSTATE 90
Washington State Archives
B1477EFC8ED461A547B567F0C3822366

199 THE MOON TREE
Washington State Archives
CA571D32E89760E64008CAE25D7E967B

200 DEDICATION OF BERGEN PLACE, 1975
Washington State Archives
A6A46B6EA9AB162038A2147B36D9C2A9